The Artist,
The Censor,
and The Nude

The Artist,
The Censor,
and The Nude

A Tale of Morality and Appropriation

By Glenn Harcourt

DoppelHouse Press
Los Angeles

The Artist, The Censor, and The Nude:
A Tale of Morality and Appropriation
By Glenn Harcourt
Artwork by Pamela Joseph
Foreword by Francis M. Naumann

Cover image: Pamela Joseph, *Censored Valpinçon Bather by Ingres*, 2012. Oil on linen, 35 × 22 in. Courtesy of the artist.

Book Design: STILL ROOM / Jessica Fleischmann with Jenny Haru Kim

Edited by Carrie Paterson and Christopher Michno

Publisher's Cataloging-in-Publication data

Names: Harcourt, Glenn, author. | Naumann, Francis M., foreword author.
Title: The Artist, the censor, and the nude: a tale of morality and appropriation / by Glenn Harcourt; [Foreword by Francis M. Naumann]
Description: Los Angeles, CA: DoppleHouse Press, 2017.
Identifiers: ISBN 9780997003420 | LCCN 2017946123
Subjects: LCSH Joseph, Pamela. | Art--Censorship. | Freedom and art. | Censorship--Iran. | Nude in art--Censorship. | Orientalism. | Art, Iranian--21st century. | Art, Modern--21st century. | Women artists. | Women in art. | BISAC ART / Individual Artists / General | ART / Middle Eastern | ART / Subjects & Themes / Human Figure | ART / Art & Politics | POLITICAL SCIENCE / Censorship.
Classification: LCC N8740 .H37 2017 | DDC 701/.03–dc23

TABLE *of* CONTENTS

Cubism, a pirated Taschen edition of western art published in Iran. Collection Kurosh ValaNejad.

Dadaism, a pirated Taschen edition of western art published in Iran. Collection Kurosh ValaNejad.

CENSORED WORKS OF ART

Francis M. Naumann

Pamela Joseph's series of paintings entitled "CENSORED" are based on well-known paintings and sculpture that were reproduced in art books published in Iran, images that were censored from view either by black felt-tip marker to cover up details that were considered inappropriate (when the books were imported from other countries) or by means of pixelization (when the [pirated] books were published within the country). The artist learned about the existence of these images from her erstwhile collaborator, the Iranian-American digital artist Kurosh ValaNejad, who lent her copies of the censored publications. At first, the censored works appeared amusing, but they quickly stimulated a series of questions about why select details were obscured in the first place. Who did the obscuring, and what exactly was it in these images that censors believed was best kept from public view? Was this just another example of censoring the male gaze, or did it involve fundamental violations of deeply held religious beliefs? If the concealment of these details was meant to eliminate sexually explicit details, then another question is immediately raised. How successful is this form of censorship? As Goya's two versions of his famous *Maja* proved centuries ago (a painting the artist includes in this series), the female figure can be far more compelling and sexually alluring when clothed. In nearly all cases of the books' censorship, the suggestion of what has been taken from view is potentially more provocative than what is visible in the original painting or sculpture.

However these questions are answered, they provided a stimulus for Joseph to turn these reproductions back into paintings, carrying with them the obscured details imposed upon them by their censors. She even went further, choosing select works of art upon which she imposed her own pixelization or covered select details with an opaque black overlay, revealing, ultimately, that her motives are inherently more painterly than a political critique of religious practices. Indeed, she feels that these censored images have provided her with an entirely new vehicle of pictorial expression, one that can be applied to

virtually the entire history of western art, with results that are often amusing, but inevitably thought provoking and visually engaging.

Although Joseph had been working on these paintings for three years, they were first shown in New York in April–May 2015, an exceptionally timely moment for a worldwide audience since it was just after the tragic terrorist attack that took place in Paris in January 2015 at the offices of the French satirical magazine, *Charlie Hebdo*. In that case, Islamist gunmen were expressing their objection to the magazine's practice of publishing anything that was critical of Islam, particularly cartoons that depicted the prophet Mohamed. A similar outrage had followed the publication of cartoons in Denmark in 2005, resulting in riots throughout the Arab world that caused the deaths of hundreds. Those who found this imagery objectionable attempted to censor it, but their actions only resulted in disseminating the imagery worldwide.

Of the styles Joseph appropriates, it could be argued that those derived from Cubist pictures are the least visually disruptive, for the pixelization process echoes the geometric patterning already imposed by the vocabulary of Cubism. In Jean Metzinger's *Tea Time*, for example, the mid-section of the image is pixelated, obscuring from view the female figure's breast (only one is visible in the painting), but that breast had already been subjected to the geometry and planar division of a Cubist space. The same occurs with Picasso's *Three Women*, but here what is being withdrawn from view is virtually genderless, making it clear that the censors were more concerned with the concept of nakedness than with anything within the image that might have been visually titillating (if the pun can be forgiven!). This reasoning, however, does not explain why in a book with reproductions of Dadaist work, the censors chose to reproduce Marcel Duchamp's infamous *Fountain* – the white porcelain urinal he submitted to the first exhibition of the Society of Independent Artists in New York in 1917 under the pseudonym R. Mutt, which was refused from display on the grounds of indecency – only to subject the image to pixelization, leaving only the outer contours of the offending object visible to viewers. Rather than select any other work by the artist that could have served just as well to illustrate the concept of the readymade, we might consider that they may have chosen this controversial artifact because it allowed the writer of the book to point out, ironically, how Americans had exercised their own form of censorship in the arts one hundred years ago.

It is worthwhile to point out that the Independent Artists' exhibition opened in New York on April 10, 1917, only three days after the United States declared war on Germany, guided by the memorable words of President Woodrow Wilson that we were doing so in order to "make the world safe for democracy." When *Fountain* was withheld from public view, it would have been impossible to ignore a rapport with the ongoing political situation, for we were essentially entering a war to protect the hard-fought freedoms Americans felt

they were guaranteed through the Constitution, most importantly, the First Amendment right to free speech. But even these cherished rights had their limitations, as was demonstrated when Alfred Stieglitz's photograph of *Fountain* was reproduced in *The Blind Man*, a journal organized by Duchamp and his friends to publicize the injustice demonstrated by the rejection of R. Mutt's controversial submission to the show. Beatrice Wood, one of the editors of the magazine, later explained that her father, who was a respected business man, refused to allow the publication to be sent through the mail, for it contained material that could be considered pornographic and, as a result, his daughter could be carted off to prison.* It is indeed ironic that this attempt to defend the democratic principles of a given situation resulted in their very violation through censorship. In the form of a compromise, the magazine was circulated by hand, and eventually reached everyone in the art world who took an interest in the story.

As Pamela Joseph's paintings demonstrate, when it comes to the visual arts, Americans are capable of being just as prudish as their Iranian counterparts. In May of 2015, Picasso's *Women of Algiers* sold at Christie's in New York for $179 million, setting the record for the most money paid for a work of art at public auction. News agencies around the world reported the event, but several – most notably a Fox News affiliate in New York – elected to obscure from view certain details within the painting that they felt might be offensive to their audience: breasts and genitalia (missing, curiously enough, a pair of buttocks clearly visible in the center of the picture). This attempt at censorship ignited critics, one finding the actions of Fox 5 New York News to be "sexually sick." When Modigliani's *Reclining Nude* sold at auction a year later for $170 million, the news was again reported worldwide, but in order to show the picture on television, Bloomberg News was forced to blur the breasts and pubic area because, as commentators explained, they thought these details were "too racy" for the viewing public. Critics again responded in uproar, but none with a greater sense of humor than Stephen Colbert, who on his nightly broadcast amusingly described the process of censorship as "de-titillating." He seized the opportunity to ask himself a series of provocative questions about what is art and what it is not. Most importantly for his own concerns, he wanted to know what his own network (CBS) would allow him to show and what they would not. He illustrated this point by taking out a sketch pad and marker and drawing two circles with dots in them. When he identified them as a pair of female breasts, censors blurred the image from view, but when he added a nose and smiling mouth below these circles – transforming the breasts into a pair of human eyes – they were permitted. Perhaps to confirm that her objections were not aimed exclusively at Iranian censors, Pamela Joseph also painted the blurred image of Picasso's *Women of Algiers*.

*See Beatrice Wood, *I Shock Myself: The Autobiography of Beatrice Wood* (Ojai, Cal.: Dillingham Press, 1985), 31-32.

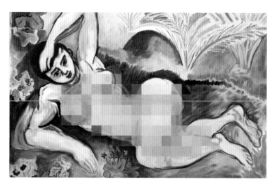

Pamela Joseph, *Censored Blue Nude by Matisse,* 2014. Oil on linen, 30 × 48 in.
Courtesy of the artist.

What might not be otherwise evident in viewing Joseph's paintings is that before applying the black lines or pixelization that serve to cover or obscure details that are deemed inappropriate for view, she paints the entire source picture from top to bottom. Only after it dries does she then apply these obfuscating elements, which causes her to re-experience the censor's gestures when covering these details, and it gives her an opportunity to exercise some control over how the elements are applied. If we look carefully at her version of Matisse's 1907 *Blue Nude (Souvenir of Biskra),* for example, we will see that the woman's breasts are still discernable through the pixelization, as are select details in Picasso's *Three Women.* It is ironic that she chose Duchamp's *Nude Descending a Staircase* as a subject, since when the work was shown at the Armory Show in New York in 1913, many critics derided the picture for its lack of a recognizable subject – the nude figure promised by its title. That did not stop them from looking, however, and finding details that their imaginations found too intimate to express publicly. Joseph also took liberties when applying the black lines to cover Manet's *Olympia,* for although she replicated the censoring process faithfully, she could not bear to cover the figure's eyes. To her mind, it resulted in a visual violation that was unacceptable, preventing the female figure from looking back at us and, for that matter, at the censor who attempts to obscure her naked body from public view, a body for which she harbors no apparent shame (rather, she openly displays an air of confidence and pride).

What Joseph's series of paintings proves is that censorship in the arts differs from culture to culture and, in most cases, only causes the audience these censors are attempting to protect to wonder exactly what is being kept from them and why, resulting in a thought process that can often be more sexually stimulating than a view of the unaltered work of art. Yet by recreating the censored images – enlarging them to the size of the originals and placing them on public view – Joseph creates a series of images that should not be found offensive by anyone, providing a biting and severely critical, while at the same time uniquely humorous commentary on the futility of censorship in the arts, no matter in what form it is practiced.

Note:

It should be acknowledged that – unwittingly – my own writings were once subjected to censorship in Iran. In 2016, I was contacted by Nadia Tahmorsi, an Iranian painter and translator whom I had not known previously, but who explained that she had recently moved from Iran to Vancouver, Canada. She told me that she had recently translated my entire book on Marcel Duchamp – *Marcel Duchamp: The Art of Making Art in the Age of Mechanical Reproduction* (New York: Harry N. Abrams, 1999) – into "Persian." She said that this project had taken her over two years to complete, and she sent me a PDF that contained all three hundred and thirty-one pages of the book laid out and translated into Farsi. She warned me that there were no copyright laws in Iran that protected authors, but she nevertheless asked for my permission to publish the book, because, as she explained, there were "many thirsty young Iranian artists who want to know more about Marcel Duchamp and Dada."

I immediately responded by saying that although most American writers would probably object to their books being translated into another language without compensation, I was not among them, for to me, it was a higher priority to disseminate information about Duchamp and his artistic contributions. I warned her that although I was at liberty to provide permission for the publication of my writings, I was not at liberty to do so for the reproductions, for they were under the control of the Association Marcel Duchamp in France, and I gave her the information to contact them and their representatives (ADAGP in Europe, and ARS in the US) if she wished. In exchange, I asked for only two things: that several comparatively minor corrections be made to the text (which I provided), and that three complimentary copies of the final publication be sent to me. She immediately responded and agreed to those terms.

After a year passed and I still did not receive the books, I contacted her again. She wrote and told me that the Ershad Ministry in Iran (the Ministry of Culture and Islamic Guidance) had authorized the publication of the book, but only asked for some minor editing of the text, and the removal of Duchamp's *Paysage Fautif* [Wayward Landscape], an abstract composition that the artist made in 1946 for his secret lover, Maria Martins. It was recently discovered that this work was composed entirely of Duchamp's semen, a medium that the Ministry of Culture and Islamic Guidance clearly considered objectionable. She also explained that even after some books were published, if these censors found anything in them that they determined violated Islamic modesty standards, they could still seize them and banish them from circulation. Most publishers, therefore, are fearful of putting money into the production of a book that might not be distributed. For this reason, my book remains in a limbo state, although I remain optimistic that my writings on Duchamp will one day reach an Iranian audience.

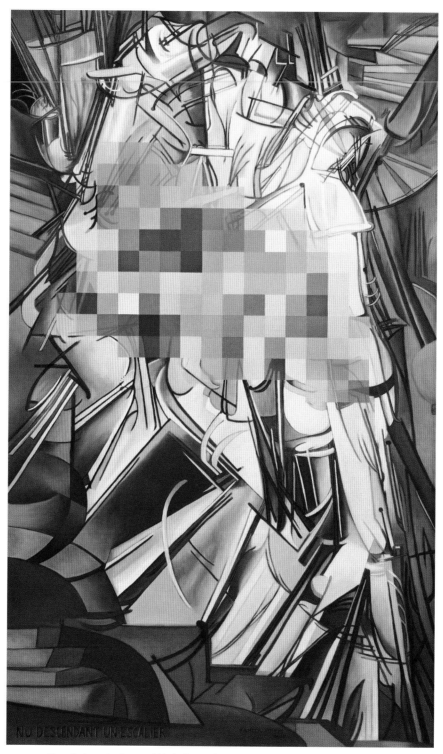

Pamela Joseph, *Censored Nude Descending a Staircase (No.3) by Duchamp*, 2015.
Oil on linen, 50 × 30 in. Courtesy of the artist.

Pamela Joseph's "CENSORED": Appropriation and Cultural Politics

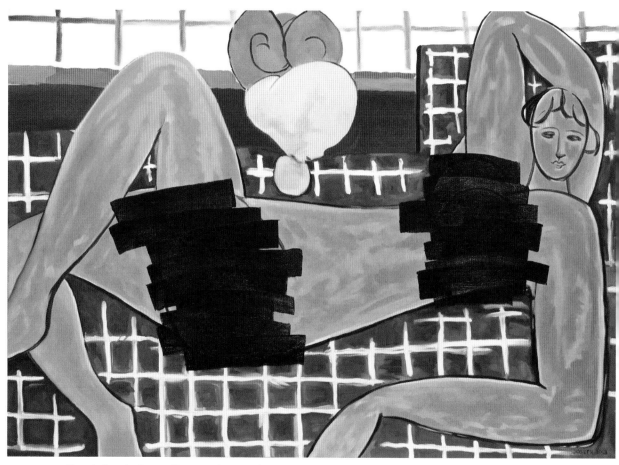

Pamela Joseph, *Censored Large Reclining Nude by Matisse*, 2013. Oil on linen, 26 × 36.5 in. Courtesy of the artist.

MATISSE AND THE CENSORED NUDE

Of all the topographies that exist in the world, that of the human body is perhaps the one that has been the most relentlessly contested – both the actual body comprising flesh and blood, and the virtual body as it is written and visualized in representation. This is true of the body both male and female, and of the body both clothed and unclothed. Issues of personal and cultural identity; of sexual and theological politics; of religious and political ideology are all articulated in terms of the body and its represented image. The body as it is lived and pictured serves both to instantiate and to adjudicate cultural norms as well as to facilitate their transgression. It motivates desire, fashion, and pornography. Its representation serves as a measure of artistic skill, of fealty to pictorial tradition, or of commitment to innovation and revolution.

A recent body of paintings by the artist Pamela Joseph engages the (represented) body on all these levels, and in a way that is both deadly serious and marked by a certain campy sense of humor. There are significant variations in her process, but what remains constant is that Joseph's finished works appear to be painted reproductions of defaced images from the western artistic canon. The subjects are all secular in nature, although several provide Renaissance or Baroque recapitulations of mythological subjects drawn from classical antiquity.

In a relatively straightforward example of Joseph's work, the *Censored Large Reclining Nude by Matisse* (2013; oil on linen, 26 × 36.5 inches), the "model" is not an actual woman, or even an actual painting, but rather an illustration from Robert Cumming's *Art* (London: Dorling Kindersley Ltd, 2005), one of the DK series of Eyewitness Companions, which has been hand censored throughout in black marking pen, presumably (as will become evident) by an Iranian government worker.[1]

The book itself was purchased in a Tehran shop, and now belongs to the Iranian-American multi-media artist Kurosh ValaNejad. It is, at least in my experience, a unique artifact, and part of ValaNejad's collection of resonant personal objects. However, in addition to whatever associations the book might carry for its owner, it can speak to a wider audience; indeed it already has done so through this series of Pamela Joseph's paintings.

DK Eyewitness Companion to *Art*, hand censored in Iran. Collection Kurosh ValaNejad.

1 The DK Eyewitness Companion to *Art* is a compact art history survey introducing a selection of technical and critical topics, followed by a historical survey covering Paleolithic to post-modern work, and cast primarily in terms of discussions of individual artists. It is the kind of work that U.S. college students might use for course revision in an introductory survey, or high school students as an aid in prepping for the Advanced Placement Exam in Art History.

It is not entirely clear who might have undertaken the original job of marking up the book. It has been suggested by the book's owner that this boring and repetitive piece-work job might have been farmed out to local "villagers" in return for a small salary. Whether or not this is actually the case, the job must presumably still have been supervised by some minor bureaucratic functionary – someone who possessed the authority to instruct the actual censor and eventually to judge the accuracy of the mark-up.

We do know, however, that this artifact is not unique in Iranian experience. As an artist, still living and working in Iran, notes:

> Ah yes... I grew up on these books. Even developed a style [sic: here = technique] for removing marker ink from printed pages (such a futile effort).[2]

He also gives an account of the larger cultural context:

> In the early eighties, our central post office had an incoming-content-checking-division. Almost every package mailed to Iran was opened and the content checked for drugs; an enemy state's political propaganda material; arms; indecent images (the definition still includes nudity, pornographic material, female hair and all other body parts except hands – but with no accessories or nail polish – and face, again with no make up or suggestive expression). The rumor was that to avoid getting Muslim men exposed to the material, the task of censoring was given to Armenian women. After a few years, with the introduction of satellite dishes, fax machines, the Internet and such, the traditional post lost its function, the Armenians lost their jobs, and people got their freak on through other channels.[3]

2 Personal correspondence with the editors; February 16, 2017.
Here is a "recipe" for ink removal, as related by the artist, who prefers to remain anonymous (Ibid., February 21, 2017): First of all, this works best on glossy coated paper.
One needs rubbing alcohol, nail polish remover liquid or pads, white hygenic cotton + lots of luck.
A – Dampen a cotton ball with alcohol [not too much because it will soak the paper and the printed ink as well as the marker ink] ... we just want the marker removed layer by layer.
B – Hold the book or magazine flat.
C – Rub the area with the moist cotton just once.
D – Throw the cotton away and wait a few seconds for the excess alcohol to evaporate.
E – Get another piece of clean, moist cotton ball and repeat the process.
Never rub/scrub! [This will destroy the image and leave a smudge.]
When using nail polish remover be careful since it can remove the marker + printing ink in one stroke.
If lucky, you will get a faded image appearing. Best results usually have a [remaining] tint of black marker ink (10%) or more.
3 Loc. Cit.

In the censored Iranian version of the Matisse on which Joseph has based her own work, the nude remains easily identifiable as a nude although the breasts and pelvic area have been rather vigorously "edited" with bold strokes of the marker. Joseph has carefully copied Matisse's original at a scale of 1:1. It thus reappears as a life-size replica of the iconic *Large Reclining Nude* of 1935. But in the copied version, the marks of the censor have been significantly altered. They are now rather lightly sketched-in, so that areas of pink flesh appear through the black overlay, and intrusions of skin are also visible where the censoring marks fail to overlap completely. It is almost as if Joseph's painted "reproduction" hints at what we (or indeed anyone) *know(s)* to be there underneath the censor's marks. Coincidentally, but quite fortuitously, it seems that through these layers, Joseph has also made visible the experience of our anonymous Iranian artist and his contemporaries.

What can we learn by looking at Joseph's image side-by-side with Matisse's original and its defaced counterpart? In most American viewers, this picture by Matisse seems unlikely to provoke any kind of censorious response. Objections, if any, might more likely focus on the lack of "realism" than on the nudity; but I suspect that the vast majority of potential viewers would be willing to accept that it is merely a work of "modern" art, a more-or-less successful piece of pictorial decoration, or what we might simply call a "pretty picture."

Robert Cumming, in his Eyewitness text, does not discuss the *Large Reclining Nude* directly, except to say that Matisse reworked the picture many times. This despite the fact that the *Large Reclining Nude* or *Pink Nude*, as it is also called, actually marks a key moment in Matisse's career: his return to serious easel painting after an eight-year hiatus during which he worked in a number of alternative mediums and developed the cut-paper techniques that were so important to his later output. Instead, Cumming's overall evaluation of Matisse stresses what one would expect: the painter's interest in color and pattern, which (says Cumming) apparently develops independently of subject matter. Thus, per Cumming's discussion, Matisse's use of the nude here and in other work might be "naturalized" simply as the employment of a motif deeply embedded in the artistic tradition.

344

Henri **Matisse**

1869–1954 ⚑ FRENCH

🏙 Paris; Vence (South of France) 🎨 oils; sculpture; collage; drawings 🏛 Paris: Musée d'Art Moderne. Pennsylvania: Barnes Foundation 💲 $17m in 2000, *La robe persane* (oils)

The King of Colour – he celebrated the joy of living through colour. Major hero of the Modern Movement and one of its founders. Professorial and social, but not convivial, and a bit of a loner.

LIFE AND WORKS

Matisse first studied law in Paris and worked as a legal clerk before taking up art studies at the influential Académie Julian and under Moreau at the Ecole des Beaux-Arts, where he met several of the future Fauves. In fact, he came to art late and almost by chance, when, aged 21, he was given a box of paints whilst recovering from an appendicitis operation. In the late 1890s he experimented with Divisionism and absorbed a deep knowledge of colour theory. In 1899, he turned to Cézanne. Although penniless, he bought from art dealer, Vollard, a small Cézanne *Bathers* which he kept all his life and used as inspiration at low or critical moments

Self-Portrait *Henri Matisse, 1918, 65 x 54 cm (25¼ x 21¼ in), oil on canvas, Le Cateau-Cambresis: Musée Matisse.* A rare painting of the master at work. He usually hides small images of himself in portraits of others.

of his career. Coming from the grey cold light of northern Europe, the discovery of the brightness and warmth of Mediterranean light, which he first experienced in Collioure, on the French-Spanish border in the summer of 1904,

Large Reclining Nude *Henri Matisse, 1935, 66 x 92.7 cm (26 x 36½ in), oil on canvas, Maryland: Baltimore Museum of Art.* He reworked this picture 22 times, altering the background and model's proportions until he was happy.

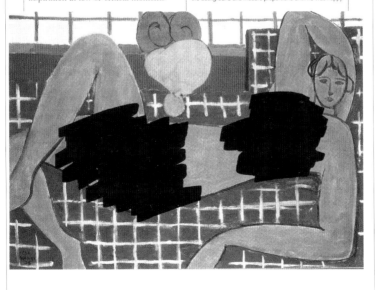

DK Eyewitness Companion to *Art*, hand censored in Iran. Collection Kurosh ValaNejad.

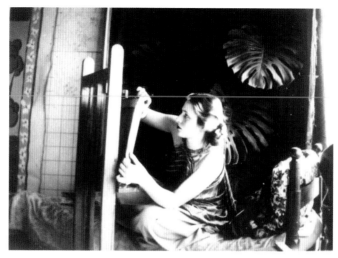

Lydia Délectorskaya in Matisse's atelier, Nice, 1932. Archives Matisse.

We do learn from Cumming, however, that Matisse's visit to Morocco in the early 1900's brought the painter "under the influence of Islamic and Persian art, both of which emphasize pattern and bold but subtle color."[4] However, Matisse's particular interest in "the exotic"[5] (and here the presence of the nude *is* key) clearly entangles the artist in the ongoing critical discussion around Orientalism and the western "male gaze," and suggests that his employment of a nude model might be rather less innocent than Cumming seems to suppose. Indeed, the model for the *Large Reclining Nude*, the Russian exile and orphan Lydia Délectorskaya, and her relationship to the painter as both lifelong muse and domestic employee, provides a key to both his personal life and his professional process from 1935 until his death in 1954.[6]

Matisse's Iranian censor must certainly be completely out of this ideological and critical loop and equally unaware of the model's biography. He (or she) seems most concerned to rectify the image in a way that simply keeps it recognizable while, at least to a certain extent, addressing its obvious violation of deeply held cultural and religious norms related, in this case, to the display of the unclothed female body. The Eyewitness text (which in the case of the Matisse entry is rather anodyne) is left intact throughout the book. There are a number of reasons why this might have been the case; the most straightforward is to assume that the book was seen simply as an archive of purely pictorial material, with a (presumably) unintelligible foreign-language text.

4 Robert Cumming, *Art* (London: Dorling Kindersley Ltd, 2005) 345.
5 Ibid.
6 For a short introduction to their relationship, which has generated considerable scholarship, see Hilary Spurling, "Matisse and His Models," *Smithsonian Magazine*, October 2005: http://www.smithsonianmag.com/arts-culture/matisse-and-his-models-70195044/?page=1. An exhibition featuring over one hundred works for which Lydia was the model was mounted in 2010 at the Musée Matisse in Nice.

Two points need to be made here. First: even as Pamela Joseph slyly pokes fun at the pretensions of the censorship with the delicate incompleteness of her own masking, she at least implicitly invites us to consider how such an image might be seen and understood in Iran. While the censor's view of Matisse's nude might be "normative," it need not therefore be exhaustive or definitive of all possible reactions, as we will soon see in considering recent contemporary artworks from the perspective of "the Iranian eye." Second: Joseph quite explicitly uses her "copy" of Matisse to encourage us to reflect back on our own biases and preconceptions with respect to the depiction of the nude female body.

Taking the second of these points first: in producing an image that amounts essentially to an exemplification of a kind of "domesticated" and modernist Orientalism, Matisse has given us an abstracted female form, no longer really representative even of a type (in this case, the Odalisque) but rather a figure drained both of particular signification and even of individual presence, a condition indexed, for example, by the flat, affectless nature of the model's gaze. On this reading, any censorious defacement of the figure is doubly unnecessary; first, because the nude image violates no obvious societal (read: patriarchal) or artistic norms (indeed, at least in this Modernist incarnation, the nude has become an essentially empty sign) and second, because the artist himself has already "defaced" the figure through the depersonalization of his depiction. (Matisse claimed to have become as familiar with the contours of Lydia's body as he was with the letters of the alphabet; but it is virtually impossible to sense this intimate familiarity in the picture of her with which he has presented us.)[7] However, the fact that Matisse's work might nevertheless motivate a feminist critique should still go without saying. Indeed, the outline of such a critique is already inherent in our own comments.

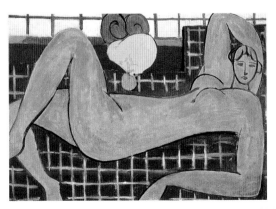

Henri Matisse, *Large Reclining Nude*, 1935. Oil on canvas, 66.4 × 93.3 cm.
Baltimore Museum of Art: The Cone Collection.

[7] For Matisse's claim, see Spurling, Ibid.

Teasing out a potential Iranian response is obviously more difficult; but it should be possible to make a few tentative and preliminary observations. Almost certainly, the view of the Ministry of Culture and Islamic Guidance,[8] which I take as the ultimate "author" of the program of censorship resulting in the defacement of the illustrations to Cumming's text, would be much more straightforward than that outlined above. Any image like Matisse's would be *prima facie* "un-Islamic" and hence subject to "correction."

There is perhaps a question here regarding what it might mean to characterize an image as being "like" Matisse's. However, a simple tabulation of the defaced images in Cumming demonstrates that neither the gender of the subject nor the style of the painter seems relevant, only the exposure of the naked human body.

This suggests that the entire western tradition, at least insofar as it is keyed to the human form, is riddled throughout with a kind of inherent vice, at least when seen from the Ministry of Culture's perspective. However, the mere existence of the censored book, even in its expurgated form, also suggests that, from the very same point of view, that tradition is still in some sense worthy of study. In any case, it cannot simply be discarded. This slightly schizoid orientation is characteristic of much post-colonial culture, and, when creatively rather than bureaucratically exploited, can be a powerful driver of critical and self-reflective cultural production.

55

century BCE Athens saw an astonishingly fertile burst of artistic creation, establishing an artistic canon that would not only dominate the Roman world but, when rediscovered by Renaissance Europe, would constitute an absolute artistic standard for a further 400 years.

Only a handful of fragments of Greek paintings have survived; many Greek sculptures are known only from Roman copies or written descriptions; and what architecture still exists is extensively ruined. But enough remains to make clear the extraordinary artistic impact of Classical Greece. The Parthenon, begun in 447 BCE, is the supreme example. Today, even stripped of its sculpture, its crumbling grandeur constitutes an emphatic statement of the lucid priorities that drove the Classical Greek world. Originally, brilliantly painted and embellished with statuary, its impact would have been more remarkable still.

Boy from Antikythera, c.340 BCE, height 194 cm (76 in), bronze, Athens: National Archaeological Museum.

in ways that were genuinely new, infusing the naturalistic with the ideal to produce a supremely self-confident image of a god-like youth. The sculpture manages the rare feat of being both supremely rational and yet at the same time extraordinarily sensual. Descriptions of Greek painting suggest it, too, reached comparable levels of technical achievement. The Roman frescoes at Pompeii were almost certainly heavily influenced by Greek originals. Perspective, foreshortening and the naturalistic representation of figures all seem to have been mastered in ways that would not reappear until

DK Eyewitness Companion to *Art*, hand censored in Iran. Collection Kurosh ValaNejad.

8 For the "public face" of the Ministry, see their English-language website: http://www.farhang.gov.ir/en/home.

Furthermore, we should call attention to the fact that the picture actually being defaced is itself only a reproduction; the mechanism of censorship operative here is quite incapable of threatening Matisse's actual masterpiece. It can (only) attempt to control the proliferation of Matisse's *Nude* by disrupting its printed circulation. (This is quite different from what we have seen in the cases, for example, of the Taliban at Bamyan or ISIS at Palmyra where actual artistic and archaeological monuments were destroyed under color of the suppression of idolatry.)[9] It also seems a bit *pro forma*: perfunctory in a way that suggests it isn't really "fooling anyone." Indeed, it is quite possible that unexpurgated copies of the same text might have been available, as it were, under the counter to those who knew where to look and whom to ask.[10] (And in any case, the prevalence of the Internet makes this kind of manual censorship virtually moot.)[11]

Finally, much as it might aspire to do so, the Ministry of Culture can hardly define or circumscribe the world of contemporary Iranian culture. It simply cannot control a system of cultural production in which questions of ethnic and cultural identity, modernity and tradition, individual freedom and Islamic norms, as well as Enlightenment liberty and authoritarian government (whether secular or clerical in nature), are all entangled with critical examinations of political and cultural imperialism, the legacy of Orientalism, the complexity of gender roles, and the complicated exigencies of living and creating in contemporary Iran.[12]

We can thus see how Joseph's *Large Reclining Nude by Matisse* sets up a complex dialog between western and Iranian culture on the one hand, and between western culture and its own self-reflexive feminist dopplegänger on the other. Joseph's pictorial machinations might initially seem superficially clever, even snarky; nonetheless they still have power enough to stimulate serious thought relevant to the problem of viewing cultural production within a non-judgmental global context.

9 In any case, this kind of brutally blind iconoclasm is hardly peculiar to Islam. Compare, to take just one example, the iconoclastic "excesses" of the Protestant Reformation, where the suppression of idolatry was also a driving motive. Whether the fact that ISIS and the Taliban profess a radical Sunni ideology, whereas the Iranian government is by definition Shi'ite in its orientation, has any bearing on these divergent cases is not a point that I can address in this forum.

10 The ins and outs of the trade in foreign books (in this case English literature rather than illustrated art-historical texts) is treated in Azar Nafisi, *Reading* Lolita *in Tehran* (New York: Random House, 2003/2008). Although it is easy to see why this book became a best-seller, and although I would certainly include it in any "must read" list of works on modern Iranian culture (especially during the revolutionary and immediately post-revolutionary periods), it should also be noted that (despite an almost universally adulatory response in the western press) Iranian scholars and feminists in exile have taken it very sharply to task for what they see as a toxically secular, pro-western, and anti-Islamic stance. This attack raises serious theoretical, religious, cultural, and political issues to which we will return.

11 In fact, penetration of the Internet in Iran equaled just over fifty-seven percent in 2015 (modest by Middle Eastern standards), but that was enough to reach over forty-five million users directly. http://www.internetworldstats.com/stats5.htm.

12 These questions will be examined in Part Two of this book.

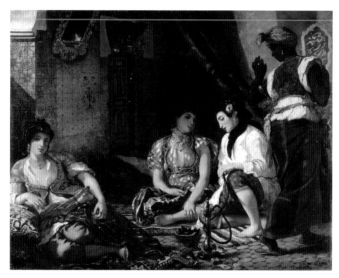

Eugène Delacroix, *Women of Algiers in Their Apartment*, 1834. Oil on canvas, 180 × 229 cm.
The Louvre.

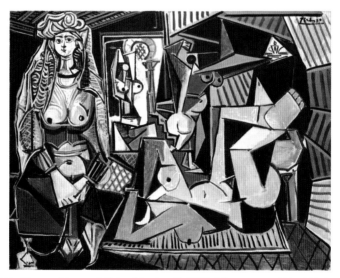

Pablo Picasso, *Women of Algiers* (Version O), 1955. Oil on canvas, 114 × 146.4 cm.
Private collection.

"BREASTINESS" AND "WESTOXICATION"

Although in a number of instances within the present body of work, Joseph is content to quote the defacement of the nameless Iranian censor more-or-less "verbatim," as is the case with Matisse, she also inflects this basic strategy in interesting and potentially significant ways. And it is not only censorship from the Islamic Republic that she takes to task, as we can see in the case of a work quite clearly related to the *Censored Reclining Nude*.

On May 11, 2015, Pablo Picasso's *Women of Algiers* (Version O), one of a series of fifteen paintings and drawings executed in the winter of 1954/1955, was auctioned by Christie's, New York for somewhat over $179 million, setting a new record for the price of a work of art sold at auction.[13] Like Matisse's *Large Reclining Nude*, Picasso's *Women of Algiers* is a monumental modernist reworking of a classic Orientalist subject, in this case a specific picture: Eugene Delacroix's 1834 *Women of Algiers in Their Apartment*, although (not surprisingly) Picasso has taken extensive formal and structural liberties with his putative source. And, like Matisse's "Odalisque manqué." discussed in the last chapter, Picasso's *Women of Algiers* has as its overarching theme what we might refer to as "venereal love," although that reference is now embedded in the work as a kind of deep meaning – based on cultural references from the nineteenth century that are no longer immediately legible, nor were likely to have been when the painting was produced in the mid-1950s.

Furthermore, as both the original Matisse and the original Picasso are canonical paintings in their own right, the extent that they have become fetishized as "a Matisse" and (especially) as "a Picasso," effectively effaces their deeper histories, in this case their connections to the work of the original Orientalist painters, where the specific sexual politics of the subjects are often quite explicit. For example, Delacroix's *Women of Algiers in Their Apartment* was originally legible as a harem scene, the women meant to be objects of voyeuristic pleasure. This picture would eventually fuel the developing discourse of Orientalism, but none of this is immediately evident in Picasso's variant. It requires a certain specialized knowledge to disentangle Delacroix's sexually charged imagery from Picasso's radical transformation, since Picasso's "game" here is to prove that he's a *better painter* than Delacroix, not to comment on Delacroix's colonialist ideology.

13 "Picasso's Women of Algiers smashes auction record," BBC, May 12, 2015: http://www.bbc.com/news/entertainment-arts-32700575.

Nevertheless, Picasso's *Women of Algiers* does display breasts and buttocks, and these are readily legible despite the painting's more-or-less radically abstract formal vocabulary. Hence, when the painting was shown on Fox 5 New York News in a report on the record-setting auction, the breasts were either blurred electronically or effectively masked by the screen crawl at the bottom of the image (to facilitate the latter tactic, the image was also cropped from the bottom to drop the breasts into the necessary position).[14] The buttocks, however, were, for whatever reason, apparently deemed less offensive and so escaped into our unprotected living rooms as well as into Joseph's work, where they provide a trenchant (and perhaps embarrassing) gloss on the Iranian material. As if emphasizing this fact, a second smaller painting of Joseph's, *Study #2 for Alger O*, 2015 "zooms in" on this feature of Picasso's work as redacted for us in the newscast.

One obvious possibility for critical inquiry raised by this citation involves a comparison between the power of censorship employed by Fox 5's video producers and that wielded by the nameless Iranian functionary. In light of that comparison, we might well ask the following: are both of these attempts to expunge an image's self-evident sexuality not essentially the same? Or are they different in some significant way?

Whatever the fundamental motivating factors in the two cases might be, it seems irrefutable that both are, in the last analysis, equally impotent. The dissemination of images today may not quite be ubiquitous, but it is pervasive enough that hand-censoring a DK Eyewitness Companion to *Art* will hardly be sufficient to effectively shield Iranian eyes from Matisse's *Large Reclining Nude*. Meanwhile, the attempt to "rectify" Picasso's *Women of Algiers* for television seems simply (and literally) laughable. Likewise, both of these interventions are clearly top-down affairs. In Iran, the decisive agency would be the Ministry of Culture and Islamic Guidance, which answers ultimately to the Supreme Council on the Cultural Revolution.[15] In America, the ultimate driver would be the Federal Communications Commission.[16]

14 Nor was this a strategy unique to Fox 5 New York News, and hence capable of being passed off merely as an ideological aberration.
15 Nadia Tahmorsi, personal communication; April 30, 2017. For a brief historical introduction to the Ministry's history, see Talinn Grigor, *Contemporary Iranian Art: From the Street to the Studio* (London: Reaktion Books, 2014) 37–40. Nafisi, *Reading* Lolita, 88–91 chronicles the author's attempt to procure texts for her course in English literature at Tehran University, as well as the general political and cultural climate that prevailed at the University in the late summer of 1979.
16 For an idea of the complexities involved in FCC regulations, a good place to start is the FCC's own Consumer Affairs site which explains how, and over what, consumers can file complaints with the Agency: https://consumercomplaints.fcc.gov/hc/en-us/articles/202731600-Obscene-Indecent-and-Profane-Broadcasts.

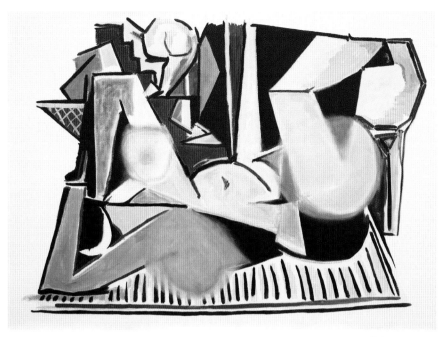

Pamela Joseph, *# 2 Study for Alger O*, 2015. Oil on linen, 26 × 30 in. Courtesy of the artist.

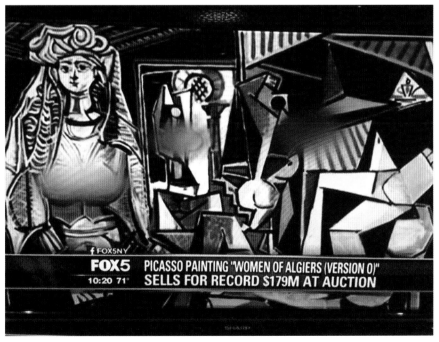

Fox 5 New York News broadcast. May 11, 2015.

The intended aim of the Ministry of Culture and Islamic Guidance (as, even more so, the Supreme Council of the Cultural Revolution) is to control both the means and the content of cultural production, to the end of fashioning an Iranian culture that is authentically and universally Islamic, always bearing in mind that the Islamic "universe" here is specifically and conservatively Shi'ite in its perspective.[17] Needless to say, this culture should also forward the political aims of the Iranian state, which are righteously "Islamic" by definition. However, this apparatus is not entirely immune to influence "from below." And, as can be seen in a short but trenchant look at the events surrounding the release of two recent Iranian films, that influence can be both effective and surprising in its direction; as the author Alex Shams observes, the general situation is such that "the lines of acceptable dissent are constantly being reformulated and redefined in an intricate push-and-pull between cultural producers, government censors, and a vocally opinionated public."[18]

The FCC, on the other hand, is also intended to be answerable, or at least minimally responsive, to a multitude of constituencies with their competing and at times incompatible agendas. Its own meta-agenda is subject to change on a time scale spanning the length of presidential administrations;[19] its operation is inevitably subject to judicial contest and must finally conform to mandates (whether clear or cryptic) issuing from the United States Supreme Court. It is thus capable of "controlling" what can be seen and shown on television, for example, only through the application of a tangle of conflicting and competing regulations that too often produce that kind of Cloud-Cuckoo-Land lampooned by Stephen Colbert in his commentary on the inappropriate "breastiness" of Picasso's *Women of Algiers*.[20]

[17] See, for example, the Minister of Culture's message of condolence (again from the English-language website) following the death of the inimitable Abbas Kiarostami, the dean of Iranian filmmakers and one of the world's foremost cinematic artists, despite the fact that Kiarostami's films have been routinely suppressed by the Iranian government: http://www.farhang.gov.ir/en/news/228537/Minister-of-Culture-sends-message-ofcondolence-on-the-sad-occasion-of-Kiarostami-s-death.

[18] Alex Shams, "Politics of the Iranian Box Office: Mocking the Morality Police and Green Movement Conspiracies," https://ajammc.com/2012/04/12/politics-of-the-iranian-box-office-mocking-the-morality-police-and-a-green-movement-conspiracy-flick/. Thanks to Hoda Katebi for providing this reference.

[19] The presidential time scale is also important in Iran, as a comparison of the cultural policies of the administrations of Presidents Ahmadinejad and Rouhani can demonstrate.

[20] The comparison drawn here between the FCC and the Iranian Ministry of Culture and Islamic Guidance is perhaps too stark – there are certainly competing politics in the Ministry even as the FCC is perfectly capable of "laying down the law" – but is certainly apt insofar as it highlights the fact that "the game" in Iran is being played for relatively higher existential and ideological stakes. Flogging (not to mention execution whether secret or public) is not to be found among the FCC's available penalties.

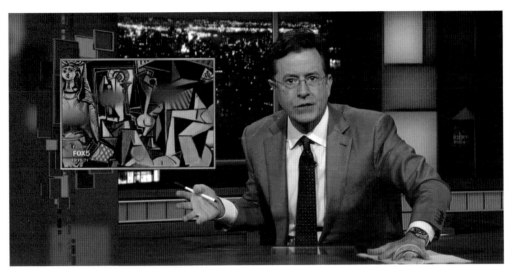

The Late Show with Stephen Colbert on CBS, November 13, 2015.

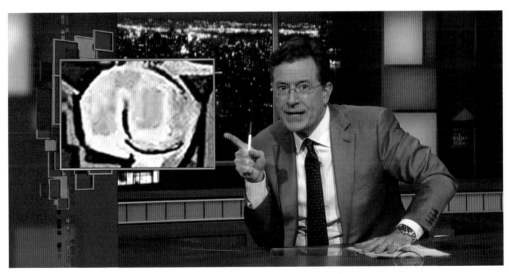

The Late Show with Stephen Colbert on CBS, November 13, 2015.

To return to Joseph's painted replica of the edited Fox 5 New York News image of the record-setting Picasso painting: although superficially it seems to duplicate the critique implicit in the *Censored Large Reclining Nude by Matisse*, its critical point is actually quite different. Rather than speaking to a crude governmental attempt to enforce a quixotic standard of morality, the edited Picasso demonstrates the absurdity almost necessarily built into a system of regulation that is constantly pushed and pulled by incompatible public interests, where pandering to a lowest common aesthetic denominator can easily seem, and almost certainly is, the safest political course.

This is quite different from an attempt, however ineffectual, to impose a uniform cultural standard by retroactively censoring works of art so that they conform to a radically different cultural tradition. Indeed, we might even look at this particular Iranian attempt as invoking a kind of inverse Orientalism. Whereas western artists, cultural elites, and large swaths of the general public have indulged themselves since the early nineteenth century in an image of the Islamic "Orient" that stressed a decadent and perverse sensuality, a violence, and an exotic otherness, the Iranian censor works to suppress, or offer a historical remedy for many of the same attributes, especially the pervasive sexuality found in many canonical western works.[21] At least in part, this effort is surely intended to forestall the ability of those same works to produce in Iranian culture a condition of aesthetic intoxication referred to explicitly, and not surprisingly, as "Westoxication."[22]

The cultural tradition to which the images in Cumming's book belongs (i.e. the western tradition) is radically different from Islamic tradition. The decision which belongs to the Ministry in this case is how to react to that fact – and that decision is not one with which all Iranians would necessarily agree, but it is a decision based on actual cultural difference. Indeed, one could argue that the Ministry's decision has more integrity than that of Fox 5 New York News, precisely because it is intended (however futilely from my point of view) to protect that tradition from something which they perceive to be a real threat to the survival of their culture, while in the case of Fox 5 New York News and the Picasso, the FCC's regulations appear only to be pandering to an assumed conservative (Christian) audience.

21 "Orientalism" has generated a vast critical and historical literature. For a brief introduction charting the phenomenon via the connection between one of the most notorious of all "Orientalist" works (Jean-Léon Gérôme's *The Snake Charmer* [c.1870]) and Edward Said's ground-breaking critique, see Glenn Harcourt, "The Spectacular Art of Jean-Léon Gérôme (1824–1904)," *X-TRA* 13.3 (spring 2011) 38–43. For the digital version: http://x-traonline.org/article/the-spectacular-art-of-jean-leon-gerome/6/.

22 In the early years of the Islamic Republic, the revolutionary regime often paired "Westoxication" (*gharzadeh*) with "*taghuti*" (satanic) and "*mohareb ba koda*" ([being] a fighter against God). Grigor, 40. It was broadly applied as a term covering any and every cultural aspect of the Shah's regime. It can also be applied very specifically. See, for example, Hooman Majd, *The Ayatollah Begs to Differ: The Paradox of Modern Iran* (New York: Random House/Anchor, 2008) 47 on the invocation of "West-toxification" to suppress the wearing of neckties as an aspect of male formal attire.

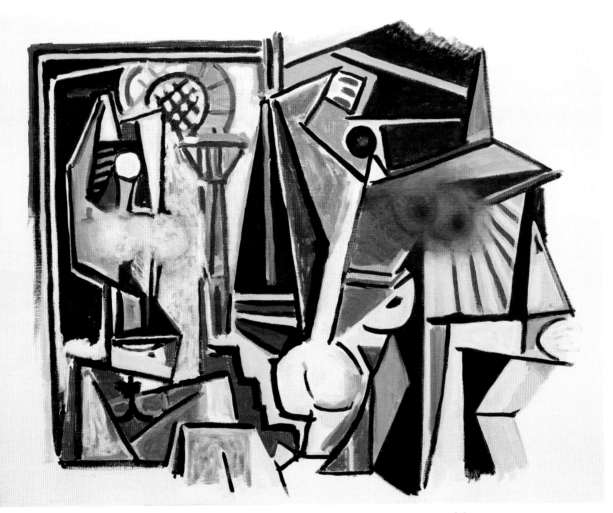

Pamela Joseph, *# 1 Study for Alger O*, 2015. Oil on linen, 23.5 × 30 in. Courtesy of the artist.

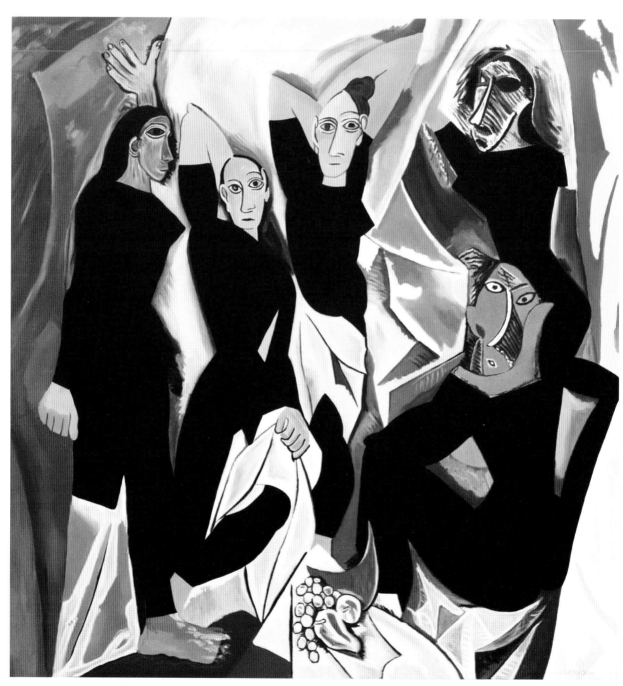

Pamela Joseph, *Censored Les Demoiselles by Picasso*, 2014. Oil on linen, 40 × 38 in. Courtesy of the artist.

PICASSO: *THREE WOMEN* AND THE *DEMOISELLES*

Almost inevitably, Iran's defense against Westoxication is too important to be left to (amateur) censors equipped with magic markers. Indeed, systematic censorship of canonical western images is also apparent in books acquired by ValaNejad that were produced by Iranian publishers. In particular, Joseph makes use of two volumes (Anne Gantef'hrer-Trier's *Cubism* [2004] and Dietmar Elger's *Dadaism* [2004]) published originally under the Taschen imprint, and later pirated in Iran.[23]

These books, with texts in Farsi, make use both of printed black bars that resemble the by-hand strategy employed by the do-it-yourself censor of Cumming's book, and also of a clever system of pixelation (much more sophisticated than the simple focus-blurring of the Fox News affiliate's images) that creates quite elegantly censored images which seem almost capable of standing as conceptual artworks in their own right.[24]

It can hardly be an accident that, in the censored or refigured aesthetic world explored by Joseph, Picasso's breakthrough pre-Cubist works are especially brutally treated: both the 1907 *Demoiselles d'Avignon* and the monumental *Three Women* from the following year.

The two works are, nevertheless, handled quite differently by the censors, as Joseph's "reproductions" make plain. In both cases, she works from illustrations in the pseudo-Taschen volume. The *Demoiselles* shows the bodies of Picasso's nudes almost entirely blacked out; only a couple of hands and fragmentary arms survive. The black areas are tight, form fitting, like spandex garments without the sheen. This has the curious effect of apparently preserving the outline of the composition, while at the same time radically disrupting our experience of the picture as a whole, which has become no more than a set of chaotic and dissociated fragments.[25]

23 Communication with Erin Levy at Taschen, Los Angeles; January 14, 2016: according to Ms. Levy, pirating is an on-going problem at Taschen, and pirated editions are collected and archived at the company headquarters in Germany. The Iranian book also misspells Elger's name as "Ditmar Eleger."

24 The obvious place to start unspooling this line of critical inquiry would be with Joseph's three versions of the pirate-inspired *Censored Small Fountain by Duchamp* (2014), which reproduce two different iterations of "R. Mutt's" ready-made sculpture first exhibited in 1917. For illustrations of all three canvases, see Francis M. Naumann, *CENSORED: New Paintings by Pamela Joseph* (New York, April 2 – May 22, 2015). This observation has also been made by Kurosh ValaNejad (Personal communications; November 24, 2015, and March 2, 2017): that the censored books themselves are unique "ready-made" works of art which now also include the artist Pamela Joseph's markings and notes.

25 "A set of chaotic and dissociated fragments" seems to capture as well the initial reaction of the censor of Cumming's DK Eyewitness Companion, where the *Demoiselles* (miraculously) escapes any interference from the censor's marker. There are a few other instances where the DK censor seems to have let his censorial vigilance slip; but this is by far the most egregious and, at least to art-historically sensitive western eyes, the most significant.

The *Three Women*, on the other hand, is transmogrified in a most extraordinary way. Rather than simply blacking out offending areas, as in the *Demoiselles*, the entire central area of the image has been pixelated so as to form a flat abstract pattern of the naked bodies, which are now reconfigured into a regular array of relatively large squares, that is: squares large enough so that anatomical detail cannot be read through their abstracting veil. Atop this abstract array sit Picasso's three "portrait" heads, each framed by an arcing and naked arm, and each treated slightly differently according to the general rubric of Picasso's contemporary mask-like geometry.

Once again, Picasso's intention is essentially effaced – one could, for example, hardly use the *Three Women* in an academic or teaching setting; it could never suffice to illustrate such a discussion. However, the pixelated squares preserve the color harmonies and contrasts originally deployed by the painter more-or-less intact. This has the effect, quite different from the one obtained in the case of the *Demoiselles*, of reconstituting the picture (almost) as an independent aesthetic or conceptual object capable of standing on its own.

What we see is clearly *not* Picasso's *Three Women*. Yet it is also not simply a defacement of Picasso's picture of the sort that some kind of moralizing vandal might be expected to make. Rather, it seems to exist in a kind of liminal space between defacement and appropriation, where censorship becomes a conceptual move rather than a simple erasure or effacement.

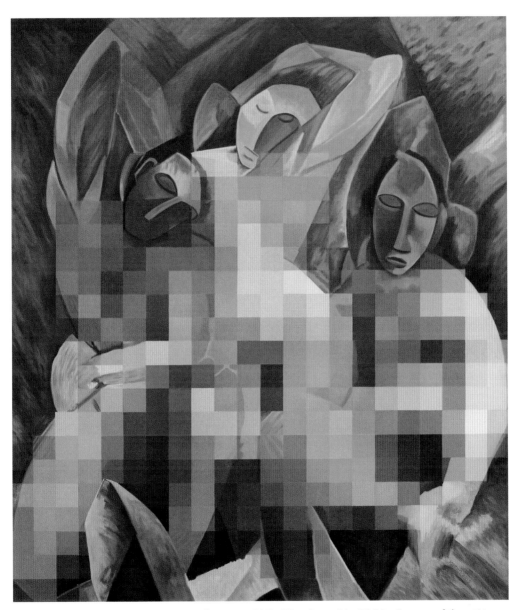

Pamela Joseph, *Censored Three Women by Picasso*, 2013. Oil on linen, 44 × 38.5 in. Courtesy of the artist.

It is difficult to guess what might have motivated the Iranian book's designers to employ such a curious double strategy, although clearly (at least to my mind) the term "designer" is an appropriate one here. Since the immediately adjacent two-page spread illustrates the blacked-out *Demoiselles*, the juxtaposition of approaches is particularly jarring, and also suggests that subject alone (groups of nude women with "venereal" overtones) was not a determining strategic factor. Indeed, what is suggested is quite the reverse: that aesthetic as well as moral factors were, for some reason, in play. Joseph herself points out, and replicates in her own 2013 "copy," the fact that the Taschen censors have carefully worked around the raised hand holding the spoon in their treatment of Jean Metzinger's *Tea Time* of 1911, an effect of extraordinary delicacy that she describes as "amazing."[26]

Jean Metzinger, *Tea Time*, 1911. *Cubism*, a pirated Taschen edition of western art published in Iran. Collection Kurosh ValaNejad.

26 Personal communication; November 8, 2015.

Pamela Joseph, *Censored Tea Time by Metzinger*, 2013. Oil on linen, 44 × 39.5 in. Courtesy of the artist.

The composition of the *Demoiselles* is characterized by jagged, fragmented, interpenetrating planes, so that the bodies of the young women both violate and are violated in relation to the planes that comprise the setting.

The *Three Women*, on the other hand, form a relatively compact mass, with the greenish towel on the left being the only obvious intrusion into the complex integrity of the two flanking figures connected by the standing figure slotted in between them. And it is precisely this massive central complexity of form that has been further abstracted by the censor through the process of pixelation.

Whether intended or not, this latter strategy has the effect of constituting itself as a historical commentary on the developing process of abstraction, seen as a series of formal moves leading eventually to the dissolution of figuration. In short, censorship has passed from moralizing censure to formalizing interpretation. The fact that Picasso's "African period," of which these two paintings are a part, also situates his tradition within a western ethnographic practice steeped in colonial and racist ideologies complicates any straightforward reading of the censor's allowances.

Likewise, both the language of (ironic) appropriation and that of (serious and historical) interpretation can be applied to Joseph's work; and while the structure of her appropriations can vary from case to case, we can also observe that her interpretations effectively fall into two distinct categories.

On the one hand (for example, in her "copy" of the *Demoiselles*), our interpretive attention is directed explicitly toward the issue of the status of the female nude in western representation and (in the case of Matisse) toward the relationship of that status to other issues of hegemonic power collected under the rubric of Orientalism. On the other hand (for example, Picasso's *Three Women*), that attention is turned toward the issue of representation *per se*, and in particular toward the developing relationship between abstraction and figuration, as well as the use of appropriation as an ostensibly central innovation within the ideology of modernism.

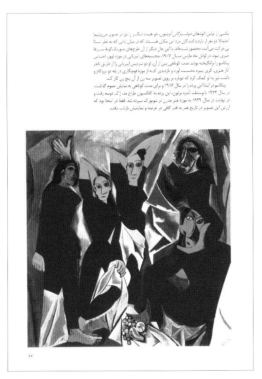

Pablo Picasso, *Les Demoiselles d'Avignon*, 1907. *Cubism*, a pirated Taschen edition of western art published in Iran. Collection Kurosh ValaNejad.

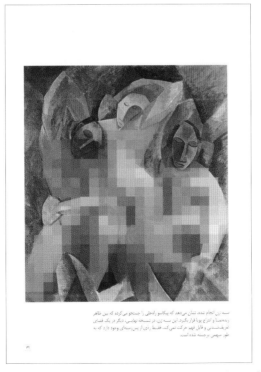

Pablo Picasso, *Three Women*, 1908. *Cubism*, a pirated Taschen edition of western art published in Iran. Collection Kurosh ValaNejad.

The Taschen censors also seem to work from differing motives, or at least to employ differing strategies depending on circumstance. Compare their pixelated treatment of Duchamp's *Fountain*[s] to their handing of his rectified ready-made *L.H.O.O.Q.* where the postcard Mona Lisa's neckline has been discretely raised with a black insert to efface all trace of her sixteenth-century cleavage. Again, the effect is quite "tasteful" and the end-in-view seems to have been to interpolate the Ministry of Culture's changes without seeming to vandalize the reproduced works.

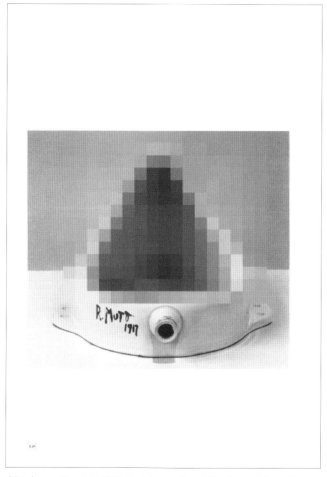

Marcel Duchamp, *Fountain*, 1917. *Dadaism*, a pirated Taschen edition of western art published in Iran. Collection Kurosh ValaNejad.

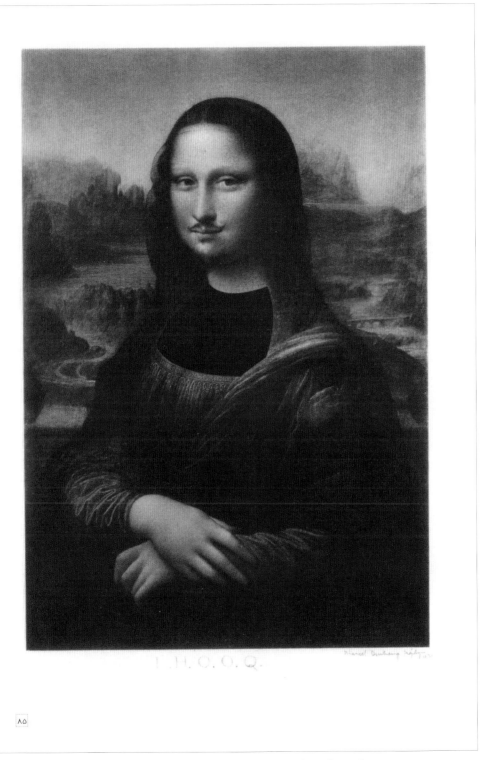

Marcel Duchamp, *L.H.O.O.Q.*, 1919. *Dadaism*, a pirated Taschen edition of western art
published in Iran. Collection Kurosh ValaNejad.

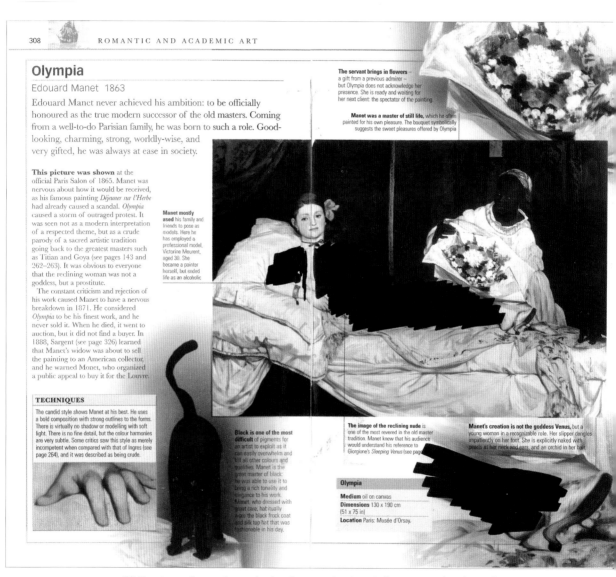

DK Eyewitness Companion to *Art*, hand censored in Iran. Collection Kurosh ValaNejad.

THE DESECRATION OF MANET'S *OLYMPIA*

Although it was first exhibited at the Paris Salon of 1865, Manet's perennially notorious *Olympia*, (1863) to which we now turn our attention, still apparently has the power to shock and enrage.[27]

If Matisse's *Large Reclining Nude* was relatively "sparingly" edited by the marker-wielding Iranian censor of the Eyewitness Companion, leaving the legs, part of the torso, and the arms visible, the *Olympia* is blotted out with a severe intensity. It receives a treatment generally reserved for the fleshy expanses produced, for example, by the great Renaissance and Baroque masters. Even the illustrated detail of the ankle, from which Olympia's slipper seems to dangle negligently, is virtually obliterated by the censor's pen. Curiously enough, the detail of the aggressive gesture with which the model uses her left hand to "cover" her genitals, to my mind one of the most provocative gestures in all of western art, is passed over without alteration. But then again, the detail is framed so that the only legible object within its compass is the hand itself. Since the model's entire body has been effaced, the gesture itself becomes illegible, its provocation circumscribed and neatly sanitized.

At the time of the *Olympia*'s production, the character of Manet's facture was widely criticized for its supposed lack of realism, and for the broadness and flatness of its modeling.[28] In light of later changes in style, that criticism, although perfectly understandable in historical terms, no longer seems to carry much weight. The model's proudly erect bearing, her confrontational gaze — the sense that, even as a prostitute, she feels herself in control of her own body — these have become more central critical issues.[29] In short, we engage the image of the model as though it carried or conveyed a real presence, the presence of a (legitimate) object of desire, even as we acknowledge the sense of paintedness embedded in Manet's style. It is as though we are now consciously aware of, and able to engage critically, a tension within the picture that nineteenth-century critics were aware of only piecemeal or on an unconscious level.[30]

27 For a basic discussion of the painting, its display in the Salon and its critical reception, as well as other relevant issues, see: Françoise Cachin and Charles S. Moffett, *Manet 1832–1883*. Exh cat. Paris: Musée d'Orsay and New York: Metropolitan Museum of Art (1983) Cat. 64, 174–183.
28 Ibid., 181–182 gives several pertinent examples from the critical literature.
29 For an exhaustive social- and art-historical analysis of the problem posed by the model's status as a prostitute, see T.J. Clark, *The Painting of Modern Life: Paris in the Art of Manet and His Followers* (Princeton: Princeton University Press, 1984) 79–146, the section entitled "Olympia's Choice."
30 According to Clark, 98, the contemporary criticism is routinely marked by "parapraxes," linguistic missteps often now identified as "Freudian slips," which can quite successfully mask deeper formal and ideological concerns. In the case of *Olympia*, problems raised both by the quality of Manet's brushwork and the nature of the model's "trade," come together in the repeated observation that the painted woman appears dirty or, more emphatically, has the appearance of a corpse laid out in a morgue. Clark, 96-98.

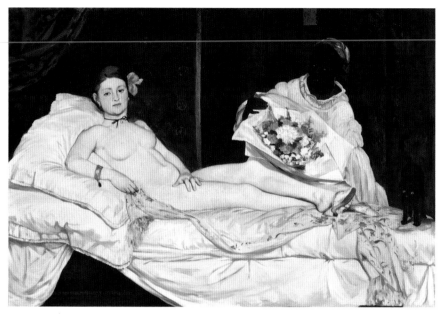

Édouard Manet, *Olympia*, 1863. Oil on canvas, 130 × 190 cm. Musée d'Orsay.

For the Iranian censor of Cumming's book, it is clearly the "presenting power" of the picture, its ability to make the model appear as if actually present, that motivates a reaction. He seems to see right through the nineteenth-century criticism of the broad, even abstract handling of the paint, and to place *Olympia* firmly in a category that also contains work by the likes of Titian and Rubens. Renoir's 1893 *Bather Arranging Her Hair* (where Renoir himself deploys an avowedly Impressionistic style to challenge the great nudes of the Old Masters) is given a similar censorious treatment.[31]

As we have seen, the censoring of Matisse's *Large Reclining Nude* is much more targeted in its defacement. And the magisterial *Demoiselles d'Avignon* is left entirely unmarked, as though Picasso's fragmented, interpenetrating planes of color are no longer capable of signifying immodest female flesh.[32] [33]

In the censored version of Cumming's Eyewitness Companion, it is as though we have been provided with a set of seat-of-the-pants critical or historical categories, where the extent of censorship of the illustrations provides an index of a work's degree of abstraction, as measured by the response of one imagined and curiously "innocent" viewer.

31 Cumming (censored edition), 311.
32 Ibid., 348–349. The same is true, for example, in the case of Henry Moore's *Reclining Nude*, Ibid., 399.
33 Joseph's *Censored Demoiselles* did not use the illustration from Cumming's text but is based on the model provided by the pirated Taschen illustration.

Admittedly, the notion of the "innocent eye" is much contested. All that is meant here is that what we observe in the by-hand censorship of the Eyewitness Companion volume may be an attempt to see with an "Islamic" eye the products of a process of cultural production that is both un-Islamic by definition, and of which the viewer and critic (the censor) may have had very little prior experience, of which, in that sense, he may have been quite innocent. The result is a kind of running critical commentary, which ironically illuminates our own critical criteria even as it runs counter to them.

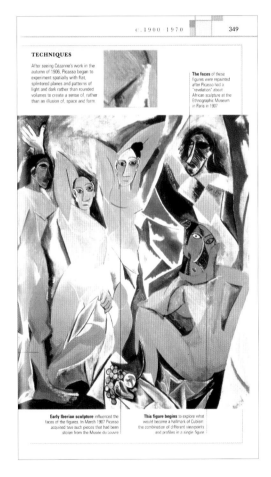

DK Eyewitness Companion to *Art*, hand censored in Iran. Right: the unmarked Picasso page. Collection Kurosh ValaNejad.

Joseph's *Censored Olympia by Manet* is likewise complex, both in its strategy and in the issues that it raises. First of all, in a major departure in terms of process, she makes a radical change in the original composition, removing completely the Negro maid with the bouquet of flowers that originally anchored the right side of the picture. This both simplifies and intensifies the picture's narrative dynamic. Originally – that is, in 1863 and again in 1865, when it was displayed in the Salon – the maid provided evidence for an immediately legible internal narrative of a sort well-known to putative viewers of the picture through the work of authors like Emile Zola and many others: the maid delivers a bouquet attesting to the (virtual) presence of a client or lover as a token of their (perhaps) on-going relationship.[34]

Indeed, such relationships would have been well known to many male viewers of the picture at the 1865 Salon as an aspect of their personal experience; it is by no means impossible that the model for the picture might have been known to one or more of them personally.[35] At the same time, the body language, and especially the gaze of the model establish a second putative relationship, this time with external (male) viewers of the picture, for whom the model becomes both an object of desire and a powerfully and sexually present subject.[36]

For contemporary, twenty-first century viewers, of whichever gender, the model for Manet's *Olympia* may still strike home both as an object of desire and as a sexually independent and present subject; but the terms within which both desire and acknowledgement are framed and enacted are much different than they would have been for an haute-bourgeois male Salon viewer in the Paris of 1865. This means that the internal narrative in Manet's *Olympia* is now primarily a subject for research under the rubric of "the social history of art." Although the external narrative remains in play, the social parameters within which that sexually present subjectivity is activated have changed markedly in the course of a century and a half.[37] Thus, Joseph's elimination of the maid bearing gifts makes the chasm between social history and viewer response immediately present.

34 In this sense, as exemplary of a class, the relationship posited by Manet places the prostitute into a marginal social "category," where (identified by a numbered file in the Prefecture de Police) she represents either "the danger or the price of modernity," or both. On the notion of "category" used here, see Clark, 102–103; the quoted description is taken by Clark from Balzac.

35 The model is Victorine Meurent (b.1844) who Manet apparently met in 1862, and who was a regular model for the painter until 1875 (and especially during the period 1862–1863). For a brief synopsis of her rather Bohemian life, see Cachin and Moffett, *Manet*, Cat. 31, 104–105. Her eventual slide into alcoholism and indigence would not have come as a surprise to those for whom she modeled or provided other, more immediately common pleasures.

36 The tradition that eventually finds its culmination, or its self-conscious immolation, in Manet's *Olympia*, finds its point of origination in the *Aphrodite of Knidos* (c.350 BCE) by Praxiteles, a work which was itself notorious in classical antiquity. Although the type of the Knidian *Aphrodite* spawned any number of sequelae from the Renaissance down at least into the nineteenth century, the related type of the "reclining Venus" provided the immediate context for the production of Manet's *Olympia*. The most immediately useful comparisons are with the so-called *Dresden Venus* of Giorgione (1510) and Titian's 1538 *Venus of Urbino*; although Manet's painting also is indebted to Goya's *Nude Maja* (c.1797–1800).

37 For some thoughts on the character of this change, see Glenn Harcourt, "Samuel Bayer: Diptychs and Triptychs," in *Artillery* online; May 30, 2013: http://artillerymag.com/samuel-bayer-diptychs-and-triptychs/.

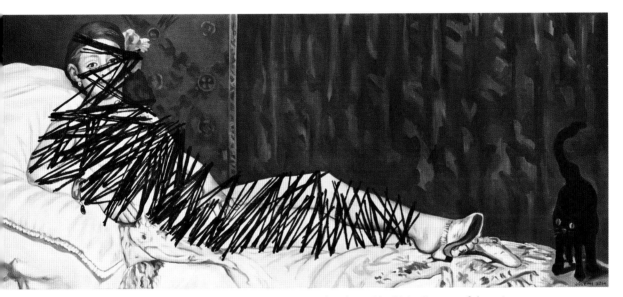

Pamela Joseph, *Censored Olympia by Manet*, 2014. Oil on linen, 14 × 32 in. Courtesy of the artist.

But the treatment of the model herself has been radically transformed as well. One of the interesting aspects of the censors' approach (both in the hand-marked Eyewitness Companion and in the "professionally" pirated Taschen volumes) is a respect for the individual face, which is left undefiled in virtually every case.[38] It is the explicit sexuality of the bodies, or, from a more focused perspective, their un-Islamic lack of appropriate modesty, that demands a redress. The ability of art to evoke or suggest an individual personal presence is apparently not an issue;[39] indeed the censors seem careful to preserve those presences, even as they castigate the immoral or immodest bodily display that they enact.

In general, Joseph respects that basic structure, even when she changes the details of the censorship itself.[40] Not so with the *Olympia*. Here, the broad strokes of the censor have been replaced with a prickly skein of thin, jagged strokes that seem to wrap the entire body as if in a web. Just in terms of the evident energy of the artist's attack, this is by far the most violent of all the pictorial defacements. One may react with amusement or outrage, but at least the work of the Iranian censor can be seen and understood for what it is: a specific, bureaucratically defined job, undertaken and performed without apparent vindictiveness or malice – a relatively boring and repetitive task more-or-less like any other and executed with a kind of perfunctory engagement and attention to detail.

By contrast, Joseph's *Olympia* seems to carry the marks of a gleefully childish defacement (I have seen similar "attacks" on the reproductions in high school art history textbooks) or (*mutatis mutandis*) of a conscious and systematic act of iconoclasm. Joseph herself has referred both to her decision that "the best way to vandalize her [the Olympia] was with the scribbling," and to her simultaneous desire "to keep that feeling of eroticism."[41] The intent seems to be violation, both of the model's body (and, by extension, her sexuality) and of her face (her individual personality or identity) rather than the kind of systematic alteration motivated by moralistic concerns that we see in the "genuinely" censored material. Only the delicately provocative ankle, which caught the eye of the Islamic censor, seems to have escaped the artist's simulated wrath. The notorious gaze is also relatively unscathed; although peering out from the violent slashes that crisscross the face, it now appears perhaps more mournful than challenging.

38 In instances of Protestant iconoclasm, where the attack is often against images implicated in the cult of the saints, it is frequently the faces which suffer the brunt of the attack, a quite literal defacement meant to destroy any sense of personal presence that might inhere in the image.

39 Although the Islamic prohibition against idolatry militates against the representation of living beings in religious contexts, secular contexts are quite a different matter: "Figural Representation in Islamic Art," Department of Islamic Art, The Metropolitan Museum of Art, October 2001: http://www.metmuseum.org/TOAH/hd/figs/hd_figs.htm.

40 One marvelous exception is Joseph's *Censored Self-Portrait 1927 by Schad* (2014) where her mimicry of the censored Taschen's pixelation becomes just transparent enough that it is possible to make out the outline of the reclining model's right breast and navel. In both Joseph and the censor's versions, the "artist's" diaphanous shirt is likewise ineffective as a covering. The blue [silk] ribbon that decorates the otherwise naked female model's left wrist present in the original Schad as well provides a resonance with Olympia's bracelet. Joseph's censored Schad painting is reproduced on page 67 of this volume, and the censored work is reproduced on page 170.

41 Personal communication, November 8, 2015.

This departure from type seems radical enough to demand an explanation. Indeed, several possible lines of argument can be suggested, although some appear to be mutually exclusive and others are intertwined in a way that might make them difficult to untangle.

The most radical argument might be phrased like this: that what is seen in Joseph's *Censored Olympia by Manet* is what the ideology behind the censorship really intends: violence against those women who transgress Islamic codes of behavior in a country governed by Sharia law.[42] And by this, of course, we mean actual women and not just their pictorial doppelgängers. The picture of the violence that desecrates the surface of Joseph's *Censored Olympia*, if interpreted this literally, would be no more than a picture of an assumed violence inherent in the Iranian reproduction that is its reference, but now stripped of its matter-of-course bureaucratic veneer.

This is a seductive argument because it seems to confirm what many in the western world think to be true: that the Islamic Republic of Iran systematically tramples upon the rights of women, sanctioning or encouraging all sorts of violations of those rights. This idea has been symbolized for many (both feminists and others) by a single, resonant image: that of the veil, by which we refer here both to the full body-covering chador and the simple headscarf or hijab. Although many Iranian women see the adoption of the hijab especially as constituting an Islamic "performance of modesty," it has often been taken in the west as a powerful visual stand-in for brutal methods of enforcing both appearance and behavior.[43] Although this is hardly the forum in which to attempt to think through the larger issues related to the state of women's rights world-wide, or to the question of women's agency when it comes to their choice of "appropriate" clothing, it should be pointed out that outside of "hermetically sealed" cultures like that embodied most viciously by ISIS and the Taliban, the actual exercise of women's rights (to some degree or another in every country and culture throughout the world) is always a matter of negotiation (read: politics).[44]

It is also possible, however, to see the *Censored Olympia* as a more general indictment of the state of sexual politics in its widest sense. Its strategy of defacement is essentially differentiated from that employed by the Iranian censors in order to draw attention specifically to the fact that the problem at issue is "bigger" than various cultural standards of modesty, it's a problem with the patriarchy tout court. This is obviously a more broadly applicable

42 While the term "Sharia law" has been construed to refer to a theocentric legal system that in its most radical interpretation is marked especially by horrific punishments and an extreme patriarchal bias, the situation in reality is much more complicated than this gross and ideologically-driven oversimplification allows. For a relatively neutral overview of Sharia in general, see this report prepared by the Council on Foreign Relations: Toni Johnson and Mohammed Aly Sergie, "Islam, Governing Under Sharia Law," last updated July 25, 2014: http://www.cfr.org/backgrounder/islam-governing-under-sharia.

43 This is also an issue that has generated an enormous amount of literature, and produced a heated and multifaceted debate. We will return to the twin issues of the hijab and the chador in the following essay as we examine how dress of the female body is inculcated in the western perspective through western art.

44 This is certainly true of Iran, as it is also of the United States and Saudi Arabia.

argument. But it also engages a tricky art-historical twist, one trenchantly summed up by the Guerilla Girls in their 1989 not very rhetorical question: DO WOMEN HAVE TO BE NAKED TO GET INTO THE MET[ROPOLITAN] MUSEUM?[45]

In its most notorious iteration, this question is paired with a black-and-white photographic excerpt of the famously languid and anatomically impossible model from Ingres' *La Grande Odalisque* (1814) topped by the Girls' signature gorilla head. On one level, the message of the poster is straightforward and forthrightly polemical. It's hard to argue with statistics. But on the level of the image, it is clever and considerably more complex in its resonance.

Far removed from that of Manet, Ingres' handling is beautifully fluid, almost hyper-naturalistic, so much so that, seen in the poster's black-and-white format, the image of the model might plausibly be a carefully shot and airbrushed photo of a living rather than a painted woman, albeit one in "gorilla drag." The image on the poster thus tends to collapse the distance between painting and model, inevitably drawing our attention to the fact that the poster's statistics refer to something more substantial than the subjects of paintings in the Metropolitan's galleries: the power relations between artists and models. And while the (male) artists involved retain their individual identities, their (female) models are subordinated to the dehumanizing expedient of "being naked" and remaining anonymous.[46]

In Manet's *Olympia*, this set of artistic power relations, as well as the presumptively similar and asymmetrical relations between master and mistress (or client and prostitute) are at once both affirmed and denied. Likewise, Manet, as a painter, both works within, and works against, the tradition embodied by Ingres – as well as that of Rubens and Titian and Giorgione. His model is present for us as a person, albeit a "working girl," at the same time that his picture is present for us explicitly as a painting. His model may be provocatively undressed, but she does not give the impression of having "gotten naked" at anyone's behest, least of all, perhaps, the painter's.

Unfortunately, that impression can hardly be entirely accurate. Although it may well be that Manet's model was as powerful and forceful a presence in real life as she seems to be in Manet's painting, the power of that presence *for us*, requires, at a minimum, the artist's collaborative skill, as well as the model's own willingness both to assume a role and to submit herself as an object of the artist's visual and painterly attention, not to say also of his desire. So Manet's painting becomes an elaborate and collaborative exercise.

45 For a brief introduction, see their website: http://www.guerrillagirls.com/#open. This provides historical background, as well as information on recent and upcoming projects.
46 As outlined above, art-historical research has generated considerable knowledge about the women who served as models for artists like Manet and Matisse. In the case of Manet's *Olympia*, that knowledge may be important to a maximally resonant reading. In the case of Matisse's *Large Reclining Nude*, it seems hardly relevant.

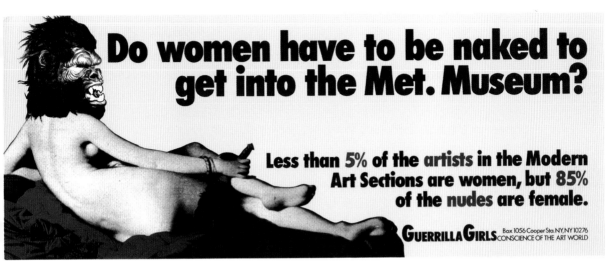

Guerrilla Girls, *Do Women Have to be Naked to get into the Met. Museum?*, 1989. Color offset lithograph on illustration board, 11 × 28 in. Gift of the Gallery Girls in support of the Guerrilla Girls 2007.101.7. © Guerrilla Girls. Courtesy of National Gallery of Art and guerrillagirls.com.

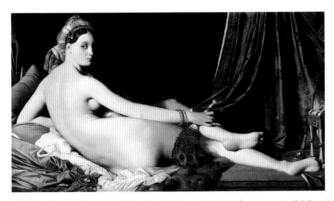

Jean-Auguste-Dominique Ingres, *La Grande Odalisque*, 1814. Oil on canvas, 88.9 × 162.56 cm. The Louvre.

In a weird way, its very existence both affirms the Guerilla Girls' critique and manages to resonate quite powerfully with it, if on a decidedly dissonant note. And it does this while explicitly addressing both the "real" world of actual power relations and the reflection of that world in representation.

It also draws our attention to another curious juxtaposition: that between the Iranian censor's desire to suppress images of un-Islamic immodesty and the plausible feminist desire to combat the prevalence of images of women in the Metropolitan Museum who have "gotten naked" in order submit themselves to (male) painters and (male) viewers as objects of sexual desire. To be sure, the strategies employed by these two groups are radically different: bureaucratic censorship on the one hand, and guerilla interventions of various sorts on the other, aimed at a liberation of those very bodies, as well the bodies of living women, from the objectification of the supposed male gaze across the board.

In a similar, if by no means an identical way, the works by Joseph that we have discussed demonstrate the skill with which her strategies have worked to address these sets of issues. By lifting the censored images out of context, she makes quite plain, at least to those who are familiar with the images presented, just how humorous and/or ineffectual these bureaucratic attempts at censorship are likely to have been.

Interestingly, this strategy is perhaps most brilliantly exemplified in a work where Joseph herself has censored her appropriated "original": the *Censored Poseuse de face by Seurat*, an image that she describes as embodying "totally my own conceit."[47] This delicate pointillist "sketch" (this seems the right word to describe this quite informal portrait, despite its rather substantial size: 50 × 31 ½ inches) is not illustrated in Cumming's discussion of Seurat and is outside the range of the Taschen editions' subject matter. It has, nevertheless, been pixelated by Joseph in a way that duplicates the technique employed in the Taschen pirate editions and uses a quite similar tonal range. The pattern of pixelation covers the model's torso and breasts as she stands frontally facing the viewer with a slight tilt of her head. She seems to eye us with a slightly wry smile (Joseph has wonderfully evoked the full potential of Seurat's style in her "recreation" of this face) while her overall pose suggests both innocence and openness.

Strangely, however, the pixelation stops roughly at the top of the pelvic girdle, leaving the model's genitals exposed, save for the loosely clasped hands that both shield and reveal them. (We might call this strategy of simultaneous coverage and revelation the "Botticelli effect" after that artist's brilliant evocation of its potential in his *Birth of Venus* from the mid-1480s.) Obviously, this ironic slip-up in "coverage" was entirely intentional: "Yes I just had to leave the hands exposed; it was so perfect in the pose." And as for the intended effect: "Very erotic."[48] That too makes perfectly clear both the subtlety of the game and the stakes on both sides for which it is played.

At the same time, the fact that the original works in the entire CENSORED series are re-crafted by a woman's hand, and a hand working at one remove from the living objectifiable flesh of the model, might well have the effect of freeing those original works from their patriarchal burden, at least within the circuit of representation, appropriation, and reproduction. In the *Censored Poseuse*, for example, it is Joseph not Seurat who mediates the enactment of the model's sexuality, who both shields her from a potential male gaze and frees her to reveal as much or as little as she will: a virtual rectified ready-made, and a pointillist Aphrodite.

47 Personal communication: November 8, 2015.
48 Ibid.

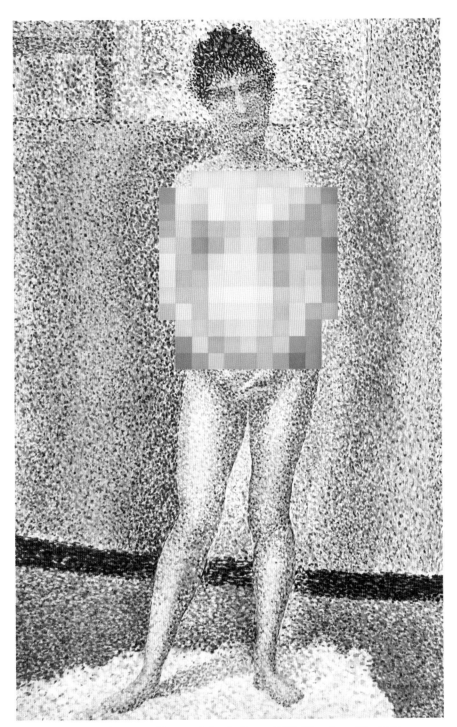

Pamela Joseph, *Censored Poseuse de face by Seurat*, 2015. Oil on linen, 50 × 31.5 in.
Courtesy of the artist.

There is, it seems to me, only one work in this group that escapes the basic terms of this analysis: Manet's *Olympia*. Both its peculiar position vis-à-vis the development of the painter's self-conscious reflection on the status of the art of painting as such, and what seems to be Manet's peculiar willingness to engage the sexual politics of his endeavor directly, render it unique within this cohort of pictures. Its status as a pivot point in "the history of style" is outside the view of the Iranian censor, whose work clearly establishes a perception of its connection to earlier, more naturalistic approaches. And as far as the sexual politics of the image are concerned, although we can easily sense the powerful and aggressive presence of the model, even in reproduction, the particulars of the social situation within which it was first displayed and viewed are recoverable only in a strictly mediated form as a narrative within Art History.[49]

Thus, the *Olympia* seems to require a special treatment by Joseph, one that both focuses our attention relentlessly on the model (hence the removal of the subsidiary figure) while at the same time signaling that the model herself is doubly (even triply) exposed: as an actual model who has "[gotten] naked" for the painter, as a prostitute frankly and imperiously on offer, and as a painted nude stripped of the mediating niceties of the academic tradition.

And this is exactly the treatment that it (the picture) and she (the model) receive. The skein of savage strokes that crisscross her face as well as her body seems much more a violation of that body than a covering or a screen, and it draws our attention to her almost as if to a victim at a crime scene crisscrossed in police tape. Our one immediate "clue" to her enacted, if not her personal identity remains that negligently slippered foot so rigorously effaced, even as a free-floating detail, by the Iranian censor. Perhaps equally important is the gesture of the hand covering the crotch, which the censor feels free to let pass unmarked, but which Joseph so assiduously paints over.

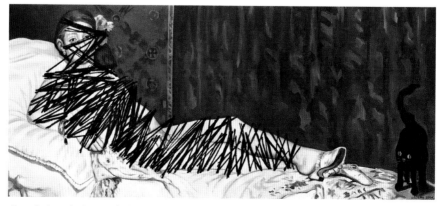

Pamela Joseph, *Censored Olympia by Manet*, 2014. Oil on linen, 14 × 32 in. Courtesy of the artist.

TECHNIQUES

The candid style shows Manet at his best. He uses a bold composition with strong outlines to the forms. There is virtually no shadow or modelling with soft light. There is no fine detail, but the colour harmonies are very subtle. Some critics saw this style as merely incompetent when compared with that of Ingres (see page 264), and it was described as being crude.

The image of the reclining nude is one of the most revered in the old master tradition. Manet knew that his audience would understand his reference to Giorgione's *Sleeping Venus* (see page

Manet's creation is not the goddess Venus, but a young woman in a recognizable role. Her slipper dangles impatiently on her foot. She is explicitly naked with pearls at her neck and ears, and an orchid in her hair.

Olympia

Medium oil on canvas
Dimensions 130 x 190 cm (51 x 75 in)
Location Paris: Musée d'Orsay

Details from Manet's *Olympia* in DK Eyewitness Companion to *Art*, hand censored in Iran.
Collection Kurosh ValaNejad.

Taken together, the ankle, the hand, and the crotch suggest, if only obliquely, the concatenation of painting and politics that animates the entire figure. This is indeed a connection fraught with meaning. It drives our understanding of Manet's *Olympia* and of Joseph's Manet. It resonates throughout the whole of Joseph's project; and provides a pervasive nexus of meaning that we are encouraged to work through here even as we also work to untangle the model from the painted threads with which she has been so firmly bound.

49 Interestingly, this "Eyewitness" account is not exactly accurate. Manet (like Degas) enlisted in the National Guard in 1870 during the Franco-Prussian War. As Paris was besieged, he was quite concerned for the safety both of his family and his studio. The French lost the war, and the revolutionary uprising and brutal suppression of the Paris Commune followed in 1871. Although all this upset and bloodshed would eventually lead to the foundation of the Third Republic, by August of 1871, Manet was suffering (his doctor's diagnosis) from "nervous exhaustion" and prescribed a period of rest in the country. Manet never did sell the work; but to describe it as "a crude parody..." captures the sense of only the most hostile criticism. Manet's work was always controversial, but by no means universally damned. So an Iranian reader/viewer literate in English would get from the book not only a censored image of the picture but an inaccurate English discussion of its context.

Michelangelo, *David*, 1501-4. Marble, 5.17 m. Galleria dell'Accademia, Florence. Photo: Jörg Bittner Unna.

After Polykleitos, *Doryphoros from Pompeii*, 1st Century BCE. Carrara marble, 200 cm. Museo archeologico nazionale di Napoli. Photo: Marie-Lan Nguyen.

HEROIC NUDITY AND MALE SEXUALITY

So far, we have been looking at a particularly volatile flashpoint: the depiction of women (mostly unclothed) within the western pictorial tradition. As the Guerilla Girls, among many others, have pointed out, the fetishization of the female nude as a subject within that tradition has produced an enormous body of work. Such work in this case might equally easily be censored as morally unacceptable (from a critical perspective outside the tradition) or, from a perspective firmly grounded within it, castigated as reflecting an irredeemably patriarchal sexual politics.

But in fact, the western tradition is not grounded in the depiction of the female nude. It is, rather, the image of the male nude as envisioned particularly by Greek sculptors of the fifth and fourth centuries BCE; then appropriated by artists and wealthy consumers in Republican and Imperial Rome; and then re-appropriated and re-imagined by the Italian masters of the fifteenth and sixteenth centuries that provided the benchmark for demonstrating both the artist's mastery of human anatomy and the painted or sculpted body's narrative potential. The self-proclaimed pinnacle of artistic achievement was thus defined as explicitly male within the pre-modern tradition in the west.[50]

50 Needless to say, the importance of the male nude continued to underpin the nineteenth-century academic tradition: look, for example, at any selection of figure drawings produced in the studio of Jacques-Louis David. However, this is not the impression one gets from looking at Cumming, where the text quickly reaches the year 1800 by page 259, and the discussion of "contemporary art" finishes up on page 477. Unfortunately, the space allotted to the art of Greek and Roman antiquity (not to mention French academicism) is grossly inadequate to an appreciation of the importance of the male nude for the origination and subsequent development of the entire classical tradition.

Obviously, reproductions of such works are clearly "inappropriate" (at least from the point of view of the Ministry of Culture and Islamic Guidance) for the eyes of properly Islamic Iranians, including Iranian men who are also expected to follow rigorous standards of decency and decorum. Hence, their eyes must be shielded as well from inappropriately explicit depictions of their own bodies. The precise nature of these prohibitions will be discussed below in relation to Pamela Joseph's appropriation of a sleeping nude "bather" by David Hockney.

But first, we turn our attention to Joseph's *Censored Neptune, Censored David,* and *Censored Zeus*. In this triad of paintings, the artist evokes the endeavor of the Eyewitness Companion censor to rectify three Renaissance attempts to embody a pinnacle of sculptural and pictorial achievement.

Although these three statues originally stood in the Piazza della Signoria in Florence, and are shown as if *in situ* in the hand-censored photo in Cumming, Joseph has extracted them from their civic context, and presents each as a gray marble figure against a neutral gray ground, highlighting their iconic status.[51] She has also simplified the composition of the *"Zeus,"* removing a subsidiary crouching figure: and in so doing she has re-identified the appropriated figure, who was originally a Hercules.[52]

[51] In fact, the David depicted in the photo in Cumming is itself a copy. Michelangelo's original was transferred to the Galleria dell'Accademia in 1873, and a copy has stood in the Piazza since 1910.

[52] The original statue in the Piazza della Signoria depicted the triumph of Hercules over the fire-breathing Cacus (one of hero's canonical Twelve Labors), who is shown as a crouching or recumbent figure. So the three figures shown in Joseph's paintings should by rights be identified as Neptune, David, and Hercules. But she has removed the figure of Cacus (similar to her removal of the black maid from Manet's *Olympia*) and thus repurposed the Hercules as a "Zeus." This kind of repurposing appropriation is actually not all that uncommon during the Renaissance and Baroque periods, where particularly successful "formal" solutions to problems of pose, expression, etc. become part of a figural archive that could be used in various narrative contexts and/or as specific references to the work of earlier masters.

Pamela Joseph, *Censored Neptune*, 2014. Oil on linen, 30 × 12 in. Courtesy of the artist.

Pamela Joseph, *Censored David*, 2014 . Oil on linen, 30 × 12 in. Courtesy of the artist.

Pamela Joseph, *Censored Zeus*, 2014. Oil on linen, 30 × 12 in. Courtesy of the artist.

The changes that Joseph insists upon in these works have the effect of abstracting the individual works from the messiness of Florentine civic pride and Medici power politics in which the originals were inextricably entangled.[53] Joseph also suppresses the names of the artists responsible for the original sculptures (Ammannati, Michelangelo, Bandinelli), not her normal procedure with other works in this series, where the "authors" of original paintings are scrupulously identified: *Censored Atalanta and Hippomenes by Guido Reni*, for example. The paintings of the Piazza della Signoria sculptures, on the other hand, have been copied from a photograph and worked up in a rather bland and uniform style, and all signed on their bases "JOSEPH 2014." This effectively "de-mythologizes" the original works and cloaks them in a white cube of post-modern anonymity.

Joseph's consistently-applied painterly technique makes it no longer all that easy to *see* the difference between an Ammannati, a Michelangelo, and a Bandinelli. But that differentiation according to protocols of stylistic excellence is itself a canonical western exercise. It already belonged to the equipment of Vasari's looking in the sixteenth century, and remains so for us today insofar as we are his intellectual descendants, or even cohabitants of a similar visual culture.[54] But it does not belong to the visual equipment of the Iranian censor, nor to that of any similarly equipped Iranian viewer of Cumming's book, for whom Michelangelo is not so much a greater sculptor than Ammannati, but a workman equally ensnared by the Islamic censor's pen.

In that sense, these pages from the censored books may show the methods that most successfully capture what we can identify as an appropriately modest and Islamic vision: one that focuses its visual attention on a "what" (the inappropriate exposure of parts of the nude male body) without regard to the "who" of authorship, or to the historical and ideological integrity of the complex cultural tradition that prioritized the depiction of the male nude over one thousand years before Ammannati or Michelangelo did their work for the city of Florence.

53 Compare the effect of the maid's removal in Joseph's redaction of Manet's *Olympia*. Her de-contextualization of the Florentine sculpture is thus essentially complete, since they were originally intended to be seen as emblematic of Florentine virtue and power and not (like Olympia) as players in a fictional narrative.

54 Giorgio Vasari was a well-connected sixteenth-century Florentine artist of moderate talent. He was also a relentless critic, biographer, and historian and collector (especially of drawings), and a writer of real genius. His *Lives of the Most Excellent Painters, Sculptors, and Architects* (Florence: 1 ed. 1550; revised and expanded 1568) is often cited as the ur-text of Art History as an intellectual discipline. It is certainly the master narrative that still governs the way in which the art of the Italian Renaissance is framed and taught. Vasari is responsible for the centrality of Florence and Florentine artists within that narrative, as well as for the establishment of Leonardo, Raphael, and Michelangelo as the absolutely pre-eminent figures of Renaissance art, seen both as a craft and as an intellectual endeavor. It is impossible to overstate his importance to the subsequent development of art and art history in the west, although (of course) that importance is now much contested.

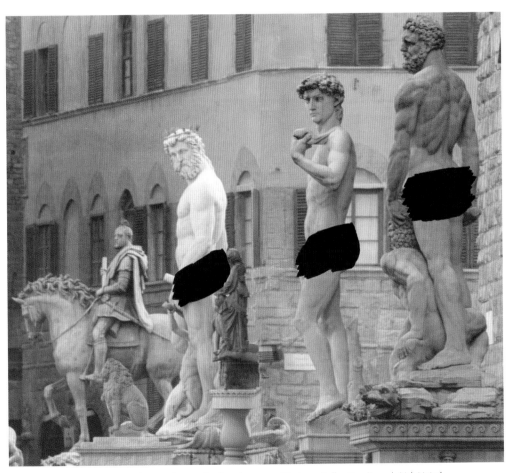

DK Eyewitness Companion to *Art*, hand censored in Iran. Collection Kurosh ValaNejad.

Returning briefly to the *Guido Reni*, the choice of this particular painting marks an interesting addition to Joseph's series, since, in the original, the fantastically flying drapery effectively conceals the genitals of the naked racers. Joseph, in her own conceit, applies one black band to effectively conceal Atalanta's breasts, and then two "non-functional" black bars to the bellies of her figures, as if to signify the censoring stroke that waits in readiness should it become necessary thanks to a reconfiguration of the wind-blown drapery.

DK Eyewitness Companion to *Art*, hand censored in Iran. Collection Kurosh ValaNejad.

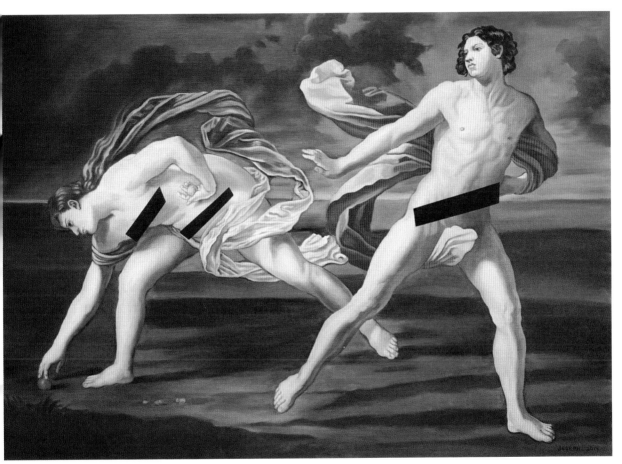

Pamela Joseph, *Censored Atalanta and Hippomenes by Guido Reni*, 2014. Oil on linen, 22 × 31 in. Courtesy of the artist.

We in the twenty-first century West are certainly capable of making severe censorious decisions. The most notorious recent example, and one that produced considerable satirical "blowback," involved the "veiling" of potentially objectionable Greco-Roman and Italian statues for a state visit by Iranian President Hassan Rouhani to Italy in January 2016.[55] In this case, the stakes were high, since Rouhani was in Italy to officially ratify contracts with Italian companies following the lifting of trade sanctions that were contingent on Iran's acceptance of severe curbs on its nuclear development program. It remained unclear, according to *The New York Times*, whether the "veiling" was undertaken at the behest of members of the Iranian delegation, or was an action of "overzealous" Italian officials acting on their own. In any case, the whole episode was brutally satirized in press reports and political cartoons; and at least one Iranian women's rights group lambasted the Italian government for capitulating to Iran's presumed political demands.[56]

Admittedly, this incident may come to sound simply silly in retrospect (at best, a "tempest in a teapot" in view of the delicacy of the dance surrounding the interlocked questions of trade sanctions and nuclear restraint), but it does provide an interesting insight into some of the cultural complexities addressed by Joseph's appropriative project. Although Italy's actual population is now largely more-or-less secular, it is a quasi-officially and historically Catholic country.[57] At the same time, the Church itself (at least theoretically opposed to the originally pagan culture responsible for the presence of the nude at the heart of the western artistic tradition) has both embraced and encouraged that tradition in a way that might well appear unseemly to outside observers – sixteenth-century Protestant reformers as well as twenty-first-century Iranian presidents.

On the other side of the equation, Iranian President Rouhani, although a member of a devoutly religious family, was educated in the west; and so must have been exposed personally and thoroughly to the bodily "toxicities" of western culture. He is also known as a cultural and religious "moderate," although we need to keep in mind that this term has both a specifically Iranian, as well as a generally western signification. Needless to say, Italy's own Muslim population of more than one million was not consulted as the government thrashed this decision out.

55 For the following summary see Elisabetta Povoledo, "Italians Mock Cover-Up of Nude Statues for Iranian's Visit," *The New York Times*, January 27, 2016: http://www.nytimes.com/2016/01/28/world/europe/hassan-rouhani-italy-visit-nude-statues-capitoline-museums.html.

56 For a photo of some of the "veiled" statues, which were more accurately boxed up, as well as a couple of representative cartoons – one cartoon showed a baffled President Rouhani puzzling over the anonymous boxes and asking if he had been inadvertently taken to an IKEA, see, for example: "Cartoonists are mocking Italy's censorship of nude statues for Rouhani," *Al Bawaba*, January 27, 2016, http://www.albawaba.com/loop/cartoonists-are-mocking-italy%E2%80%99s-censorship-nude-statues-rouhani-798490. See also Grigor, 106: "In 1982, amid the Cultural Revolution, when Tehran University's Department of Fine Arts was closed down, the figurative sculptures in the exhibition halls (*salon-e juri*) were covered because of their nudity."

57 Roman Catholicism was the official state religion of the Republic of Italy from 1929 (Lateran Treaty) to 1988 (ratification of a concordat with the Vatican); but the Church has historically had and continues to enjoy special privileges within the Italian state. Eighty percent of the population identifies as Roman Catholic, although many of these "believers" are only nominally or non-practicing Catholics. Still, Catholic culture is pervasive within Italy, not a surprise since Rome is after all the "ground zero" of the explosion of institutional Christianity in the west.

Taking all of this into consideration, it should be clear that the boxing up of potentially objectionable artworks, while perfectly understandable in a purely theoretical sense, or on a superficial reading of the cultural, and especially the political complexities in play, in fact involved covering more than breasts and genitals (whether male or female) and was arguably *more* severe (e.g. culturally damaging) than any of the Iranian censors' actions as chronicled by Joseph, or even as enhanced by her "campy" additions or *faux* Freudian double entendres.[58] Indeed, as the opposition politician Renato Brunetta posted on Facebook: "This submission" (that is, the boxing up of the statues) constituted nothing less than "the surrendering of our art and culture."[59] And, although the context of Brunetta's remarks (an attack on the policies of Prime Minister Matteo Renzi in general) makes it clear that he intends by "our" to imply "our [Italian] art and culture," the "surrender" to which Brunetta refers clearly involves an attack on iconic works central to the development of the western cultural tradition in general.

Tweet from Bloomberg News reporter Alessandro Speciale.

58 See especially her painted copies of the statues from Florence's Piazza della Signoria, where the potentially phallic resonances of the originals are pointedly exposed in her versions of the censored images.
59 As reported by *The New York Times*, op. cit.

Pamela Joseph, *Censored The Sunbather by Hockney*, 2012. Oil on linen, 38 × 38 in. Courtesy of the artist.

CONSENTING ADULTS

One of the things that Pamela Joseph absolutely does not share with her censorious Iranian counterparts, and especially with whoever it was that marked up the illustrations to Cumming's text, is a sense of "camp," especially as that word might be tied up with work carrying sexual and, in particular, homoerotic overtones. So when she tweaks her *Censored Neptune* in a way that seems to adumbrate the presence of an erect penis, it could be suggested that she is perhaps having a "gay" joke at the expense of the Iranian censor, a joke in which he may very well be unable to see the humor.[60]

Generally speaking, this kind of campy humor is not built into the tradition of the western male nude, although a serious (if only intermittently visible) homoerotic current flows through that tradition from classical antiquity through the Renaissance (think of Donatello's bronze *David* [c.1440s] for the most important and "notorious" example[61]) down to the present day. Among the works selected for this series, Joseph comes to grips with this issue most directly in two related pictures, both entitled *Censored The Sunbather by Hockney* and both dated 2012, one of which, the smaller, is essentially a figural detail extracted from the larger. The picture is a study of a young, well-muscled man sunbathing in the nude, laying face-down on a white towel spread out beside a swimming pool that, in the larger version, carries the wonderful pattern of Hockney's "signature" ripples. The picture is formally quite interesting, and a marvelous demonstration of the way in which framing and viewpoint can establish a clever interplay between perception in two and three dimensions.

But the narrative or emotionally resonant focus is certainly the recumbent male nude, to which Joseph draws our attention pointedly in her version that is edited as well as censored.

60 Sexual identity in Iran has quite a complicated history due to traditions of homosocial culture as well as changing conventions under different regimes, but several good references include books by Janet Afary: *Sexual Politics in Modern Iran* (Cambridge UP, 2009) and *Foucault and the Iranian Revolution: Gender and the Seductions of Islamism* (University of Chicago Press, 2005); as well as Afsaneh Najmabadi, *Women with Mustaches and Men without Beards* (University of California, 2005). Thanks to Hoda Katebi and Kurosh ValaNejad for providing these references.

61 Donatello's *David* is revered as the first life-size male nude figure cast in bronze in the west since classical antiquity; it is also more biblically accurate than Michelangelo's brooding giant in that Donatello has given his virtually naked hero (who wears only an elaborate helmet and boots) a youthful smoothness of musculature that suggests a body just coming into (sexual and intellectual) maturity. The statue carries a homoerotic charge that is unmistakable (if often unremarked) and was from the time of its completion displayed in the privacy of a niche in the Medici Palace courtyard.

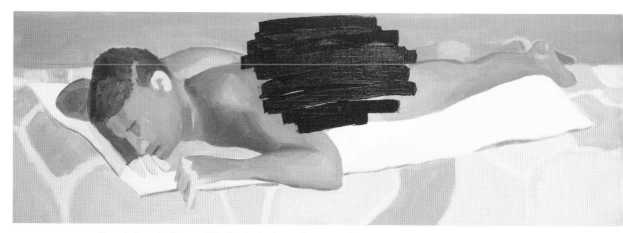

Pamela Joseph, *Censored The Sunbather by Hockney*, Detail, 2012. Oil on linen, 10.25 × 30.25 in.
Courtesy of the artist.

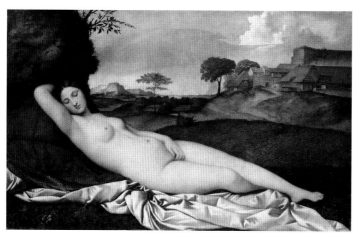

Giorgione, *Sleeping Venus*, 1508–10. Oil on canvas, 108.5 × 175 cm.
Gemäldegalerie Alte Meister, Dresden.

Donatello, *David*, c.1440s. Bronze,
158 cm. Museo Nazionale del Bargello.
Photo: Patrick A. Rodgers.

Taken either way, in its entirety or as "excerpted" by Joseph, Hockney's painting is imbued with a sense of quiet and restful isolation. At least superficially, it doesn't carry the sense of entangling sexual politics that encumbers that iconic sleeping female nude, Giorgione's *Dresden Venus* (c.1510). Although Hockney's nude sleeper is subjected to the same (or at least a theoretically equivalent) objectifying gaze, and presents himself as an equally passive and potentially compliant object of desire, even a knowledge of Hockney's own sexual orientation is not really sufficient to render the picture ideologically objectionable in anything like the way that might seem appropriate in the case of Giorgione.[62]

One might expect the situation to be radically different in Iran. Certainly, homosexuality is taken there as a very serious matter. Sexual activity that qualifies as lesbian or homosexual is illegal under the Iranian penal code, and, when prosecuted, can result in imprisonment, corporal punishment (flogging), and even, in "extreme" cases, execution.[63]

Yet the Iranian censor's response to what a western viewer might see as an image with an explicitly homoerotic inflection is not really any different from what can be observed in more straightforward cases of the Iranian censor's swift pen. Clearly, the notions and adumbrations of gay sexuality that have been discussed are external to the limits of this visual and conceptual universe. The censor simply does not see what a western audience sees nor respond to what he does see in a way that parallels the western response.

62 In short, Hockney's is a "safe" picture. Giorgione's Venus, on the other hand, not only invokes contemporary issues centering on the ideas of the passive (or unconscious) object of desire inevitably subjected to the mastering male gaze, but embeds that conflict within a much deeper and older opposition: the originating human division between Nature and Culture, which has both been routinely sexualized and relentlessly exploited in a way that mirrors this sexualizing ideology.

63 Iran is in fact an enormously hostile environment for its LGBT community. In some ways like the censorship of pictures, the "censorship" of Iranian sexual identities is a fraught and complex issue, with implications for global politics and those opposing the ideology of "Westoxication." See Jay Michaelson, "Iran's New Gay Executions," *The Daily Beast*, August 12, 2014, http://www.thedailybeast.com/articles/2014/08/12/iran-s-new-gay-executions.html.

Nevertheless, the response that Joseph reproduces in both her versions of the censored Hockney is extremely important for our understanding of exactly how it is that the censor does approach the job at hand. Although not nearly as complex as the one addressed to women, Islam does provide a kind of "dress code" for male believers. How this code plays out in practice varies among Islamic cultures (this is [obviously] true for the women's code as well), but the foundational principles are simple and constant across the board.

Islam admonishes both men and women to dress always with modesty, lest both those who dress and those who see be tempted to what we would refer to as "sins of the flesh." In practice, this means at a minimum that the "intimate parts of the body" must be kept covered in a way that is not "suggestive." The Arabic term for "intimate parts..." is "'awrah," which can also be translated as "nakedness," although the term figuratively also applies to young women; the term in Hebrew is similar, and subject to the same gendered duplicity. Literally speaking, if the 'awrah is exposed, a person can be considered naked, even if that would not technically be the case according to western custom or linguistic usage (think: swimmer in a speedo). For a man, the rule is simple and unambiguous: the 'awrah (the man's nakedness) is that section of the body that stretches from the navel to the knees. And this is (more-or-less) exactly what the Iranian censor has covered. Thus, far from representing an extreme or unusual case (because of the way in which, for western viewers, the picture is resonant with issues of gay sexual politics) the censored Iranian version provides a clear demonstration of the ideological base line in play: insofar as possible, cover the 'awrah. This is the minimum that Islam demands.

of the swinging London of the 1960s and not ashamed to continue the theme.
KEY WORKS *Wet Seal*, 1966 (London: Tate Collection); *What do you Mean, what do I Mean?*, 1968 (Private Collection).

David **Hockney**

● 1937– ⚑ BRITISH

🏠 UK; USA 🎨 acrylics; oils; prints; photography
🏛 London: Tate Collection 💲 $2.6m in 2002, *Portrait of Nick Wilder* (oils)

A genuinely gifted artist with an acute eye and fertile imagination. Once the bad boy of British art, now a respected elder statesman. Sadly, he seems to have decided not to extend his talents (like Degas) and has settled to live the good life on undemanding potboilers (like Millais).

A truly great draughtsman – focused, precise, observant, free, who has a brilliant ability to extract only the essentials. Timely reminder of the pleasure and novelties of seeing and recording perception with feeling, still important for art even after 500 years. Has stunning technique with pencil, pen, and crayon and an immaculate sense of colour. Can make the commonplace memorable and moving. Chooses autobiographical subjects.

At his best as a draughtsman (drawing, prints, and paintings). Brilliant observer and re-creator of light, space, and character in portraits, but not as convincing (though never uninteresting) when he tries to work solely from the imagination or to be a painterly painter (from the 1980s onwards). Inspired designer of sets for theatre, opera, ballet. Is experimenting with Cubism and photography.

KEY WORKS *Peter C*, 1961 (Manchester: City Art Gallery); *We Two Boys Together Clinging*, 1961 (London: Arts Council Collection); *California Bank*, 1964 (London: Mayor Gallery); *A Bigger Splash*, 1967 (London: Tate Collection)

Sunbather *David Hockney, 1966, 183 x 183 cm (72 x 72 in), acrylic on canvas, Cologne: Ludwig Museum.* 1966 was the era of the Beatles, Rolling Stones, and the Beach Boys. Homosexuality was legalized in the UK in July 1967.

DK Eyewitness Companion to *Art*, hand censored in Iran. Collection Kurosh ValaNejad.

Daryoush Gharahzad, *Untitled (Identity Series)*, 2014. Acrylic and oil on canvas, 140 × 300 cm. Courtesy of the artist.

CENSORSHIP AND APPROPRIATION

It should go without saying that neither this book nor Joseph's "CENSORED" series is intended as a characterization or an indictment of Iranian viewers in general, or even of all observant Iranian Muslim viewers. Least of all should it be seen as a criticism of artists living and working in Iran.

Despite all the vicissitudes attendant on the Revolution and the subsequent establishment of the Islamic Republic (including both internal repression and international sanctions) Iran has had, and retains, a cosmopolitan culture; its artists are well aware of the western tradition, as they are of their own multifarious cultural history; and they are perfectly capable of traversing the difficult terrain that maps their contemporary situation without sacrificing their integrity to the blindness of a censorious bureaucracy.

Pamela Joseph's wonderful series of censored replicas raises a complex picture of a cultural vision that is other than western. Moreover this is an "other" that seems to systematically denigrate and defile what is highlighted as an icon of central cultural importance in the West: the image of the unclothed human body, both male and female. That image is, for viewers embedded in the western tradition, "clothed" (as it were) in a rich symbolic and metaphorical history. Its mastery was for centuries the primary benchmark of artistic success, as it later became a site for the staging of artistic revolution. It has also been a site of theological and political (even legal) contest. It is virtually impossible to imagine the development of western culture absent that centrally important image.

But at the same time, the particular works that we see in this series underline for us the ultimate futility of the Iranian censors' bureaucratic attempts at the moralizing suppression of that tradition. Those attempts may appear to hide the surface of the picture, but they cannot so easily mask what everyone knows is underneath. They may appear to deface the integrity of iconic artworks, but they cannot either reach the originals or damage the cultural tradition in which those originals are embedded, and they don't pretend to do so. They can certainly express the Islamic regime's displeasure with "decadent" and "immodest" and "un-Islamic" western culture, but, in the last analysis, they cannot prohibit or prevent either the exposure of Iranian artists to that culture, nor the artists' ability to exploit that culture to their own ends.

It may well be that the regime sees this as a fight against "cultural imperialism" (what the Iranian government has in fact called a "soft [as opposed to a "cold"] war), and it has certainly been the case that western culture has been and continues to be wielded in that way; but this is hardly the end of the story. In a multi-cultural, post-modern world where images circulate across cultural and national borders with surprising ease and rapidity, and where appropriation, re-appropriation, reconfiguration, repurposing, and reevaluation have become norms of cultural production across the board, Iranian artists will hardly be disrupted in their approach to western visual culture by a few swipes of a marking pen or patterns of artful pixelation.

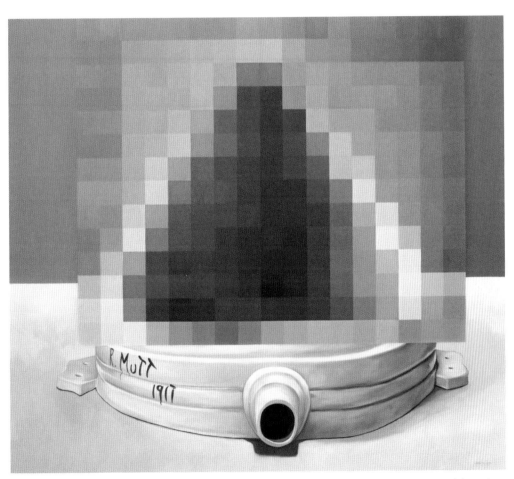

Pamela Joseph, *Censored Small Fountain by Duchamp (Tan)*, 2014. Oil on linen, 19 × 21 in. Courtesy of the artist.

When Walter Benjamin published his classic essay "The Work of Art in the Age of Mechanical Reproduction" in the *Zeitschrift für Sozialforschung* in 1936, he could have had no conception of the world that lay ahead.

Although certainly a brilliant piece of social and political analysis, "The Work of Art…" was grounded in an analog world. Its argument turned importantly on the characteristics of photography as a reproductive medium embedded in the technology of film. This technology tied photography to its subject (although Benjamin does not identify the nature of this bond explicitly) by a relationship of indexicality, which advances truth claims about photography's own "authenticity" and "authority" in the face of the competing claims advanced by "an original work of art."[64] And although Benjamin describes how this works out in practice, in theory it is the incompatibility of these claims that works to disrupt what the author identifies as the "aura" attaching to an "original" work by virtue of art's originating moment of ritual functionality.

Of course, by 1936, the notion of the "auratic" nature of original works of art was already under attack in any number of ways. Precisely because it seems to adumbrate issues also raised by Pamela Joseph's work, we should point out the way Marcel Duchamp's *L.H.O.O.Q.* can stand as characteristic of this attack. Duchamp's "work" consists of a defaced postcard of one of the most iconic of all paintings, Leonardo's *Mona Lisa*, who has been given a dandy's upturned mustache and goatee (a typical act of "school-boy" vandalism[65]) and a cryptic caption that "explains" her enigmatic smile by means of a "hidden" sexual reference to the "fact" of her "hot bottom."

Interestingly enough, Duchamp seems to accept without demur the photographically generated postcard as an adequate substitute for the original work, whose aura, not to mention the Louvre's security system, theoretically make it inaccessible for the kind of "rectification" that Duchamp seems to be proposing.[66] Although we now accept Duchamp's *L.H.O.O.Q.* as in some sense an original work – even in authorized reproductions[67] – our ability to do that depends equally on our ability to detach the notion of "original" from precisely those auratic notions of authenticity and authority that were keys to Benjamin's analysis.

64 See Walter Benjamin, "The Work of Art in the Age of Mechanical Reproduction," in *Illuminations* (New York: Schoken, 1969) 221, especially on the entanglement of "authenticity" and "authority."
65 Compare the discussion of Joseph's much more radical defacement of Manet's *Olympia*, above.
66 Duchamp also proposed using a Rembrandt as an ironing board, but this was certainly a purely conceptual suggestion. Dawn Ades, Neil Cox, and David Hopkins, *Marcel Duchamp* (London: Thames and Hudson, 1999) 156: the suggestion was made in one of the notes collected in *The Green Box*.
67 Notably the twenty-four reiterations included in the ongoing production of the *Boîte-en-Valise*. See Ades, et al., 174-182: the entire argument (with references) is important for our discussion of originals and reproductions. For a comprehensive survey of the *L.H.O.O.Q.* and its various iterations, appropriations, and reconfigurations, see Francis M. Naumann, "Marcel Duchamp's L.H.O.O.Q. The Making of an Original Replica," in the exhibition catalog *Marcel Duchamp: The Art of Making Art in the Age of Mechanical Reproduction* (New York: Achim Moeller Fine Art, 1999-2000), 10-15; 37, cat. Nr. 99.

Needless to say, this kind of detachment has become universally accepted as a "standard operating procedure" in the art world. At the same time, the advent of digital technologies has radically disrupted the notion of photography's inherent indexicality, perhaps in the process fatally compromising the photograph's claims to authenticity, authority, and a final characteristic stressed by Benjamin as inherent in all true originals: their historicity (what he calls their ability to provide "historical testimony"), which is itself inextricably tied to their position within a particular cultural tradition.[68]

It should by now be easy to see how all of these issues are at play – and how they have become both more complex and mutually interpenetrating – in Joseph's globalized series of censored Masterpieces. To return to our original "relatively straightforward example": there is an "original" work of art, say Matisse's *Large Reclining Nude* (1935). That original is (digitally) photographed, resized, color-corrected, etc. and eventually used as an illustration in Robert Cumming's Eyewitness Companion to *Art* (London: Dorling Kindersley Limited, 2005). Although DK Ltd. is based in London, the color reproductions used in the Eyewitness Companion were prepared by an Italian company called GRB, while the book was printed and bound in China. At some point after 2005 (that is, during the presidency of the politically and culturally conservative Mahmoud Ahmadinejad) the book was imported into Iran and censored by hand before being offered for sale on the open market.

68 Benjamin, 221. This is an intensely contested patch of critical landscape. For a brief introduction to some of the relevant issues, see Glenn Harcourt, "Photographing the Catastrophe," on Taryn Simon's monumental project, *A Living Man Declared Dead and Other Chapters I - XVIII*, *X-TRA* 15.4 (summer 2013) 70–83. http://x-traonline.org/article/photographing-the-catastrophe/. But keep in mind that this represents only one possible approach.

The censored book – now become an "original" due to the markings themselves – then passed through several hands on an international journey which displaced it from its particular Islamic context[s],[69] until it was couriered to an Iranian-American artist, Kurosh ValaNejad, who recognized its potential as a ready-made art object and as inspiration for his erstwhile collaborator Pamela Joseph. The book arrived in Joseph's studio and became the model for a (slightly-altered) copy executed at a scale of 1:1 in respect to the "original" Matisse. Judged by a Duchampean standard, what we now have is a copy of a rectified ready-made (the censored reproduction[70]) in which the number of mediations (mechanical and otherwise) between the final product (Joseph's painting) and Matisse's *Reclining Nude* might baffle even an intellect as sharp as Benjamin's. In any event, it is probably fair to say that, even if Matisse's original picture could have been said to possess an aura of authenticity, that aura has certainly been stripped away as part of the process of its reiterated transformation.

Yet, equally certainly, no one would deny that Joseph's painting deserves to be viewed as a genuine work of art, albeit, perhaps, a "post-auratic" one.[71] Indeed, by virtue of its clear place within an economy of appropriation, citation, and reiterated re-interpretation, it can stand as an iconic example of the cultural moment that is more commonly referred to as post-modern.

There is one final question, though, that seems to follow from the preceding discussion, and it concerns the place of Joseph's paintings (and by no means hers alone) within that long-standing tradition of western art-making, the attention of which is focused on the human body as the central aesthetic "problem" and the primary narrative vehicle. This is not necessarily an easy question to answer with absolute, or even relative, certainty.

69 Here, I intend to refer both to the original bureaucratic context of its censorship and to the context of the book's initial circulation through post-revolutionary Iranian artistic culture.

70 In fact, compared to Duchamp's own *L.H.O.O.Q.*, which provides a kind of precedent, the censor's work, which has presumably been executed without the intervention of aesthetic choice or appreciation, is closer to Duchamp's prescriptive pronouncements about this type of art making than is the artist's own choice of the aesthetically and historically charged Mona Lisa. On Duchamp's demand for visual "indifference" and the suppression of "aesthetic emotion," see Pierre Cabanne, *Dialogues with Marcel Duchamp* (London: Thames and Hudson, 1971 [original French ed. 1967]) 48.

71 On the idea of "post-auratic art," see Jurgen Habermas, *Legitimation Crisis* (Boston: Beacon Press, 1973) 84-86.

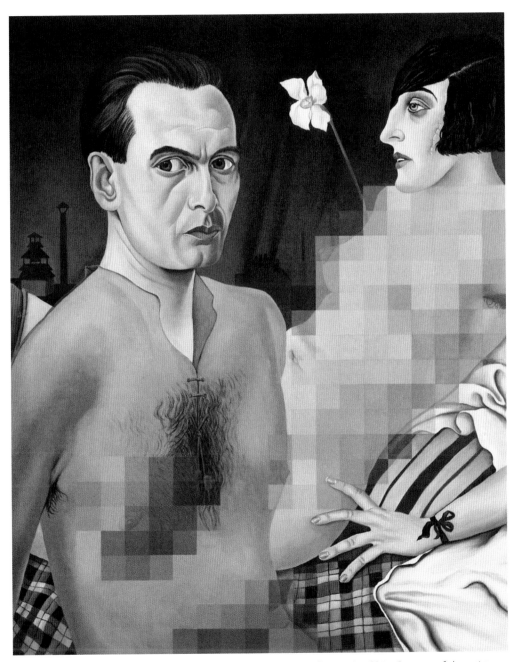

Pamela Joseph, *Censored Self-Portrait 1927 by Schad*, 2014. Oil on linen, 40 × 32 in. Courtesy of the artist.

There is no question that the issue at the center of the present work is the status of the human body – and especially, if not exclusively, the female human body. And this is certainly the case both for the Iranian censors and for the artist herself, although for rather different reasons. For the Iranian censors, the reasoning is pretty straight-forward, and in the non-Islamic West, this Iranian response tends to be evaluated according to how the issue cuts with respect to the female body in particular. In short, the western critic would tend to make this a feminist issue, a matter of women's rights, of women denied control over their own bodies. Yet the censor's work is in fact carried out without respect to gender, a fact that is acknowledged in Joseph's own work.

In the Christian tradition, at any rate, it is easy to spot similar (though not identical) phenomena – the practice of encouraging communities of cloistered and habited nuns, for example, where the female body is reserved inviolate and immaculate as befitting one who has committed herself to being a "bride of Christ" – and it is not by accident that all those bunches of leaves (whether fig or otherwise) seem fortuitously to cover the genitals of Adam and Eve in thousands of representations of the Garden of Eden: this does not generally happen on account of *their* shame or as part of the narrative of *their* Fall, but rather as a way of protecting the eyes of (fallen) viewers from temptation to the "sins of the flesh."

For Pamela Joseph, however, the situation is political as opposed to theological, and she is clearly not affirming the sinfulness of the body itself nor the sinfulness of its fully naked representation. Indeed, the violation of taboos against the representation or the agency of the naked female body has been a trenchant and powerful (western) feminist strategy over the years.[72] On the other hand, the representation of that body by and for male viewers, and for the satisfaction of their presumed desires for possession and violation, are equally to be contested. The boundary case here, of course, is hard-core pornography; but a brilliant work like Bernini's *Apollo and Daphne* (1622–25) might equally be censured.[73]

[72] One need hardly think farther than the work of performance artists like Carolee Schneemann.
[73] Within Pamela Joseph's *oeuvre*, a humorous, soft-core take on these issues can be found, for example, in the "Roman Calendar Girls" series from the exhibition *Cherchez la Femme* (2003). But she has been engaged with these issues throughout her career.

Gian Lorenzo Bernini, *Apollo and Daphne*, 1622–25. Marble, 243 cm.
Galleria Borghese, Rome. Photo: Joaquim Alves Gaspar.

It is not, however, generally speaking this kind of work (Bernini) that is made the subject of Joseph's reproductive scrutiny in her current series. She seems much more drawn to late nineteenth and early twentieth century work, and I would argue that there is a particular reason for this attraction. Returning once more momentarily to the Matisse *Large Reclining Nude* – although it clearly makes reference to the tradition of the reclining female nude that is so deeply embedded in the history of western art, it might legitimately be asked: Does it in fact belong to that tradition? I think that a case can be made that the answer to this question is "No."

If we look at the iconic examples of this tradition, for example Titian's *Venus of Urbino* (1538), the basic conceit of the picture (and something it shares with all the other iconic examples) is the desire to give the represented female figure a palpable, almost physical presence. Like Giorgione's *Sleeping Venus* (1508-10) or Velazquez' *Rokeby Venus* (1647-51), Titian's picture is embedded in its own complex cultural and sexual politics, the bearer of its own particular meaning. But the working out of those meanings in all three cases depends on our willingness to acknowledge the presence of Venus as an incarnate image of male sexual desire, an acknowledgment that is itself dependent on the naturalistic style of the pictures. In other words, the style and the "meaning" of the pictures are inextricably bound up with one another, the style is the vehicle by means of which the meaning becomes (literally) incarnate; and this "meaningful embodiment," I would argue, constitutes a necessary condition for the cultural production that we refer to as the Classical tradition.

Matisse's picture obviously falls outside of this parameter. Although the naked female body is indeed its ostensible "subject," the picture is quite explicitly (even superficially in the sense of being "all on the surface") about what it means to be a picture. That leaves the sexual politics of the subject matter isolated, unprotected, and, again, literally on the surface of the canvas. It also leaves the Iranian censor's bureaucratic "correction" of the image readily available for Joseph's ironic and feminist appropriation.

Titian, *Venus of Urbino*, 1538. Oil on canvas, 119.2 × 165.5 cm.
Galleria degli Uffizi, Florence.

Giorgione, *Sleeping Venus*, 1508-10. Oil on canvas, 108.5 × 175 cm.
Gemäldegalerie Alte Meister, Dresden.

Diego Velázquez, *Rokeby Venus*, 1647 - 51. Oil on canvas, 122.5 × 177 cm.
The National Gallery, London.

Interestingly, the picture around which this reading pivots is precisely Manet's 1863 *Olympia*, where the artist (almost magically it seems) is able to evoke from his model a sense of powerful and immediate presence, while at the same time focusing our attention on the constructed nature of the painting as a painting. And perhaps this diversion or reduplication of focus is necessary, since Olympia's presence is established by a gaze that is at once dominant and indifferent: indifferent alike to the painter, her client, the salon audience, a modern viewer, the john, or the art historian.

Equally, Manet's picture holds a unique position among the censored works singled out by Joseph for her own exercise in critical and political re-appropriation; and she plays on the way Olympia herself has been the subject of Manet's unique artistic disfiguration, as well as on the way that her reproduction has been marked by an unusual departure from the matter-of-fact employment of the censor's thick pen. Joseph's own disfiguration displays an intensity of violence that borders on a desire for desecration, a blotting out of identity or being that seems almost sadistic in its intent. It is not entirely clear to me whether this special treatment is in fact intentional, or merely fortuitous. But in either case, it marks Joseph's *Censored Olympia by Manet* as likewise pivotal in her recent work.

Olympia – that is, the depicted model herself – also seems to challenge expectations with respect to the tradition at the cutting edge of which she falls. She is at once a commodity available either for regard or purchase, and a woman in control of the disposition of her own body as well as its construction as "a work of art."[74] In this way Olympia, as the keystone of this extended meditation, comes closer than the literal, but quite differently intended, Venuses of Giorgione or Titian to embodying the complexities and contradictions of being and meaning that characterized the original Venus, both as a goddess and as a subject, for example, in the art of Praxiteles. In the case of Giogione, by way of contrast, Venus has become an embodiment both of the essential passivity of the "natural world," and of Man's active ability to transform that world through the production of culture; while for Titian, her cultural transformation takes the form of the institutionalized domesticity marked by the sacrament of marriage.

Thus, while Olympia continues to ply her trade unimpeded in Paris, albeit now from the walls of the Musée d'Orsay, the so-called Capitoline Venus, a copy (probably at a couple of removes) of the original Knidian Aphrodite by Praxiteles, became one of the hapless and potentially "offending" statues boxed up for the visit of Iranian President Rouhani to Rome in January 2016. That its cleverly contrived pose is the same one

[74] And as such, she clearly has something in common with contemporary figures like Lady Gaga.

incorporated by Botticelli to enhance the playful eroticism of the goddess in his *Birth of Venus* makes it once again clear how an essential classical icon has been repeatedly revisited, reclaimed and re-imagined as part of the on-going Western artistic tradition.

Over the course of this argument's unfolding, we have seen how that tradition has been challenged or denied, for example by Manet with his *Olympia*, by an Iranian censor with his marker, and by zealous Italian bureaucrats with their boxes. Only in the case of Manet, however, has that challenge been delivered with self-consciousness, and deployed at the moment of modernism's coming-into-being. The challenge raised by Joseph's "CENSORED," on the other hand, belongs unambiguously to our post-modern present, and the shifting gender expectations that she creates provides an unlikely bridge to the next series of work to be discussed.

Capitoline Venus, from an original by Praxiteles (4th century BC). Marble, 193 cm. Palazzo Nuovo, Musei Capitolini, Rome. Photo: José Luiz Bernardes Ribeiro.

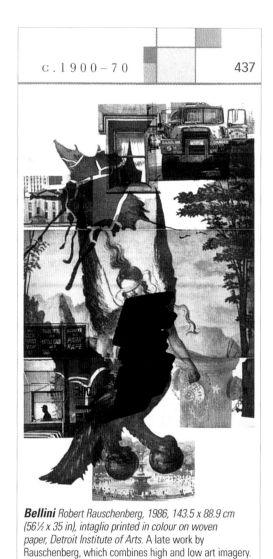

c.1900-70 437

Bellini Robert Rauschenberg, 1986, 143.5 x 88.9 cm
*(56½ x 35 in), intaglio printed in colour on woven
paper, Detroit Institute of Arts.* A late work by
Rauschenberg, which combines high and low art imagery.

The central image in this post-modern work is Bellini's interpretation of
the Iranian mythical winged creature Simurgh, who is depicted usually
as a chimera without a human face, though understood as female.
DK Eyewitness Companion to *Art*, hand censored in Iran. Collection Kurosh ValaNejad.

Post-modernism and the Construction of Culture

Considering art, photography and films by

Aydin Aghdashloo (Iran), Boushra Almutawakel (Yemen),
Ana Lily Amirpour (Great Britain/USA), Gohar Dashti (Iran),
Daryoush Gharahzad (Iran), Shadi Ghadirian (Iran),
Bahman Ghobadi (Iranian Kurdistan), Tanya Habjouqa
(Jordan), Katayoun Karami (Iran), Hoda Katebi (USA),
Simin Keramati (Iran/Canada), Mohsen Makhmalbaf (Iran/
Great Britain), Shohreh Mehran (Iran), Houman Mortazavi (Iran),
Manijeh Sehhi (Iran), and Newsha Tavakolian (Iran/USA)

Jean-Auguste-Dominique
Ingres

One of the major heroes of French art and the master of high-flown academic illusionism. Great admirer of the Italian Renaissance and Raphael. Tortured, uptight personality.

His work conveys total certainty: his subjects were well established and officially approved: portraits, nudes, and mythologies, all painted with the high "finish" required by the Academy. He created the most manicured paintings in the history of art — everything carefully arranged (hair, hands, poses, clothes, settings, faces, smiles, attitudes, even light) and some of the most exquisite drawings ever made, with a total mastery of line and precise observation.

Notice the way he (usually but not always) manipulated this artificial idealism and fused realism with distortion, so that the end result is alive and thrilling, and never dead academism: chubby hands with tapering fingers (can look like flippers), strange necks, and sloping shoulders. He had an interest in mirrors, painting figures that are reflected in mirrors; maybe his (and his society's) whole world was that glassy reality/unreality of the looking glass?

KEY WORKS *La Grande Odalisque*, 1814 (Paris: Musée du Louvre); *The Apotheosis of Homer*, 1827 (Paris: Musée du Louvre); *Madame Moitessier*, 1856 (London: National Gallery)

The Valpinçon Bather Jean-Auguste-Dominique Ingres, 1808, 146 x 98 cm (57.? x 38.? oil on canvas, Paris: Musée du Louvre. To produce artistic harmony, the body is distorted; for example, the back is too long

DK Eyewitness Companion to *Art*, hand censored in Iran.
Collection Kurosh ValaNejad.

Medici Venus. Marble, 1.55 m.
Galleria degli Uffizi, Florence.
Photo: Wai Laam Lo.

Jean-Auguste-Dominique Ingres, *The Bather*,
1808. Oil on canvas, 146 × 97 cm. The Louvre.

INTRODUCTION

Whatever else we might say, the paintings in Pamela Joseph's "CENSORED" series might be seen as constituting a critique of the cultural policy of contemporary Iran's clerical government, which would place her own work in an ambiguous position vis-à-vis the practice of many contemporary Iranian artists, especially those still working inside Iran and under the cultural regulations imposed by the governing clerical establishment.

Take, for example, Joseph's *Censored The Valpinçon Bather by Ingres* (2012). The original painting by Ingres (1808, painted at the French Academy in Rome) is a classic example of nineteenth-century Orientalism, its subject what we would describe as an "odalisque" or harem-girl.[1] The reproduction of the original in Cumming has been hand-censored in black marker so as to virtually obliterate the body, leaving only the sensuous curve of the model's right arm more-or-less completely visible. The model herself is seen from the back, with her head turned away, in a pose that echoes the Praxitelean type embodied in works like the so-called *Medici Venus*. Her hair is done up in a brightly colored cloth (a kind of hijab-manqué).

How might these versions (the "original" by Ingres, the censored "Iranian" version available in Cumming, and Joseph's own *Censored Bather*) reflect on the works of contemporary Iranian artists who have continued to work in-country, both pushing against and working around government restrictions on the process of cultural production? This is not a question that I can answer with any certainty; but it is possible, I think, to advance some reasonable suggestions, grounding the argument in material from two excellent recent surveys of contemporary Iranian art, one by Hamid Keshmirshekan, a leading authority on Iranian art based at the London Middle East Institute, and another by University of California at Davis professor of art history, Talinn Grigor.[2] In order to unravel these propositions, however, it is necessary to lay out a few basic ideas and principles.[3]

1 The classic introduction remains Edward Said, *Orientalism* (New York: Vintage, 1979).
2 Hamid Keshmirshekan, *Contemporary Iranian Art: New Perspectives* (London: Saqi Books, 2013); Talinn Grigor, *Contemporary Iranian Art: From the Street to the Studio* (London: Reaktion Books, 2014).
3 Unless quoted and cited, readings of specific works of Iranian art, and comments on the issues they raise and their relationship to pictures from Pamela Joseph's "CENSORED" series, are my own.

First of all, it is always necessary to keep in mind both the relationships and the discontinuities between contemporary Iranian art created in-country and that created by Iranian artists in exile. For both groups, as well as for all Iranians both at home and abroad, the central and irreducible fact of life and culture is still the revolutionary upheaval that began in 1979, which led eventually to the flight of the shah and the collapse of the Pahlavi dynasty, as well as to the subsequent establishment of the Islamic Republic. Inevitably, the cultural and political dislocations and reconfigurations precipitated by the continuing struggle that came to be called the Islamic Revolution are still profoundly present and on-going. This creates a strong sense of continuity between art created in-country and that produced by artists in diaspora. At the same time, the blunt fact of being either "there" or "not-there" serves to open and foreclose different sets of strategic and expressive possibilities.

As Talinn Grigor concisely observes in her *Contemporary Iranian Art: From the Street to the Studio*, "To produce [contemporary Iranian] art is to reproduce Iranian identity."[4] The crucial question devolving from Grigor's thumbnail formulation brings us immediately to the heart of the issue: what, exactly, is "Iranian identity?"

Like all such "identity questions," this one is complex and multi-faceted, and its answer(s) are intensely contested. Its implications might be radically different, for example, for a revolutionary/socialist-Islamist artist living and working in-country and close to the centers of clerical and cultural power, and for a young film director of Iranian heritage like Ana Lily Amirpour (b. 1980), whose 2014 Farsi-language genre film, *A Girl Walks Home Alone at Night*, envisions the (Iranian) patriarchy's worst nightmare as a hip, young, skateboarding and chador-wearing vampire.[5]

A Girl Walks Home Alone at Night, written and directed by Ana Lily Amirpour, 99 min., Kino Lorber, Inc., 2014. Film.

4 Grigor, 94.
5 In an interview with *Rolling Stone*, Amirpour explains the juxtaposition of skateboard and chador, which might seem incongruous to western eyes: "'From the moment I felt the cape on me, it felt so natural and good,' Amirpour says. 'It felt like the wind [...] like I was a stingray, a creature. It was amazing.'* She suddenly had the idea of using a chador-clad skateboarder as the heroine for some sort of major story – and to her, there was nothing more major than vampires." And as far as her exclusively male victims are concerned: "A vampire who looks like a vulnerable hipster but feasts on drug dealers and alpha brutes... well, that's just badass." Amy Nicholson, "Meet the Woman Behind the Year's Best Iranian Vampire Western," *Rolling Stone*, November 19, 2014: http://www.rollingstone.com/movies/features/girl-walks-home-alone-at-night-ana-lily-amirpour-20141119.

A Girl Walks Home Alone at Night, written and directed by Ana Lily Amirpour, 99 min., Kino Lorber, Inc., 2014. Film.

Grigor's Epilogue, which centers on the rather unlikely story of Mir-Hossein Mousavi, both an architect and designer of buildings and popular political movements,[6] describes the complexity this way: "[The] struggle of identity formation is a pictorial discourse, which has on its wide spectrum the street at one end" – that is, the poster and propaganda art of the revolutionary streets – "and the studio at the other." The private studios and house-galleries where avant-garde art can be produced and displayed generally outside of government interference is a crucial component to our argument.[7]

Grigor's "studio" is in some ways not unlike author Azar Nafisi's apartment in Tehran, where her female students were free to meet and discuss American and English literature.[8] The apartment in Nafisi's best-selling post-9/11 memoir, however, sits at the center of a reading of Iranian [post-revolutionary] culture that has been hotly contested as a "neo-Orientalist narrative" with dangerously pro-western political, religious, and cultural overtones.[9] The issues touched on in this debate are centrally important to our own work, and we will return to them as context demands.[10]

6 Grigor, 241–253. Mousavi helped bring about the Islamic Revolution and was a former Prime Minister (in fact, Iran's last). He ran unsuccessfully for President in 2009 when was defeated by the radical Mahmoud Ahmadinejad. A driving force behind the Green Revolution (see political poster opposite), in 2011 he was placed under house arrest following pro-democracy uprisings in many countries throughout the Arab world but has continued to wield influence as a political prisoner, as evidenced by his name being chanted at pro-reform demonstrations before the reelection of Iran's moderate president Hassan Rouhani on May 19, 2017.
7 Grigor, 242.
8 *Reading* Lolita *in Tehran: A Memoir in Books* (New York: Random House, 2003).
9 See, for example, Fatemeh Keshavarz, *Jasmine and Stars: Reading More Than* Lolita *in Tehran* (Chapel Hill: University of North Carolina Press, 2007). The critique, presented in Keshavarz in exhaustive detail, is a reflection of a bitter disagreement between academics in exile who take varying positions vis-à-vis post-Revolution Iran, the Islamic regime, secularism and the "toxic" legacy of colonial culture creating a self-propagating Islamophobia.
10 See Grigor, 241–242.

"Hey youth, come along. Mir-Hossein Mousavi Khameneh." Political poster supporting the 2009 Green Revolution, Tehran. Photo: Talinn Grigor.

The Marriage of the Blessed, written and directed by Mohsen Makhmalbaf, 70 min., Makhmalbaf Film House, Inc., 1989. Film stills and movie posters.

In Mohsen Makhmalbaf's 1989 film *The Marriage of the Blessed*, the story of the deeply troubled internally conflicted Haji is a brilliant exemplification of Grigor's formulation of the identity problem played out cinematically.[11]

At the heart of the work by Makhmalbaf (b.1957) is a young Iranian photographer suffering from what we would now call PTSD as a result of his traumatic experiences as a soldier in the Iran–Iraq War. This suffering further intensifies as he attempts to reintegrate himself into civilian society and reestablish a relationship with his fiancé, who is herself a pioneering woman artist and documentary photographer. Although Haji's camera (a synecdoche for Haji himself) is described at his wedding celebration as "the passionate eye of the Revolution," what it/he sees in the final analysis is a country (Iran) and a world (both his and ours) sliding inevitably into a chaos of violence and self-destruction.[12] Nevertheless, the film is neither overtly critical nor ideologically strait-laced. It derives its power both from the sympathy of its portrait of the suffering Haji (who, as a non-martyr, must bear the psychological burden of the war) and the complexity of its portrait of Iranian society as something that must be negotiated from day to day.

Haji has no "apartment" into which he can escape as if into a world of literary fantasy (however apparently liberating). Those interior spaces which "belong to him" comprise the locked psychiatric ward which he shares with other "blessed" yet profoundly damaged survivors of the Iran–Iraq war (the western literary analog might be Ken Kesey's *One Flew Over the Cuckoo's Nest*) and the dark studio where he obsessively screens documentary footage of world-wide famine, suffering, and institutionalized violence.

For viewers, the space reserved for their personal, phenomenological relationship to the issues enacted in the film is the physically dark environment of the theater itself. So, in that sense, they themselves (and not only if they are Iranian) can identify with Haji and his battle with the intertwined demons of trauma and memory. The filmed context of that struggle, however, gives the film a specifically Iranian resonance. We will see something similar when we look at artist Shadi Ghadirian's work; but, in general, the dialogic relationship between private engagement and public statement will remain a source of tension and potential contradiction.

11 *The Marriage of the Blessed*, VHS, Directed by Mohsen Makhmalbaf (Iran: Makhmalbaf Film House, Inc., 1989). For a brief but trenchant analysis of the film from a broader revolutionary perspective, see Christopher de Bellaigue, *In the Rose Garden of the Martyrs: A Memoir of Iran* (New York: Harper Perennial, 2006) 141-145.
12 The film was shown at the Locarno Film Festival in 1989. Although it was the eighth highest-grossing Iranian film of 1989, it generated considerable controversy, primarily for what many perceived as an "irreverent" stance toward the martyrs and "blessed" survivors of the Iran-Iraq War, which had only recently come to an end (perhaps fortuitously, the film was not released until after the death of Ayatollah Khomeini on June 3, 1989). For an in-depth exploration of the film, its political and cultural context, and an interview with the director, see Saeed Zeydabadi-Nejad, *The Politics of Iranian Cinema: Film and Society in the Islamic Republic* (Oxford/New York: Routledge, 2010) 55-69.

Houman Mortazavi, *1386 Nudes (cut up nude drawings from 2007)*, 2007. Cut up drawings and glue, 11 × 11 × 12 cm. Courtesy of the artist.

CONTRADICTIONS IN THE STUDIO

Artists working in Iran seem publicly to have accepted, at least by and large, the general cultural topography that is also mapped out by the swipes of the government censor's marker across the pages of Cumming's book. In so far as one can tell, both from a survey of the work reproduced in Grigor and Keshmirshekan, and from other readily available sources of pictorial material, the nude has been effectively banned as a subject of legitimate Iranian public art (at least since the "veiling" of the nude statuary in the Department of Fine Arts exhibition galleries in 1982[13]), and that exclusion is not really contested, at least not explicitly.

Indeed, a work like *1386 Nudes* (2007) by Houman Mortazavi (b.1964), where the artist has cut up a series of nude drawings and pasted the resultant squares one on top of another to create a kind of gluey, lopsided archive of inaccessible and barely identifiable fragments both tacitly acknowledges the exclusion – in that sense it amounts to an exercise in (self-) censorship – and works around it using a clever conceptual strategy.[14]

Grigor trenchantly concludes, with respect to Mortazavi's work (and that of others) that, at least within "the studio," "the nude, in its most fascinating and disturbing, its most tender and vulgar forms is always present," a phenomenon she brilliantly dubs "the revenge of the closet."[15] We might, using a slightly different vocabulary, dub it "the return of the repressed."

13 Grigor, 106.
14 Ibid., 15, illus. 3. As Grigor rather cryptically observes, Ibid., 16: "That which has been said [or, shown] is conditioned by the (im)possibilities to which this narrative about pictorial discourse belongs." In other words, the act of creating the work is essentially just such a narrative; and we all "know" what is inside the stack of fragments.
15 Ibid., 117.

Indeed, Grigor herself can only acknowledge this vengeful return explicitly by means of an anonymous documentary photograph, an archival fragment of fragmented bodies, rather than a work of art. It shows a quasi-bird's-eye view of the surface of a work table, taken in "[t]he home-studio of an [unidentified] Iranian artist" (Tehran, 2009).[16]

On that working surface, in addition to some miscellaneous and impersonal objects, are three piles of snaps. So far as this can be discerned, each pile consists of a series of small images of young women standing "at ease" with their hands to their sides. Every one of these figures is wearing low-slung jeans or similar pants, and they are all topless, with breasts fully exposed. The images have been trimmed at the sides to follow the contours of shoulders, arms, and hips, and the head of each figure has been neatly snipped off. At the far left of the frame a pair of quite fragmentary (male) hands – presumably those of the artist – holds one of these disfigured snapshots.

On one level, the little snapshots evoke an image of male desire, even a kind of juvenile and radically depersonalized pornography; but on another, the women in the photos seem objectified in a different way: they are potentially sexual yet innocent beings, like so many Eves in the Garden prior to the Fall, and the violation of their bodies resulting from their decapitations resonates with a kind of systemic degradation of identity or systematic process of effacement. Conversely, should we see it as being in the nature of disguise, or even as the trace of a contract of anonymity between artist

16 Ibid., 117, caption to illus. 78.

and models? Decapitation, however, is only one, albeit the most radical, of several strategies of self-effacement employed by artists in the work under review here. However, in common with the others, it seems at least a potentially polyvalent pictorial move, and it need not necessarily be seen as a sign of the punitive power of clerical patriarchy.[17] Unfortunately, the very off-handedness of the image, its status as a kind of snapshot of snapshots and repetitive in subject without any articulating structure, forces us to leave these questions open. The photographs are a work *in statu nascendi*, in the process of coming into being, and suggest that "the studio" remains a place of multifarious potential for the expression of criticism as well as the enactment of transgression, but also, perforce, a place of work continually "in progress."

Anonymous artist's studio, Tehran. Photo: Talinn Grigor.

17 For a marvelous gender-reversed instance of the use of decapitation, see the on-going hallucination of the prostitute Zarrinkolah in Shahrnush Parsipur's extraordinary short novel *Women Without Men* (New York: The Feminist Press at CUNY, 1989 [Persian]/2011 [English translation by Faridoun Farrokh]) 61-66. Superficially, Zarrinkolah's vision of endless headless men might be read as signaling her own objectified status. For the prostitute who "services" twenty or thirty clients a night (Zarrinkolah was exceptionally good at her job) all johns are the same; they are no more than the means of making a living, even as she is for them no more than a minimally conscious object of desire. But as the novel's magical narrative plays out, it becomes clear that the vision represents something quite different: it is an image of latent female empowerment and hovers ineffably in the background at Zarrinkolah's final apotheosis as a [literally] transparent vessel of transcendent maternity. Parsipur's novel was adapted as a feature film (available with English subtitles) in 2009 by the Iranian director and international art star Shirin Neshat. Parsipur herself has been politically active since the 1970's and spent time in prison under both the shah's and the Islamic Republic's regimes. *Women Without Men* was banned at the time of its original publication, and its author now lives as a writer in the diaspora.

The passage of the body from the studio (strictly construed, as in the anonymous photo illustrated in Grigor's text) to the gallery or museum, however, elicits the tacit admission, itself also an indictment of the system, that, for the Iranian artist working in-country, the body is something always already censored.

In Manijeh Sehhi's 2002 installation *Fresh Weather*, for example, a series of translucent black [acrylic] cubes enclose clay figures twisted and contorted to fit the confinement of their imprisoning space.[18] In this stark presentation, where only one body is visible and the rest are concealed by black fabric shrouds, the notion of the self-destroying bodily invisibility of imprisonment is hard to avoid. This theme continues in her video work *Woman* from 2006, which explores the complex relationship between social "visibility" and personal "privacy." Although it is hard to get a sense of narrative flow from a sequence of stills, the "climactic" image seems to show a single woman posed as if to address whoever it is on the side of the scrim that separates actor from audience.

Manijeh Sehhi, *Fresh Weather*, 2002. Installation. Courtesy of the artist.

Manijeh Sehhi, *Woman*, 2006. Video still. Courtesy of the artist.

18 Grigor, 146; 147, ill. 88.

Manijeh Sehhi, *Woman*, 2006. Video stills. Courtesy of the artist.

Against this notion of the body as a thing that has been effectively, almost sanitarily "disappeared" from view, or at least from public space, we might counterpoise Katayoun Karami's photo series "Censorship" (2004), where the artist uses a sequence of self-portraits to display the work of censorship as if it were a source of existential devastation. On her website portfolio, the artist writes,

> Censorship knows many guises, the likes of which, or at least in my country, Iran, force themselves on the public domain as much as they do on the private. Being it through the rough imposition of moral strictures, or the subtle filtering of the unconscious self, the impact of both ends up the same; suffocating, hurtful and, ultimately, destructive.[19]

Grigor argues that Karami's photos present "a frank commentary on the condition of artists and women in contemporary Iran," a conclusion that seems incontestable, at least for a woman of Karami's generation (b.1967).[20] In this situation, the body and the self seem bound together in immediate jeopardy. In one of the photos, which resembles nothing so much as a mug shot of a political prisoner, the artist has covered the details of her nude torso with a 1993 Iranian license plate and slashing marker strokes: in theory, a strategy not unlike that employed by the Iranian censor who produced Pamela Joseph's "raw material," but the effect of physical and psychic injury is much more immediate and potent. Indeed, Karami herself comments [ironically] on this self-portrait: "How better to protect the dignity of my being, than having my naked flesh concealed by the crude strokes of the cultural guidance official's 'moral values' marker?"

Another work from the 2004 series shows her face masked by a hand, and as she explains in the same text on her website,

> double-exposed with a puzzle, and so divided in many pieces, [my] uniqueness instantly destroyed. [...] But the jigsaw does not extend fully to the mind, the sole domain where women can still hold onto their self-determination and autonomy.

The piece is also like a Rubin Vase, and the optical illusion of a hand grasping a miniature figure's naked torso, seen from the side, adds to the artist's insistence on her body's lack of visibility, which she describes as physical proof of her existence, an existence that "must be publicly denied."

19 All artist quotes are from Katayoun Karami, "Censorship 2004,": http://katayounkarami.com/Gallery.
20 Grigor, 146-148; 149, ill. 90.

Katayoun Karami, *Untitled (Censorship self-portrait)*, 2004. Photograph. Courtesy of the artist.

Karami's work in both photography and sculpture is imbued with traces of trauma, as her website portfolio makes plain. Another example of her self-portraiture illustrated here from the 2009 "Resurrected" series is especially jarring. Both the pose and the barbed wire crown of thorns identify the artist as the dead or suffering Christ (in itself an interesting strategic move) with tumbling cascades of hair concealing otherwise exposed breasts. This abject body (whose radical *imitatio Christi* suggests the Virgin Mary or the repentant Mary Magdalene) is further disfigured by its frame's broken glass and a crudely lettered text in English and Farsi. Looking just at the English elements of the inscription, the most frequently repeated word seems to be "atheist," although the words scattered across the figure comprise an expansive and resonant – and, we assume, personal – vocabulary: *resurrect, right, female, independent, insight, intolerance, crave, charisma, prophet, love, justice, miracle, blasphemy, rapture, lust, defiance,* among others. Given all this visual and textual material, it should be possible to construct a reading of the image that captures both the sense of abjection that seems to pervade the figure, and the status of the entire image as an artistic and existential manifesto.

Katayoun Karami, *Untitled (Censorship self-portrait)*, 2004. Photograph. Courtesy of the artist.

However, given also the complex and contradictory nature of the text (for example, the juxtaposition of "atheist" and "blasphemy" against "prophet" and "justice") as well as the use of an explicitly Christian visual quotation within a putatively Muslim context, this reading would demand the broadest possible visual, biographical, religious, and political contextualization, as well as all the interpretive delicacy necessary to approach the work of an artist who describes her own work as the visual text which

> speaks a common language in the place where I live.
> Portraits of my generation, our common experiences and
> challenges in life. A generation that has experienced
> revolution, war, immigration and more. Experiences, any one
> of which are said to be sufficient to turn a boy into a man,
> but which are apparently assumed to leave the other sex
> wholly untouched. In my own small, personal voice I say:
> Not so.

Katayoun Karami, *Untitled (Resurrected series)*, 2009. Mixed media. Photo: Mahmoubeh Maddah.
Courtesy of the artist.

A closely linked issue, to which Karami has also spoken, is the invisibility of the body in society. Shadi Ghadirian alludes to this by means of synecdoche or indexical trace, as in her series on the complexities of gender relationships provocatively titled "Nil." In her magnificently composed and dramatic photograph *Nil #1* (2008), the juxtaposition of a pair of shining new red high heels and a pair of worn and scuffed military boots, one of which is marked by a drip of fresh, glistening blood, condense (even in this single excerpted image) a powerful and resonant narrative.[21] Even the relative placement of the shoes evokes an image of absent bodies standing facing each other and thus enhances the narrative, which Ghadirian herself describes in these terms:

> I wanted to talk about the woman and the man both inside the house. And show also the war, there is a war. The man is in the war. The woman is inside the house. She is waiting for him.[22]

The woman – the man – the house – the war – waiting: this is really all one needs to know in order to understand how the photo's luminosity opens up its important questions: Which woman? What man? Whose house? Which war? Waiting for what? It is not entirely clear from the photos how we are to understand the relationship between these two worlds; that is, the world "inside," and the world without – the world represented by the war. It seems certain that the artist sees the world "inside" as being under threat, and identifies that threat as coming from without: a seemingly endless sequence of "wars and rumors of wars" [Matthew 24:6] that she associates with the male presence. The juxtaposition of discarded shoes suggests the dominant position of the woman within the relationship through its contrast between "her" fashionable contrapposto and "his" rather flat-footed defensive stance; but the glistening trace of fresh blood on one of the boots also suggests the proximity of violence, and the possibility of trauma: the sort of interior, psychic damage that bedeviled Haji in *The Marriage of the Blessed*.

21 For the series as a whole, see the museum catalog with essay by Kristen Gresh, *She Who Tells a Story: Women Photographers from Iran and the Arab World* (Boston: Museum of Fine Arts, MFA Publications, 2013) 84–91.
22 Ibid., 86.

Shadi Ghadirian, *Nil #1*, 2008. Photograph, 76 × 76 cm. Courtesy Robert Klein Gallery.

Shadi Ghadirian, *Nil #4*, 2008. Photograph, 114 × 76 cm. Courtesy Robert Klein Gallery.

Shadi Ghadirian, *Nil #14*, 2008. Photograph, 76 × 114 cm. Courtesy Robert Klein Gallery.

Those images in the series that don't actually contain munitions, ammunition, hand grenades, etc., keep the presence of the war oblique, as in *Nil #1*, but also in *Nil #4*, an image which presents a stark contrast between a brightly colored headscarf [hijab as "fashion statement"] and the gritty monochromatic metal of a soldier's helmet. Furthermore, *Nil #14*, where a truncated view as if into a closet shows an expansive array of brightly colored women's garments (blouses, sweaters, perhaps a scarf) interrupted by a single jacket of military khaki bearing the designation "RANGER," provides an equally expressive if less narrowly focused commentary on the gendering of couture, which stands throughout as a metaphor for the contrast between the world inside (the house) and that outside, in this case: the battlefield. However, the fact of the military jacket's English identification complicates any simple notion of (the) war as confined or contained, and in fact it implicates the multifarious foreign interventions that both permeated the Iran–Iraq War of 1980–1988, and others that have been ongoing in the strategic crossroads of the Middle East since classical antiquity.

Among Iranian female artists of Ghadirian's generation (b.1974), we can compare the work, for example, of Gohar Dashti (b.1980), which is at once more literal (a [married] couple actually appear as actors in Dashti's narratives) and features a quite surrealistic mise-en-scene.

In the photo series "Today's Life and War" (2008 – that is, exactly contemporary with Ghadirian's "Nil") Dashti sets her protagonists adrift on the battlefield (the best they can do for a house is a bunker padded with sand-bags) where they must attempt to reconstitute the routines and rituals of daily life within a blasted and war-scarred landscape: they set off from their wedding in the junked remains of a car gaily decorated in pink; they attempt to converse over tea under the watchful "eye" of an abandoned tank's cannon, etc.[23]

As a child of the Iran–Iraq War (1980–1988) Dashti's visual meditations on the traumatization of a life scarred by institutionalized violence bring her evocative tableaux-vivants literally to life. Considering the fact that she grew up on the border of Iran and Iraq, these site-specific photographs, one can imagine, may very well take place in a landscape immediately familiar to her.

23 Ibid., 92–99.

Gohar Dashti, *Untitled (Today's Life and War)*, 2008. Photograph, 70 × 105 cm. Courtesy of the artist.

Gohar Dashti, *Untitled (Today's Life and War)*, 2008. Photograph, 70 × 105 cm. Courtesy of the artist.

Although it might seem natural to view Dashti and Ghadirian together as representatives of a single generation without direct or conscious recollections of the 1979 Revolution, and hence as members of a post-revolutionary cohort of artists, this is not quite how things are viewed in Iran, at least from the perspective provided by social scientist Shahram Khosravi. Khosravi's research defines the "emic post-revolutionary generation" as having been born during the 1360s of the Iranian calendar (1981–1990), the often so-called "60-generation." This generation has a strong sense of self-conscious internal cohesion, according to Khosravi, and feels itself especially targeted by authoritarian restrictions. At least to a certain extent, this feeling is well-grounded in genuine cultural perceptions; yet it also becomes a kind of self-fulfilling prophecy.[24]

24 For this generational insight, as well as innumerable other observations on Iran throughout the post-revolutionary period, see the invaluable work of Shahram Khosravi, *Precarious Lives: Waiting and Hope in Iran* (Philadelphia: University of Pennsylvania Press, 2017). With thirty years of in-country observation and no obvious ideological axes to grind, this look at Iran's contemporary youth culture through the anthropological and sociological lenses of an Iranian social scientist provides both valuable objective data and descriptions, and a vivid sense of the interiority and lived experience of his informants. Also essential, and a work that resonates with numerous points throughout the argument is Roxanne Varzi, *Warring Souls: Youth, Media, and Martyrdom in Post-Revolution Iran* (Durham and London: Duke University Press, 2006).

Looking again at Dashti's photographic series "Today's Life and War," we see a hypothetical social situation that is understandable in terms of Khosravi's analysis of the desires characteristic of the "60-generation," of which Dashti herself is *almost* (or perhaps "liminally") a member. The young couple who serve as the protagonists of the series seem intent on establishing a relationship at once familial, yet cut off from the complicated set of generational and marital connections that define the traditional, patriarchal Iranian family. Their relationship seems rather to be founded on the idea of *mojaradi* ("single," but in a wider sense "autonomous," or "free from societal entanglements").[25] They are young, typically hetero-normative, childless, and their relationship is played out against a backdrop defined by the detritus of past, present, and future war, a powerful metaphor for what Khosravi defines as "precarity," the precarious nature of contemporary Iranian existence.

Khosravi uses the short-hand "precarity" throughout his study "to cover a broad range of social vulnerabilities that Iranians are struggling with: from insecure work conditions [a major "revolutionary" failing] and physical vulnerability [including, the near-criminalization of youth] to hopelessness, purposelessness, alienation, and disconnectedness from a sense of social continuity," as well as a "growing sense of [internal] exile from home and homeland among Iranian youth."[26] And yet, Dashti's photographs are not marked by a sense of hopelessness in the face of insurmountable odds. Rather, they speak of a sense of hope among the rubble; of struggle, but also (especially in the "honeymoon" picture) of endurance grounded in a kind of suffering good humor. In conclusion, the "60-generation" has felt itself alienated from the dominant culture, but has also wanted a "normal" life. Unfortunately, having been born out of the wreckage of the Iran–Iraq War, that normalcy has proved elusive. The couple here can live within the system well enough to avoid the kind of violent existential "censorship" that marks, for example, Katayoun Karami's "Resurrected" and "Censored" series, or a work we will soon discuss, *Biopsy of a Close Memory* by Simin Keramati [illustrated on page 131], but their opportunities are truncated, circumscribed, cut off by circumstance, and they are forced to live in the metaphorical shadow of what surrounds the coming into being of their generation.

25 Khosravi, 94–104. From one of his female informants (twenty-eight, an architect, unemployed, still living with her parents): "Marriage and starting a family do not fit our style. We want to keep our freedom [personal autonomy] even after marriage. We do not want the former generation's form of marriage. *Mojaradi* means [...] experiencing life in its real sense [...] experiencing love and sexuality" (96).

26 Ibid., 5; 4–6 gives an overview of the concept's development in social science in general, as well as its applicability to the Iranian situation in particular.

Aydin Aghdashloo, *Crumpled Miniature*, 1980. Gouache and crayon on board, 75 × 57 cm. Courtesy of the artist.

ORIENTALISM – MODERNISM –
POST-MODERNISM

In order to understand the ways in which Iranian artists engage in the development of a globalized post-modern culture using a uniquely useful set of conceptual tools, we must return for a moment to Ingres' *Bather* (both the original and the censored versions). Here, we see that all three engage yet another set of issues connected first of all to fundamental western ideas about "the [exotic, dangerous, and decadent] Orient." Through that engagement arises another set of questions surrounding the related idea of "modernity": its origins in the "enlightened [and/or Christian]," rational, and progressive west; modernity's impact on traditional non-western societies (including that of Iran); and its implications as an (often politically and culturally aggressive) springboard into the (post-)modern world of globalized western culture and hegemonic late or post-industrial capitalism.

The censored Ingres can provide a glimpse into this maze of complexity and contradiction, where originary and fundamental western misreadings of "the Orient" have so often and so apparently led to perversely misguided attempts by "Orientalized" populations to efface traditional or home-grown identities, and to replace them eventually through the imposition of international-style western modernisms. The eventual endpoint of this cultural arc is quite evident, for example, in the policies of the Pahlavi dynasty, especially those initiated during the so-called "White Revolution," launched in January 1963.[27]

Thus, it is not hard to imagine that Iranian artists (both at home and in exile) could feel a sense of vindication in the fact that the censor has placed this particular Ingres, as it were, "under erasure,"[28] since it embodies a set of western cultural preconceptions with long-lasting and pernicious after-effects across the both colonial and post-colonial worlds: the naked odalisque of the past has been transformed into a skyscraper in the best steel-and-glass international style.

[27] See Grigor, 26–28 for a brief introduction. Keshavarz, and others, have argued that Nafisi's *Reading* Lolita *in Tehran* is an attempt to produce precisely this kind of resolutely secular, westward-looking effacement of home-grown Iranian culture.

[28] The term *sous rature* (usually translated as "under erasure") popularized by the French-Algerian philosopher Jacques Derrida, is generally employed in the context of literary-critical or philosophical texts, but seemed almost literally apposite here in the visual case of the censored nude. It implies a kind of "necessary impossibility" or a state of ineradicable necessity: the idea that a concept (Heidegger first used the term with respect to the idea of "being") is both necessary to some discourse, yet totally inadequate to its function within it. Derrida's childhood in Algeria adds an important post-colonial resonance to the term: see David Tresilian, "Algerian Derrida," a book review of Pierre Nora, *Les Français d'Algérie, avec un document inédit de Jacques Derrida* (Paris: Christian Bourgois, 2012) in *Al-Ahram Weekly*: http://weekly.ahram.org.eg/News/2186.aspx.

Indeed, Shadi Ghadirian has attacked the aesthetic of Orientalism directly, in her series "Qajar" from 1998, where the word "Qajar" refers to the Turkic dynasty that ruled Iran from 1785–1925. Essentially ethnic and cultural interlopers, their eventual overthrow led to the initial ascendency of the Pahlavi dynasty.[29] "Qajar" can thus stand as a kind of shorthand for a period of orientalizing influence on Iranian self-presentation. Ghadirian's series of photographs provides a set of carefully reconstructed female studio portraits from the late nineteenth-century, formally posed (that is: mimicking the formal conventions of western studio portraits) and yet "Qajar" in every other way, especially in terms of stereotypes of fashionable yet concealing dress and overall structure of female self-presentation.

What differentiates Ghadirian's work from the period's authentic photographs, which became of interest to western anthropologists and thus objects of study reinforcing orientalist stereotypes, is a certain contemporary self-possession on the part of the models. Additionally, the inclusion of post-modernizing props (sunglasses, a contemporary newspaper, a boom-box, a can of Pepsi) that effectively erode the apparent "rootedness" of the images in time, while at the same time undercutting the apparent "given-ness" of the photographic view, now made visible by Ghadirian as culturally and ideologically determined.[30]

Likewise, those "rectified" western works appropriated by Joseph for her "CENSORED" series may raise the (unconscious) specter of Orientalism, even if in a more attenuated way than that articulated by Ghadirian with her faux-Qajari photographs. Still, the defaced and recapitulated images can nevertheless force us to consider the larger issue of how modernity and post-modernity are conceived by contemporary artists in Iran. In particular, the idea of modernity as a totalizing cultural ideology appears deeply problematic, while its fragmented and uniquely globalized successor will have deep impacts on the formulation of ideas of personal, ethnic, national, and religious identity.

29 Although this history may seem remote to western readers, it should be at least passingly familiar to fans of the graphic novelist Marjane Satrapi. See her *Persepolis: The Story of a Childhood* (New York: Random House/Pantheon, 2003) 19-21 for her capsule summary of these events. Upon careful examination of Satrapi's graphic recasting of her childhood during the 1970s and 1980s, important (if often implicit) resonances can be seen with much of the work discussed here.

30 For several examples of Ghadirian's "Qajar" portraits, see Gresh, ills. 4; 6-9; or the artist's website: shadighadirian. com. For an interesting collection of examples plus a link to a "comprehensive" database of Qajar visual materials (at Harvard) see the "Qajar Women," Museum of Islamic Art in Qatar: http://www.mia.org.qa/en/qajar-women. See also the discussion in the catalog *She Who Tells a Story*, 26-27.

Shadi Ghadirian, *Untitled (Qajar series)*, 1998. Photograph, 90 × 60 cm.
Courtesy Robert Klein Gallery.

The idea of modernism as a comprehensive public and civic cultural framework is perhaps most aggressively embodied in works of architecture and civic planning.[31] In Iran under the Pahlavis, this modernist vision in effect not only defined the agenda of the "White Revolution" but was formalized in 1969 in a new master plan for Tehran formulated by the architect Abdol-Aziz Farmanfarmaian in association with the American firm Victor Gruen Associates,[32] best known at the time for its seminal work in American shopping mall design. Metaphorically speaking, it is easy to identify the ideal inhabitant of this secular and modernist metropolis with the always fashionable Empress Farah, Andy Warhol's subject,[33] who was a relentless patroness of "the arts" and played a significant role in implementing these neo-Corbusian urban and architectural schemes, as well as in the foundation of the Tehran Museum of Contemporary Art (TMoCA), originally intended to serve as a repository for her personal collection.[34]

As if to complicate matters further, the shah's nascent idea of a modernist Iranian identity was bonded to a sense of deep historical continuity rooted in a pre-Islamic identification with the Persian Empire, the 2,500-year anniversary of which was celebrated with great official pomp in 1971. Unfortunately, the Pahlavi attempt to link its utopian vision to this deep Persian and pre-Islamic (hence essentially secular) history was doomed by their own perceived illegitimacy, an artifact of their continued ascendency thanks to American and British complicity in the overthrow of the democratically empowered regime of Prime Minister Mohammad Mosaddegh in 1953. Mosaddegh was something of a hybrid: a modernist (thus capable of being seen as repudiating Iranian tradition) yet also a strong nationalist, for whom modernism could be harnessed to an anti-colonialist agenda. The Cold War machinations leading up to his overthrow were a complex and long kept secret, but from the point of view of America and its British allies, his continued hold on power threatened, among other things, the essential continuity of access by western governments to Iran's railroads and oil reserves. He died under house arrest in 1967, by which time the "White Revolution" was already well under way.[35]

31 The iconic and originating example is still Baron Haussmann's twenty-plus year renovation of Paris, undertaken at the behest of Napoleon III in 1853.
32 Grigor, 26; 28, ill. 5 (the plan as realized according to a 1974 map of the city).
33 Warhol's 1977 portraits capture both Empress Farah's glamour and something of her drive and determination. See, Grigor, 217, for Afshan Ketabchi's pseudo-Warhol *Liz Undercover* (2008, print on canvas, 60 × 30 cm) – a portrait of Elizabeth Taylor wearing a hijab and executed as if in Warhol's "signature" style.
34 For a summary of the sweeping and utopian high-modernist reforms, see Grigor, 19-20. For a graphic evocation of this "white" utopia, see Ibid., 32, ill. 9.
35 Mosaddegh had been appointed Prime Minister by the shah in 1951 following a favorable vote of the Majlis (roughly: Parliament) and was likewise committed to modern and secular values, but also to a national and social agenda much more "radical" (that is, left-leaning) than that of the shah himself. For a survey of Iranian art during the period that includes Mosaddegh's presence as a force in Iranian politics, see Keshmirshekan, especially Chapter Two, "Decades of Hesitancy and Confrontation: Modernism Versus the Status Quo," 51-92.

The competing democratic and authoritarian modernity(s) eventually became entangled with a resurgence of ideas of Islamic identity, which, to a greater or lesser extent, rejected both the notion of a deep "Persian" history and any rapprochement with an increasingly "westoxicated" society. Following the 1979 Revolution, this notion of "Iranian" as fundamentally Islamic and Shi'ite became inculcated as official policy; but the struggle outlined here is hardly over.

Within the world of the visual arts, and painting in particular, artists worked through these issues in any number of ways, exploring approaches that have been tagged with rubrics like "nativism," "nationalism," "modernism," and "neo-traditionalism." Keshmirshekan has provided an important background for the more contemporary issues discussed here, grounding the evolution of modern Iranian art within opposing modes of "hesitancy" and "confrontation."[36]

In some ways, however, these explorations have only served to highlight apparently intractable artistic problems embedded in both theory and practice. Although abstraction within the long-standing Islamic calligraphic tradition provides endless opportunities for work that might be labeled either "conservative" or "progressive" in strictly formal terms, such work is also easy to (mis)read as narrowly nativistic and ideologically constrained: too doctrinaire and safely Islamic to function as a marker of a truly national and contemporary identity.[37] On the other hand, it is difficult to imagine how an Iranian Abstract Expressionism might be framed so as to give voice to a specifically and recognizably Iranian identity, rather than one that remains "tragic... timeless" and international.[38]

In Iran, the language of post-modern art that uses the figure as its central subject (especially a language that relies on quotation, citation, re-configuration, incongruous or meta-critical juxtaposition, and historical re-visualization) has been used in several ways: to indict the errors of "westoxication" and (more importantly) to leverage an image of identity, in fact a multitude of interpenetrating and overlapping identities, in contradistinction to that comprehensive, monolithic image of identity articulated by the revolutionary Islamic regime. Although this assertion may seem counter-intuitive, it has proved out in numerous post-colonial and non-western contexts; for example, in art from Haiti and across Africa.[39]

36 Keshmirshekan, 94ff. See also his early chapters on Qajar (pre-Pahlavi) and related post-Qajar developments.

37 For any number of examples, some quite elegant and beautiful, see Keshmirshekan, 195-228, "The Development of Traditionalist Trends: Calligraphic Tendencies and Miniature Painting," which also sets these works into a wider "neo-traditionalist" (Keshmirshekan's term) context.

38 This sense of tragic timelessness has in any case become indelibly associated with the definitive American version of Ab Ex, thanks to the notorious 1943 "Statement" by Adolph Gottlieb and Mark Rothko. Herschel B. Chipp, *Theories of Modern Art* (Berkeley and Los Angeles: University of California Press, 1968) 544-545.

39 For Haiti, see Glenn Harcourt, "Junk Yard Angel. Review: *In Extremis: Death and Life in 21st-Century Haitian Art.* Fowler Museum at UCLA, Los Angeles, September 16, 2012-January 20, 2013," *X-TRA Contemporary Art Journal*, Vol 15, No 3 (2013) 66-81. For Africa, Glenn Harcourt, "Continental Drift. Review: *Earth Matters: Land as Material and Metaphor in the Arts of Africa.* Fowler Museum at UCLA, Los Angeles, April 23-September 14, 2014," *X-TRA Contemporary Art Journal*, Vol 17, No 3 (2015) 54-73.

To elaborate on this idea, we will take a single artist as an example: Aydin Aghdashloo (b.1940), who (like a modern Jacques-Louis David) has survived and prospered to the present day, despite his close pre-Revolutionary association with the Empress Farah and her "westoxicated" cultural policies.[40]

During the period prior to the Revolution (pre-1979) Aghdashloo, although clearly a much more knowledgeable student, approached the western canon in a way not entirely dissimilar from that employed by Cumming's anonymous censor. Focusing his attention in particular on fifteenth-century Florence (and artists like Botticelli, Pollaiuolo, and Ghirlandaio), one aspect of his practice consisted of the replication and disfiguration of iconic examples of this body of work. Take, for example, his *In Praise of Sandro Botticelli* (1975). Here, he systematically, carefully, and quite literally defaces Botticelli's *Portrait of a Man with a Medal of Cosimo the Elder* (c.1473–74 and now in the Uffizi) as the portrait of the young man is transferred to the medal that he holds (which thus becomes a commemoration of himself) while a fifteenth-century landscape (cribbed from the view through a window at the back of Ghirlandaio's famous 1490 *Portrait of an Old Man with a Young Boy*) shines through the emptiness left by the absent face: a curious kind of "Magritte effect," where the central void becomes a window-within-a-window, piercing the literal flatness and illusions of the painted canvas.

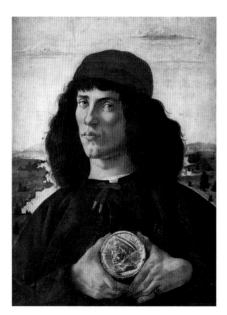

Sandro Botticelli, *Portrait of a Man with a Medal of Cosimo the Elder*, c. 1473 - 74. Tempera on panel, 58 × 45 cm. Galleria degli Uffizi, Florence.

Domenico Ghirlandaio, *Portrait of an Old Man with a Young Boy*, c. 1490. Tempera on wood, 62 × 46 cm. The Louvre.

40 Grigor, 107. Keshmirshekan, 169–171. See also Aghdashloo's website: http://www.aghdashloo.com.

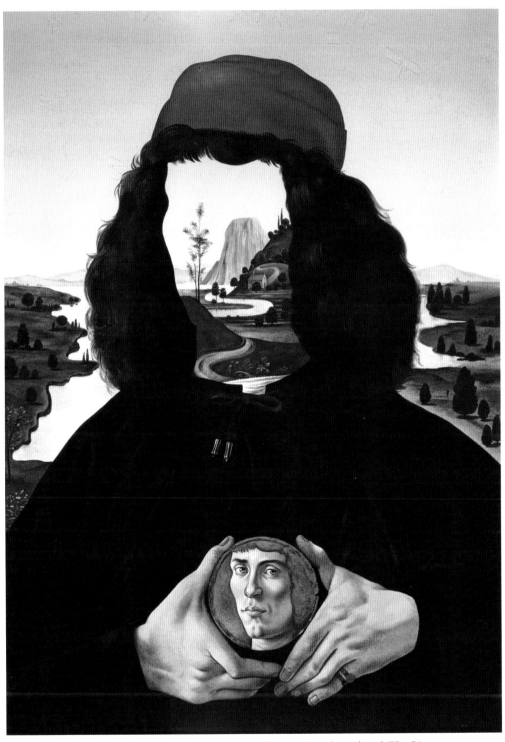

Aydin Aghdashloo, *In Praise of Sandro Botticelli*, 1975. Gouache on board, 75 × 56 cm.
Courtesy of the artist.

In Praise of Sandro Botticelli is part of the series "Memories of Destruction" which to a great extent comprises an extended and fractured homage to the work of these fifteenth-century Italian masters,[41] resonating (at least in this case) with a surrealist tendency to see the painting as a kind of materialized "dream work," as well as offering a cutting edge appreciation of post-modernist strategies of quotation and appropriation.

The painting indeed offers up a critique of sorts; however, its stance on the status of the western canon is, to my mind, at best ambiguous. Seen straightforwardly, pictures like this one may embody a self-conscious distancing from the art of the West precisely because it constitutes a coherent and canonical tradition: they are "memories of [a] destruction" that can only take place as recapitulated and revisualized memory. Yet they may also constitute a backhanded denunciation of the decadence of Iran's own secular cultural and intellectual elites, whose "presence" constitutes no more than an absence or an erasure, an essential emptiness (at best, a displacement, as in "Botticelli's" medal) within a tradition on which they have no claim, and which, conversely, has no claim on them.

Although Aghdashloo asserts in the autobiography provided at his website that he has spent a career "injuring and disfiguring [his] Renaissance paintings," it is still unclear whether his fifteenth-century subjects are in fact those "boastful and pompous creatures, unaware of the cold winter behind their backs" to which he makes reference – indeed, this seems a singularly inappropriate observation especially for his Italian subjects basking as they often do under the Tuscan sun.

In any event, the chronological spread of the pictures across thirty-plus years, beginning during the final twilight of the shah's failing reign – those "final days of carelessness and merriment" to which Aghdashloo refers, make the works as a group difficult to encompass with a singular interpretation. Nevertheless, this painter from an older generation, who confronts iconic western works according to an opaque strategy at once surrealist and post-modern, does share one thing with many of his younger compatriots: a sense of lack or loss. As he himself says, following the Iran–Iraq War he came explicitly to see his art-making as comprising "acts of lamentation, seeking justice," and himself as "the narrator of the injuries conquering the land."[42]

41 In fact, north European artists (notably Jan van Eyck and Pieter Bruegel the Elder) are also represented in Aghdashloo's oeuvre.
42 All quotes are from the artist's website: http://www.aghdashloo.com/?page_id=204.

Aydin Aghdashloo, *Lady in Red*, 1977. Gouache and pastel on board, 77 × 59 cm. Courtesy of the artist.

Aghdashloo's complex process of appropriative distancing and denunciation is perhaps brought home most forcefully in a beautiful 2009 diptych entitled *Mors-Vita* (Death-Life).[43] The work itself comprises two faux-fifteenth-century bust length portraits of the same young woman. She stands rigidly behind a parapet facing in profile to the left, and is seen against a rich blue Renaissance backdrop [image not available]. This rigid profile view is often used as a Renaissance commemorative marker, where the intention is to memorialize a dead spouse or other deceased family member. Although the picture does not seem to be a copy of any specific portrait, its most well-known precedent might be Ghirlandaio's posthumous *Portrait of Giovanna Tornabuoni* (c. 1490), who died in childbirth in the year her portrait was commissioned, although the embroidery on her sleeve, as well as her hairstyle, echo other more-or-less contemporary profile portraits from the Pollaiuolo workshop. The actual profile of the "sitter" has the delicate stylized beauty which gives this whole body of "Renaissance" works a kind of family resemblance; while each panel of the pair is inscribed in gold in a fine Renaissance script, one (on the left) "MORS" and the other "VITA."

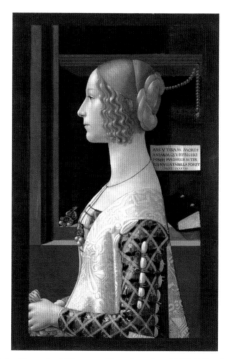

Domenico Ghirlandaio, *Portrait of Giovanna Tornabuoni*, c. 1490. Mixed media on panel, 77 × 49 cm. Museo Thyssen-Bornemisza, Madrid.

43 The *Mors-Vita* diptych was auctioned at Christie's on October 27, 2009, for a gavel price of $86,500.

Finally, the face of the sitter in the left-hand ("MORS") panel has been scribbled out with a series of ocher-umber-brown strokes as if to indicate that identity itself (even an entire tradition of representing identity) is "erased" either by death, or by the passage of cultural and political time.

Meanwhile, in the [illustrated] "yellow version" the right-hand face (presumably to be associated with VITA) is blacked out, but apparently not as an act of *faux* censorship or defacement. Rather, the area of flat blackness that replaces the figure's head seem to open up onto an infinite celestial darkness, as if to say that *this* model's identity has been somehow lost in transcendence (or in translation).

A comparison between this and other work from the same period shows a profound dissimilarity between Aghdashloo's defacements and the work of the anonymous censor. The former does not seem to be concerned with the low scooping necklines and evident décolletage, or the uncovered hair of his as-if sitters. It is again and again their individual physical features, their markers of personal (as opposed to social, ethnic, or religious) identity that have been replaced, marked or scratched out. This suggests a comparison with Joseph's re-working of Manet's *Olympia*, which displays its own savage, identity-destroying disfigurement. For Aghdashloo, however, there is no strategy of gender politics motivating his hand: images of both men and women suffer the same fate. However, it is just as clearly not the western tradition as a whole that is under attack here. Aghdashloo's meticulous painting style, as well as the evident appreciation for that tradition which is notable in his early education as an auto-didact and copyist, suggests rather quite the opposite, as does the tone of the prose in his website autobiography taken as a whole.

Nevertheless, Aghdashloo's autobiography, at least in my opinion, holds the key to the puzzle here, in a piece of almost off-hand advice given to the young artist as he worked on a commissioned copy: that "[copying the work of another] is no more than a futile exercise and [...] that a true work of art seeks a goal dictated by the artist's own actions and experiences."[44] That is, that a "true work of art" expresses (in this case) the individual identity of the artist and not the identity of any other. Thus it is not the fifteenth-century Italian style of Botticelli, for example, that fails to serve the artist's ultimate end. It is the fact that a portrait by Botticelli perforce carries an Italian, not an Iranian identity, indeed: it carries the identity of Botticelli rather than that of Aghdashloo, an alien or "invasive" identity that must somehow be exorcised before the artist's work can become, on its own, "authentic."[45]

44 http://www.aghdashloo.com/?page_id=204.
45 For Aghdashloo, the notion of an "Iranian identity" is clearly, if complexly, entwined with particular sense of his own individual identity.

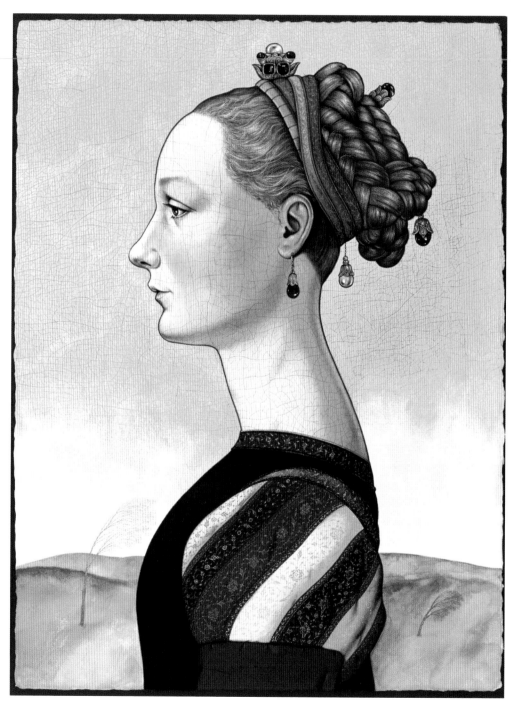

Aydin Aghdashloo, *Mors - Vita*, 2009. Gouache on card, diptych, each 77 × 59 cm. Courtesy of the artist.

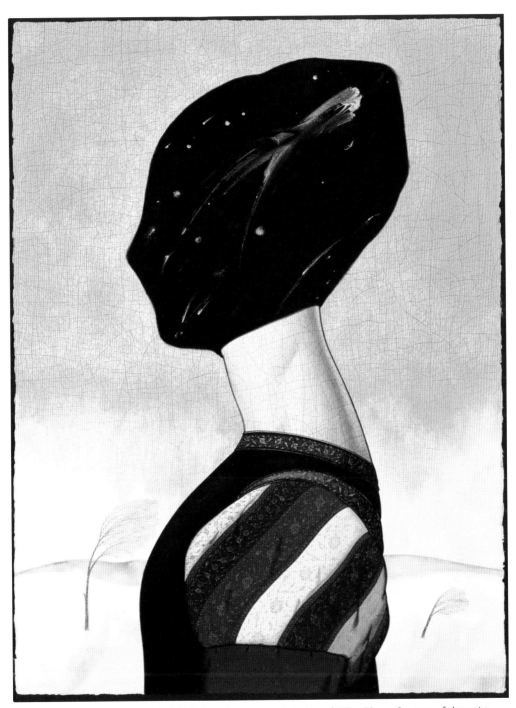

Aydin Aghdashloo, *Mors – Vita*, 2009. Gouache on card, diptych, each 77 × 59 cm. Courtesy of the artist.

Yet Aghdashloo's sense of Iranian identity with its strategy of entwined appropriation and distancing does not define only his relationship to the western tradition. His gallery of "Occidentals" is matched by a parallel series of "Orientals" which, although in a somewhat different way, also seems to signal a deep ambivalence about "his own" artistic tradition.

A beautiful example from the series "Memories of Destruction" (2012) shows, against a broadly modeled but abstract background, a shallow bowl of a type known, in the west, to most anyone who has taken an Introductory Art History course as an iconic example of "Islamic art": the bowl is white, its center decorated with a calligraphic interlace, its rim decorated with a very simple yet elegant calligraphic inscription in Arabic (such inscriptions most often record Koranic verses, although Arabic proverbs are also common). However, as the bowl falls through what seems to be an infinite space, it begins to break up, rather like a satellite reentering Earth's atmosphere. In more immediately relevant terms, it seems to signal the disintegration of a tradition that stretches deep into the Islamic and perhaps even the pre-Islamic Persian past (the ceramic in the picture here probably dates to roughly the 10th century CE).

Aghdashloo also employs a similar strategy in his extended series of works that show Persian miniatures that have been crumpled, are depicted torn and falling like his broken bowl, or appear as to have been partially burned. These begin at least as early as the *Crumpled Miniature* (1980), where a burnt out match appears lying in front of the damaged sheet. There is minimal use of cast shadow, hardly enough to establish a sense of floor and wall; but suspended "in space" above the delicate yet crumpled painting, there hangs a ghostly "X" – barely visible. It might almost be a sign that the work (and the tradition for which it stands) have been "placed under erasure" by the nascent Islamic Revolution. These crumpled, torn, burned, and falling miniatures continue to appear at intervals until at least 2010; and as if to reinforce the idea that, unlike the 15th-century Italian reworkings, they convey a sadness at the loss of what we can perhaps read as a profound and "deep" Iranian identity, the subjects of the miniatures can almost always be identified as "falling angels." Clearly, something more personal, even spiritual, is at stake in these elegiac works than the forsaking of a purely *artistic* identity.

Aydin Aghdashloo, *Memories of Destruction*, 2012. Gouache on board, 100 × 75 cm. Courtesy of the artist.

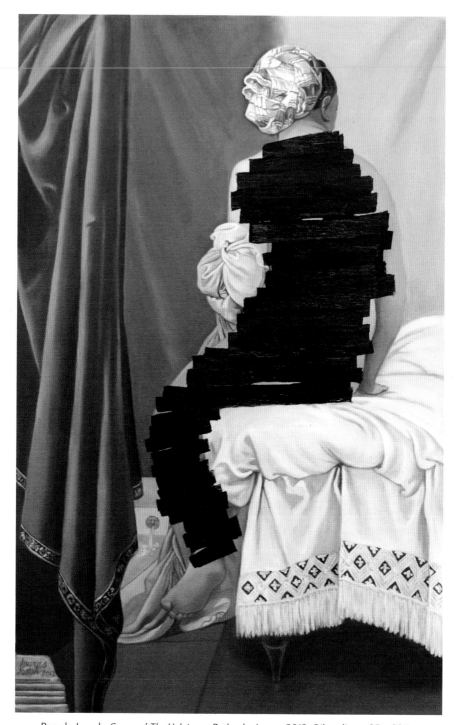

Pamela Joseph, *Censored The Valpinçon Bather by Ingres*, 2012. Oil on linen, 35 × 22 in.
Courtesy of the artist.

CONSTRUCTING IDENTITIES

If we can allow the act of appropriation itself to hold a kind of privileged status as a means of "bracketing" or "suspending" opposing ideologies, then rich meanings can be drawn from an artist's intention to reform a prior masterwork and move it toward a postmodern comment on the conditions under which cultural production occurs.

For example, doubling back again to the touchstone of Joseph's works: because of their particular "prehistory," it is possible to read her paintings either in relation to the post-classical western artistic tradition and its on-going reliance on the nude (and especially the female nude) as a centrally important subject, or in relation to the situation of contemporary Iranians in general and/or to post-modern techniques of contemporary Iranian artists in particular. There is clearly a complicated "global – local" dialog underpinning the "CENSORED" paintings, and also a set of resonances that connects Joseph's personal history (both as an artist and a [western] feminist) to the development of feminist ideology and feminist artistic practice with which she has been intimately involved since the 1970s. The relationship between "Iranian" and "western" or "global" feminism is itself to a certain extent fraught – not least by a secular western orientation that is sometimes taken to preclude the idea of an indigenous or Islamic Iranian feminism, which several scholars have argued exists in a separate space that is both informed by and running counter to western feminism.[46]

It would indeed be ideal if all of these conflicting readings and competing feminisms could be "superimposed" on one another; but this is not necessarily the case – they are in a sense like oil and water, and if held together, must also be held separately and apart. The central act of censorship in Iran that produced the American artist's "subjects" plays quite differently than the scenario under which the censored versions were (re)produced. Indeed, that identical act of originating censorship identifies real constraints on Iranian cultural production. Nevertheless, despite these apparent incongruities, it may be possible to keep all of these realities in mind simultaneously for the sake of our argument.

Like Prof. Schroedinger's notorious cat, the censor's original intention is at once both "dead" and "alive" until its status is resolved by a conscious choice on the part of the artist, viewer, or critic. In a sense, both Joseph and Aghdashloo have produced works that share a sense of "deep (cultural) history," and that probe the particulars of the cultural traditions out of which

[46] For a summary of the theoretical and political issues involved, see Nima Naghibi, *Rethinking Global Sisterhood: Western Feminism and Iran* (Minneapolis: University of Minnesota Press, 2007).

their own work grows. Both also critique but finally extol the efficacy of resonating in some way with those traditions as a means of investing contemporary work with a sense of personal and community-based identity. For Joseph, that community is grounded in gender, for Aghdashloo it is (presumably) the community subsumed under the term "Iranian," even if it is not quite clear what particular meaning might be entailed by that rather general term.

For women artists in Iran today, and indeed for some of their male compatriots, such forays into theoretical physics are a bit beside the point. The challenges they face are immediate and substantial, both as artists and (more fundamentally) as people living in a country that has been isolated from the world post-revolution, and where western sanctions have imposed a heavy toll on daily life. Daryoush Gharahzad's *Untitled* (2012; acrylic on canvas, 160 × 150 cm – from the "Identity Series") provides a kind of shorthand guide to the complexities of contemporary life among young Iranian women through the taxonomy of clothing, which ranges from the full and quite concealing chador to hip couture. Executed in Warholesque colors, twenty-three smallish figures are individually isolated or arrayed in groups of two or three against a roughly applied light-grayish background, reminiscent of a concrete wall with wheat pasting, a pictorial strategy that gives the whole a decidedly diagrammatic feel.

The point of view from which Gharahzad (b.1976) "speaks" is that of a generation that has essentially known no Iran save that of the Islamic Republic; compare, for example, Aydin Aghdashloo (b.1940) whose lived historical experience must almost certainly extend back to the time of secular and social-democratic dreams embodied in Mohammad Mosaddegh. Aghdashlooo thus perhaps has the luxury of reflecting on deep cultural time and slowly developing traditions. He can also (again perhaps) envision an Iranian identity that somehow transcends both Persian and western artistic histories; and he has certainly earned the success to do so. An artist like Gharahzad, on the other hand, embodies something more pressing and immediate, an engagement with post-revolutionary Iranian culture as it exists today, a fascination with cultural currents, and a vision of "the street" where the ever-present graffiti creates the sense it could just as easily be located in contemporary Paris or Berlin or New York as it could on the streets of Tehran.[47]

Regardless of their mode of dress, Gharahzad paints his female subjects as displaying a pronounced reticence. Most are turned away, some as if

[47] This interest in and engagement with the currents of globalized cultural immediacy, in which can be seen (among other things) a profound denial of history, is certainly what Aghdashloo alludes to in his reference to a contemporary cultural practice marked by what he refers to as "crumpling and throwing away": http://www.aghdashloo.com/?page_id=204.
Both "the street" and the inscribed wall are key concepts for Khosravi's analysis. For the street in general, see Khosravi, 121–171; for the wall and its graffiti, 172–190, including discussions of the work of contemporary Tehrani street artists A1one, NAFIR, and Black Hand. See also Figs. 1–3.

Daryoush Gharahzad, *Untitled (Identity Series)*, 2013. Acrylic on canvas, 160 × 185 cm.
Courtesy of the artist.

merely by accident, others with heads bent over or turned aside as if to avoid eye contact. Some of them in sunglasses, or striking poses, embody a pop sensibility of "urban cool."

These representations are even more pronounced in Gharahzad's works from the "Identity Series" in 2015. Graffiti and simple street art are scattered about the compositions, the apparently random marks of an urban presence. Among them are figures, all women wearing the hijab. What marks them all is their utter and absolute anonymity. Each and every one is different in terms of how they dress, how they stand at ease, how they carry their bodies, how they express their engagement with the urban space. They are clearly individual women, but with living personalities effaced or hidden. The faces that do appear look elsewhere than at the viewer. Eyes concealed by sunglasses, their expressions are completely without affect. Yet they have an eerie anonymous presence within the narrow foreground space, which also seems to confine them by literally cutting them off at the feet.

Daryoush Gharahzad, *Untitled (Identity Series)*, 2015. Acrylic and oil on canvas, 150 × 180 cm.
Courtesy of the artist.

Daryoush Gharahzad, *Untitled (Identity Series)*, 2015. Acrylic and oil on canvas, 140 × 160 cm.
Courtesy of the artist.

Daryoush Gharahzad, *Girl with Red Scarf*, 2010. Acrylic and oil on canvas, 155 × 160 cm.
Courtesy of the artist.

The effect of the figures is distinctly unnerving for a western viewer. In art-historical terms it might be possible to use the work as an exemplary deconstruction of the category "portrait," but the point seems more pressing than that: perhaps a meditation on the interplay between presence and absence that resonates with a hostile and deeply depersonalizing urban environment. The paintings do not assign blame for this situation; they are only "political" in a tacit and tangential way. But they clearly define at least one aspect of the contemporary Iranian situation: a masking of the body through the national dress code that is at once in part arbitrarily enforced, in part self-employed as a kind of camouflage or resistance to the norms of prior "west-toxicated" generations.

For quite a different view, see Gharahzad's 2010 *Girl with Red Scarf*,[48] who, despite, or in part because of the de rigueur sunglasses and negligently yet fashionably worn headscarf, confronts us with an apparent self-assuredness and ease. Although different in virtually every other particular, that gaze, even if occluded by the dark lenses, almost inevitably within our specific context suggests Manet's *Olympia* and that model's ability to project herself as an ostensibly real and living presence into her own specific and particular world.

48 Roya Khadjavi Heidari and Massoud Nader, *Portraits: Reflections by Emerging Iranian Artists* (New York: Rogue Space Chelsea, exhibition catalog 2014) 33.

In Bahman Ghobadi's exuberant 2009 pseudo-documentary *No One Knows about Persian Cats*, we can trace the tribulations of one real-life spiritual relative of Gharahzad's *Girl with Red Scarf*, Negar Shaghaghi, who, with her *mojaradi* "companion" Ashkan, takes the audience on a frenzied tour of Tehran's underground music scene in pursuit of the band and the documents they need to "escape" to London, where they hope to crack the "indie rock" scene. Although the film was shot in Tehran during the reactionary presidency of Mahmoud Ahmadinejad, it presents a powerful portrait of a youth culture driven to articulate a viable identity that is at once specifically Iranian and yet part of a universal youth/music culture, as well as to stay one step ahead of the ever-present authorities for whom their entire lifestyle is anathema. Negar, in particular, is a passionate and empowered presence, an utterly sympathetic young woman enmeshed in a life and a dream that are equally criminal in the eyes of the regime.[49]

No One Knows about Persian Cats, written and directed by Bahman Ghobadi, 106 min., Mij Film Co., 2009. Movie poster.

49 *No One Knows about Persian Cats*, DVD, Directed by Bahman Ghobadi (Iran: mij film, 2009). The film won the Special Jury Prize *Un Certain Regard* at the 2009 Cannes Film Festival. Negar and Ashkan eventually made it to London, where they performed as the (banned in Iran) duo Take It Easy Hospital. Another of the film's featured real-life performers, Hichkas (Soroush Lashkary), the "godfather of *rap-e farsi*," is the subject of an extended study in Nahid Siamdoust, *Soundtrack of the Revolution: The Politics of Music in Iran* (Stanford: Stanford University Press, 2017) 235–262. The book as a whole provides an essential background for this aspect of contemporary Iranian youth culture. The filmmaker Bahman Ghobadi (b.1968) continues to make topical and controversial films that make him a persona non grata in Iran with dual themes of pop music and ethnic tensions in his birthplace of Kurdistan.

No One Knows about Persian Cats, written and directed by Bahman Ghobadi, 106 min., Mij Film Co., 2009. Film.

If Gharahzad is interested in visualizing women as sympathetic and resonant surrogates for the general state of contemporary Iranian culture – that is, the state of the contemporary youth culture as it is played out especially on the streets of Tehran – women artists, film directors, and other cultural producers similarly re-figure observations like his through their work, which expresses a sense of their own lived experience. How that experience can be used as a means of identity construction is grounded in a specifically Iranian struggle that nevertheless takes place within a globalized and historicized arena.[50]

These women artists, and the women in their works, are not "surrogates" for anything. Gharahzad's *Girl with Red Scarf* instantiates clear ideas of identity, freedom, fashion, desire; and she presumably has a particular, personal identity. Nevertheless, in the painting she remains a kind of stand-in for the actors in a still unfolding history, where identity construction, both individual and communal, has political currency and carries with it the seeds of social change and the real possibility of personal danger.

In sum, we must remember, at this point in our argument especially, that the works of the artists here under discussion, as well as those produced by the women to whom we will now turn, share the following characteristics.

50 For relevant background, see Keshmirshekan, 272–276, his cited references, and, particularly, his illustrations.

First and most importantly, they stand (even, at least in theory, militantly so) against the imposition of state-imposed identities intended to inculcate conservative religious, national, and cultural ideologies, although this is not to say that they are necessarily or radically secular. For them, there are, indeed, Muslim feminists.[51]

Second, their work also potentially runs counter to the discussion of "Iranian identity" raised by artists discussed earlier in connection with explorations of the deep (pre-Islamic) history of Iranian culture. Thus, they question both the appropriate relationship of contemporary Iranian art to the art of Iran's own historical past, and to that of the (hegemonic) western artistic tradition. Yet these questions may well be raised pictorially in ways that appropriate and re-purpose the historical past, as well as the artifacts and structures of globalized or hegemonic western culture.

And finally, following the well-known cultural critic Homi Bhabha, we need to see the work of Iranian women artists as potentially having a disruptive effect on pigeonholing attempts by scholars or curators both western and within Iran itself to establish apparently strategic group identifications or gender solidarity: "Despite shared histories of deprivation and discrimination, the exchange of values, meanings, and priorities may not always be collaborative and dialogical, but may be profoundly antagonistic, conflicting and even incommensurable."[52]

51 Keshavarz, 8: "I am a Muslim, a feminist, a literary scholar, and a poet[.]" See also Staci Gem Scheiwiller, "In the House of Fatemeh: Revisiting Shirin Neshat's Photographic Series *Women of Allah*," in Staci Gem Schweiler (ed.), *Performing the Iranian State: Visual Culture and Representations of Iranian Identity* (London: Anthem Press, 2013) 201–220. This wide-ranging and fascinating book contains essays covering the whole of recent Iranian history from the Qajar Dynasty to the post-revolutionary diaspora.
52 Keshmirshekan, 277. This same antagonism can also be played out in terms of the search for an individual identity, especially by "children of the diaspora." See, for example, Azadeh Moaveni, *Lipstick Jihad: A Memoir of Growing Up Iranian in America and American in Iran* (Cambridge, MA: Public Affairs/Perseus, 2005). For a broader context, see the discussion in Keshmirshekan, 270–308, under the heading "Contemporaneity Versus Questions of Cultural Specificity," as well as Keshmirshekan's quoted interview in Tara Aghdashloo, "Notes on Women in Iranian Art," February 27, 2014: http://www.ibraaz.org/reviews/54.

In order to get some idea of the existential issues in play here, consider, for example, the brutality referenced in Simin Keramati's work.

The starkly physical metaphor of a run-away nosebleed in the serial set of images *I am not a female artist from [the] Middle East in exile, I am an artist* (2014),[53] presents a simple, yet stark and powerful visualization of the complexities referred to by Bhabha. Here, the slowly accumulating trickle of blood can be read as the artist's own view of an ongoing commentary about her own work, with its attempts to pin down her psychological and existential experience using a succession of categories: "female," "exile," "Middle East." Only in the final image, when the flow of blood has stopped and the artist enjoys a casual cigarette, can we catch the sound of her own self-identification "I am an artist."

But what exactly does that assertion mean in this case? The blank stare, the bloody smile and blood-stained face are vaguely threatening; they may even suggest the kind of satisfied satiety that marks the visage of the vampire at the end of a successful feeding.

The thematics of the vampire story are deeply entwined with issues surrounding sexuality; as well as a complicated interpenetration of ideas of passivity and agency (both sexual and existential: the vampire – of whichever sex – is a powerful and aggressive sexual predator, but one whose agency is severely constrained by external factors). Thus Keramati can be seen here as an initially passive victim "turned," as it were, by her own artistic efforts; and in that sense it might be possible to understand her persona as related to those seen recently in a series of films that center on the power of the female vampire. Obviously relevant here is Ana Lily Amirpour's *A Girl Walks Home Alone at Night*; however, we can also cite the brilliant Swedish "coming-of age" film *Let the Right One In* (2008) as well as its English-language "clone," and the 2013 *Only Lovers Left Alive* with Tilda Swinton's tour-de-force performance.

In addition, as far as we can tell from the sequence of stills, Keramati's video seems to provide us with a glimpse of the artist's radical self-transformation. From an impassive and "wounded" visage across which the blood of the nose-bleed runs unimpeded, she transforms her face so that it displays a circumspect confidence. This sense of activity is apparent despite the bust-length format of the shot, and at the appearance of the cigarette, long time emblem of the thoroughly "modern" and independent woman, she seems to draw nourishment from her own blood. To say the least, this is a radical transfiguration, elegantly accomplished and using a minimum of carefully chosen means.

This work also takes up themes of staining, violence and projection from Keramati's 2012 video *Biopsy of a close memory*.[54] Beyond the grossly ironic understatement of the title (the "operation" Keramati illustrates could hardly be more removed from a clinical "biopsy," where living tissue is removed from

53 http://www.siminkeramati.com/gallery_26.html.

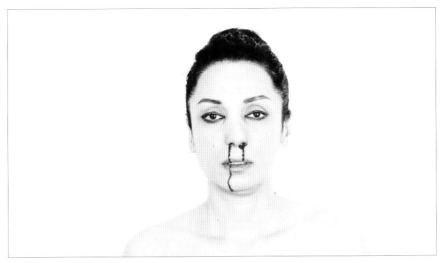

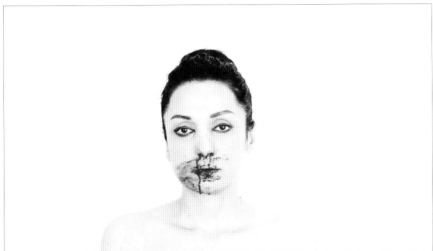

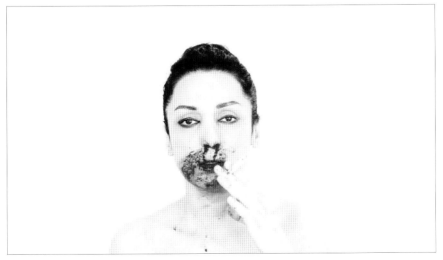

Simin Keramati, *I am not a female artist from [the] Middle East in exile, I am an artist*, 2014. Video stills.
Courtesy of the artist.

a body to examine it for disease), the video constructs a narrative of bloody, horrific violence, the object of which is the (literal) defacement of the young woman, presumably the artist herself, depicted bust-length in the images.

The explosion of red across the face and upper body of the subject dressed and scarved in pure white suggests violation of the basest sort; its resonances for a western viewer are unmistakably sexual (as, for example, in the violation of virgin purity) while its literal effect appears at the very least to be of humiliating debasement of the body and a stark transformation from subject into object. The video unfolds dramatically yet with utter simplicity as the explosion of red begins in a targeted way toward the (closed) eyes but soon disperses, while the head (originally seen erect and fully frontal) turns toward the left. The figure's affect thus transforms from actor bracing for impact to endurance of the kind familiar to anyone who has seen contemporary performance art. Not even Joseph's defacement of Manet's Olympia suggests this level of violence to the figure, an effect enhanced by the use of video with its documentary overtones.

Keramati herself has connected the piece to the memory of all the "massacres"[55] and "wars" to which she has been exposed by the media virtually throughout her life.[56] She mentions explicitly the Iran–Iraq War, "the massacre on the streets of Tehran in 2009" [the government's quite brutal suppression of the Green Movement uprisings following the election of President Mahmoud Ahmadinejad], as well as wars and massacres in the Balkans (Bosnia and Serbia), Somalia, Afghanistan, Iraq, and Syria. This gives the work a distinctly political dimension as these are all predominantly Muslim communities – many of which have suffered from civil wars, internal repression, externally orchestrated bombing campaigns and drone strikes, crimes against humanity and genocide – and reinforces the way that the artist uses her own physical body as a surrogate for the pain of reiterated physical and psychological trauma Muslims have faced.

Given the impact of even mediated exposure to actual rather than computer-generated cinematic violence, and in particular its potential link to heightened levels of anxiety, including PTSD, the cathartic and/or therapeutic potential inherent in a work like Biopsy seems evident. However it might look to me, Keramati's video is not a mini-American horror film; and in this sense it is much more immediate in its approach than the somewhat later I am not a female artist ... It is, rather, an agonized cri de coeur, a protest at the prospect of being a woman living always already in a region prone to violent conflict.

54 The short title, Biopsy is given in Keshmirshekan, 276–277, caption to ill. 5.69; the longer version is from Keramati's own English language website, http://www.siminkeramati.com/gallery_23.html, which also gives a more extensive sequence of stills.
55 As we have recently seen so vividly, for example in Aleppo, the enormity of the suffering encompassed by the collective term "massacre" necessarily comprises a multitude of individual sufferings.
56 "It is all about war and massacre that happens in the war. War between nations, countries, religions and ideologies. [...] Ever since my childhood I have witnessed so many wars on the news." http://www.siminkeramati.com/about.html.

Simin Keramati, *Biopsy of a close memory*, 2012. Video still. Courtesy of the artist.

A similar point can be made when considering Tanya Habjouqa's 2009 series "Women of Gaza,"[57] which takes place against the 2008–2009 Gaza War and the political ascendancy of the Iran-supported Hamas Party. Habjouqa (b.1975) is not in fact Iranian. She was born in Amman, Jordan, was educated in the United States, and spent time in Texas documenting the plight of Mexican migrants before returning to the Middle East. Winner of a 2014 World Press Photo Award for her series from the West Bank, "Occupied Pleasures," she has focused on gender and human rights issues and spent time in Israel/Palestine trying to find ways to communicate the "absurdity and real politic," and even "humor" of daily life in the region.

Her pensive study of a young woman sitting on a park bench in full niqab (the black, ankle-length garment which leaves only the eyes of the wearer visible through a narrow slit) can be counterposed to Keramati's work in that it is continually apparent that qualities of identity, individuality, and humanity are hard to efface entirely. Despite her niqab, the woman's whole pose, her body language as she sits slightly pigeon-toed and with folded arms at the very edge of the bench, the wary glance of her eyes, even the wonderfully bright little stuffed teddy bear attached to her massive purse, gives her a presence that is quite independent of religious ideology (the artist herself states that she is not a proponent of the niqab but sees her own "resentment" as something she challenges in her photographs[58]). Indeed, the insistent presence of the eyes, difficult as they may be to see at first glance, makes Habjouqa's student resonate in a curious way with the model for Manet's *Olympia*, whose commanding gaze is also the motivating force behind the sense of presence conveyed by a body that, in superficial terms, could not be more different.

Thus the picture itself strikes a delicate balance between cultural criticism and poignant, humane portraiture. On the one hand, it might be hard for many (especially western) viewers to see anything other than an indictment of enforced gender segregation and marginalization: Could the student be any more isolated? Could she take up any less room on the bench? However, the context of the surrounding conflict and the important idea of the woman's agency in seeking out a quiet contemplative space are necessary to consider, just as much as the photographer's composition, with its careful yet unobtrusive balance and its delicate interplay of greens, grey, and white. What potential does the bench hold to be populated with still- or now-absent figures, and how does the background and shelter of the trees resonate with the woman's clothing?

57 The "Women of Gaza" series was also shown in the exhibition *She Who Tells a Story*, and Habjouqa's work is discussed in the catalog. See 111–117. For this particular image, Ibid., 113, ill. 73.
58 *She Who Tells a Story*, 112. Habjouqa has tackled some marginal or openly transgressive subjects: Middle Eastern women who drive race cars "Ladies Who Rally" [2011] and drag queens in Jerusalem "Jerusalem in Heels: Transsexuals of the Holy Land" [2005–06]. Like "Women of Gaza," however, much of her work grows out of her daily experience in strife-torn locales also including Lebanon and Syria.

Tanya Habjouqa, *Untitled (Women of Gaza)*, 2009. Photograph. ©Tanya Habjouqa / NOOR. Occupied Palestinian Territories, Gaza, Gaza City, October 18, 2009.

We care about the answers to such questions not so much because the photo's subject is exemplary of some larger class of women who wear the niqab, but because she is so clearly also and already a particular young woman. There is a politics behind the portrait, and a complex one at that: the world of Gaza under the control of the corrupt Hamas government, a land desolated by war, isolated economically by Israel, and yet still besieged both from within and without. And yet for all that informs the scene, that politics remains insufficient to "explain" the picture and elucidate the interiority of the woman enshrouded within the cocoon of the niqab, whose being still leaves its traces on the surface of the photo.

Of the entire series to which this single image belongs, the photographer states: "2009: Gaza is a difficult place for women. The siege not only affects the economy, but the most basic of dreams and space to simply be. [...] Life continues, and so do the traditions and self-respect – a resistance to letting suffering be the standard definition. [...] How do the women of the Gaza Strip bring up their families and attempt to live normal lives? This work goes beyond the stereotypical depictions, exploring their lives as they work, rest, and seek moments of freedom wherever they can find it."

Another potent image from the series [not pictured here] is a three-quarter-frame portrait of a woman wearing a niqab and carrying her video camera. Like Haji in Makhmalbaf's *The Marriage of the Blessed*, she is as much a fearless documentarian and eye of her own culture, using her camera toward political ends, as one who is being observed by the photographer and her audiences. On a lighter note, in another of Habjouqa's images [not pictured here], an English Literature student in a rose-colored hijab takes a smartphone picture, perhaps of Habjouqa but perhaps a selfie, while a woman in a niqab in the background looks on. The photographer catches the expressive, happy

face of the young woman, perhaps looking at herself or her audience with whom the photo will be shared.

Clearly, in both the West and elsewhere in the world, religious, cultural, political, and feminist ideologies all form the backdrop to women's various practices/interpretations of Islamic modesty, as do competing ideas of identity, freedom (both of choice and of action), morality, and appropriate social interaction (to provide a suggestive if incomplete list). For example, the Egyptian feminist Nawal El Saadawi has characterized the application of makeup as an exercise in female identity construction that is similar to the wearing of the hijab or niqab.[59] Indeed, the Yemeni artist Boushra Almutawakel (b.1969) reports that hearing El Saadawi make precisely this claim in a lecture was a defining moment in her photographic career.[60]

Almutawakel's much reproduced *Mother, Daughter, Doll* (2010) uses a sequence of "identical" photographs to explore the changes in presence, apparent, or expressed identity in three figures (including a doll) during a process of progressively more complete veiling, culminating in a virtually complete effacement. In fact, nothing at last remains other than the black backdrop.[61] In some ways Almutawakel's work is a kind of experimental cultural anthropology. She states, "I wanted to explore the many faces and facets of the veil based on my own personal experiences and observations: the convenience, freedom, strength, the power, liberation, limitations, danger, humor, irony, the variety, cultural, social, and religious aspects, the beauty, mystery." For Almutawakel, advocacy or critique are tacit and respectful of cultural norms, yet the cases of how the hijab and the niqab are used throughout the Muslim world and the West are important and pressing for her, even in conservative Yemen where changes, for example, in allowable public dress are not likely any time in the near future. Almutawakel states: "I don't feel comfortable without [the veil] in many places in Yemen. This is a highly segregated society in which men don't have much interaction with women, though that is changing in the cities. It is advantageous and empowering in some ways as it protects and privatizes the woman's body."[62]

Mother, Daughter, Doll also documents a performance of identity. The progression of images suggests ways in which Almutawakel, in different frames, meets or confounds the expectations of portraiture much like Gharahzad. Starting with the top-left image where Almutawakel and her

59 Nawal El Saadawi (b.1931) is an Egyptian feminist, physician, psychiatrist and author whose writing and activism, and particularly her implacable stance as an opponent of female genital mutilation, are by now legendary. The following provide an excellent thumbnail introduction to her voluminous published work. For her work as a feminist and social critic: Nawal El Saadawi, *The Hidden Face of Eve. Women in the Arab World* (London/New York: Zed, 1980/2007). For her (equally harrowing) literary output: Nawal El Saadawi, *Woman at Point Zero* (London/New York: Zed, 1975/1983/2007).

60 The anecdote is reported in *She Who Tells a Story*, 43 and El Saadawi's position is adopted by the artist in "Challenging the Norm: Q+A with Boushra Almutawakel," *The Economist*, August 16, 2012: http://www.economist.com/blogs/prospero/2012/08/qa-boushra-almutawakel. The iconic *Mother, Daughter, Doll* series (2010; part of the larger *Hijab* project) is illustrated, Ibid., 45–49.

61 All images discussed in this section can be found at the artist's website: http://boushraart.com.

62 *She Who Tells a Story*, 44.

Boushra Almutawakel, *Mother, Daughter, Doll* (The Hijab Series), 2010.
Digital photographs, 40 × 60 cm each. Courtesy of the artist.

daughter are smiling and engaging, the series of self-portraits progresses gradually to a withdrawal into expressionless visage and then to the disappearance of the face entirely behind a full veil. This sequence has been positioned in western exhibitions along with Almutawakel's statement against what she calls "excessive" covering, especially of children. However, within the context of this study a different statement about representation is being made clear: how the body as central subject of "understanding" in the western tradition is, when hidden, a confounding matter for the western gaze. Indeed, it is true that in the western tradition the visual trope for "uncovering the truth" – VERITAS FILIA TEMPORIS, "Truth the Daughter [Unveiled by] Time," as the classical tag line goes – involves the unveiling of a naked woman; this is also, incidentally, the fundamental structure of Duchamp's *Large Glass* (1915–23). In the final frame of Amutawakel's series, the "erasure" of the figures confronts the category "portrait" seen as a revelation of inner being by means of its inversion of the trope that "truth" equals "uncovering."

"The Hijab Series," viewable on Almutawakel's website challenges cultural assumptions further with a sequence of double portraits where a man and a woman switch gender roles by means of a simple "hijab swap." The work was well-received in Yemen by some, but not all. Her multiple studies in this series of a pair of eyes "speaking" through the slit of a full niqab are also illuminating, as is a different series, "Hands," in which she focuses on similarly nuanced expressive possibilities for work, pleasure and play (with both men's and women's hands) that do not require a reading of the full body.

For an Iranian pendant to Almutawakel's *Mother, Daughter, Doll*, it is hard to imagine a better candidate than Gohar Dashti's *Me, She and the Others* (2009) [images not available].[63] Like *Mother, Daughter, Doll*; *Me, She and the Others* explores putative changes and continuities of identity attendant on degrees of "veiling," here involving only the hijab and the chador, but the strategy is rather different. Dashti's piece comprises a series of triple portraits in which the same woman presents herself as she would normally be dressed "at work," "at home," and "out in public." The pictures thus belie mere possibilities; rather, they instantiate day-to-day actualities, and thus visualize the same transformations in appearance that run as a leitmotif through Azar Nafisi's *Reading* Lolita *in Tehran*, as Nafisi and her students attend university, socialize (or demonstrate) in public, or relax in Nafisi's apartment, which has become a sanctuary home-away-from-home for a heterogeneous "family" of readers, thinkers, and political activists.[64]

At the same time, however, these are quite decidedly not narratives of life, at work, at home, and out in public. Rather, they comprise a kind of catalog of the kinds of dress characteristically associated with being in these

63 Gohar Dashti's works can be seen on her website: http://gohardashti.com.
64 There is, of course, one obvious difference: Nafisi's report is grounded in memories of the past, its "reality" is historical or archival; Dashti's work records an almost immediate present grounded in the lived experience of her subjects.

various social and cultural arenas. The portraits are taken in a full frontal, slightly over half-length format with the figures standing against a flat black background. The poses are relaxed, but without any particular affect – they are perhaps reminiscent of how one might stand to have a driver license photo snapped: the faces are easily recognizable, but with frontal gaze and uninflected expressions, they are essentially emotionless personal presences. In addition, the photographer seems to take no overt stance with respect to the desirability of the general cultural state of affairs that is depicted in her photographic record, but rather acts as a documentarian.

Like Habjouqa and Almutawakel, however, Dashti's aim is made clear by the statement that she includes with the images. This oblique commentary is also a presentation of daily life at the time the photographs were taken: "*Me, She and the Others* documents women born in Iran after the Islamic Revolution. I have photographed these women in three distinct contexts: (from left to right) at work, at home, and out in society. Despite being obliged to adjust their appearance in certain environments, women remain an influential presence in Iran's culture."[65]

To a certain extent, this formulation supports the conclusion drawn by Keshmirshekan at the end of a thoughtful and nuanced discussion of the issues in play for contemporary Iranian artists (in particular, the "revolutionary" generation born since the late 1970s, whose social and cultural reality has been mediated throughout their lives by the overweening presence of the Islamic Republic): "While experiencing profound yet contradictory changes in the social and cultural spheres, and [while] religious ideology and revolutionary fervor remain the culture of the state,[66] this younger generation – the majority of the Iranian population[67] – appear neither very enthusiastically revolutionary nor very ideological."[68]

Most immediately apparent in Dashti's series of triptych portraits is the striking sense of each particular woman's personality, something that comes through in their various modes of dress, which are as different from each other as the women are from one another. So far as we can tell, and as Dashti's text affirms, the woman who chooses bare shoulders at home is no more or less "influential" than the woman who switches out only the color of her full hijab when in the three different environments. But interestingly, [at least] one of the triptychs illustrated in Keshmirshekan has been edited out of the "comprehensive" set of images provided on the artist's website.[69] In this

65 http://gohardashti.com/work/me-she-and-the-others/#text.

66 As under so many authoritarian regimes, the interplay between rigid ideology and a rather more malleable (read also: uncertain and arbitrary) day-to-day practice is characteristic of life on the Iranian street. There almost always seems room for cultural maneuver, but hardly ever any certainty as to how much or for how long. Bahman Ghobadi's 2009 film *No One Knows about Persian Cats* (see discussion above) shows how this dynamic works out in excruciating detailed practice.

67 As of 2016, over half of the Iranian population was under 35 years of age, that is, born since 1977.

68 Keshmirshekan, 295. The illustrations he includes as adjuncts to his argument can, as a group, easily provide a visual summary of cultural production under the rubrics "heterogeneity" and "hybridity."

69 Ibid., 304.

particular image, the subject wears a white tube top that leaves her shoulders completely bare and exposes a thin band of midriff as well. Nothing nearly this "aggressive" appears among all of the images illustrated on the site.

Do the artist's circumspect comments then reflect a degree of self-censorship? Perhaps, since Dashti is working in Iran, but, taken as a whole, the "message" of both images and text remains the same: to illustrate the degree to which differences among Iranian women themselves, as well as differences in their modes of self-presentation, do not exclude them from having an impact on civic life, as much as that impression seems to have been forwarded by some commentators in the West. Dashti's statement, in fact, is directed outward, a one-line "explainer" toward an unspecified (if presumably western) general audience that has made contradictory assumptions about women based on their modes of self-expression, which, as the artist tacitly acknowledges, are still subject to certain "obligations," e.g. regulations.

Nevertheless, Dashti's images themselves suggest another truth that remains in her text regardless and is evident in the way that the "at work" images are not identical to those representing the women "out in society." In all the cases presented by Dashti, regardless of the rigid conservatism of the "public" image that can be seen in the adoption of a full and carefully worn chador, there is a less rigid, more informal (even if still relatively conservative) style that is considered appropriate for adoption "at work." Clearly, it is the act of appearing "in public" that carries the most ideological weight; this is the moment at which traditional codes of dress and behavior must be most stringently enforced to avoid the pollution of "westoxication" and to create a coherent national image of an egalitarian or "socialist" society aiming to equalize the appearance of class differences.

When we looked at the implications of Pamela Joseph's "CENSORED" series, we saw how a discussion of censorship and body politics could culminate (in the 2014 *Censored Olympia by Manet*) with a meditation on the intersection between modalities of representation (Manet's "style") and questions of presence and identity, both public and private. Ultimately, in all the [Iranian] works seen thus far, both personal freedom and public visibility within a community or a polity remain underlying themes. Thus, both western feminism and Iranian contemporary art share a mutual point of reference in the censored works that motivated the production of Pamela Joseph's series "CENSORED": both depend on an active dialog with past works of art that have led to misinterpretations and projections by others vested with the cultural authority to "see" them "correctly."

Contemporary with Dashti's *Me, She and the Others*, is the work of Shohreh Mehran (b.1957). In one example from her "School Girl" series (2009) [images not available], she brilliantly documents both the fact and the social effect of the dress code promulgated under Iran's revolutionary

Islamic ideology with a study of three young women (who we can easily imagine among Azar Nafisi's students) striding along arm-in-arm as a chador-clad and (due to the radical cropping of the image) literally faceless trio. Tara Aghdashloo, a critic, journalist, curator, and daughter of the painter Aydin Aghdashloo, concisely captures "[the] sense of heedless jubilance in the way the students are walking: hands around each other's necks, with their *mantos* gracefully flowing;" on the other hand, in her description of the picture she also admits the fact that we see the female students "in concordant uniforms designed to dilute individualism," although she asserts in response that they can never hide this individual presence completely.[70] Other works from this series, however, seem uncomfortable with this [too] easy reading of a coexistence of individuality and conformity. At times, the relationship between the depicted women seems more conspiratorial; at others, their depictions might be taken to indicate surprise, even fear (of being caught "on camera") in that they block their faces from view; and, whether conscious or not, they also demonstrate a complicity in reinforcing a certain anonymity.

Although the "School Girl" pictures confront issues central to our inquiry directly, it is clear that, for Mehran, the concept of "veiling" itself exercises a particular fascination, as can be seen from her 2014 solo exhibition *Whatever is Veiled Makes My Imagination Soar*, held at the Etemad Gallery in Tehran, where some of the work, at least, might suggest the wrapping projects of Christo. The work, especially when taken in concert with the title of the show, can easily seem ironic. She states, "In the folds of everyday life, we see objects wrapped in heavy cloth. Strings and stones and ropes and wires prevent the curtain to lift and expose the object. Clarity is impossible, transparency is lost. On the sidewalk, by the roadside, around posts and beams, upon rocks and cement, all across the sky: that which must not be seen is everywhere, veiled and silent. And we accept this obscurity."[71] In this series, Mehran's radical shift away from human subjects opens up the idea of a "veil" to a multitude of possible interpretations, some including social critique; yet this inherently polyvalent playfulness clearly disrupts the simple gendered binary that so often oversimplifies western engagement with the "veiling" issue.

Mehran's previous exhibition *Defaced* (Etemad Gallery, Dubai, 2013), as interpreted in the online catalog to the show by Mani Haghighi (b.1969), an Iranian screenwriter and filmmaker, suggests "ostensibly, images of criminals [...] routinely published in daily newspapers. These criminals – men and women – have been arrested, some even handcuffed. They are covering their faces in an effort to resist identification; but their effort is a paradoxical gesture: it is at once a sign of embarrassment and an act of defiance. Is it

70 Tara Aghdashloo, "Notes on Women in Iranian Art," *Ibraaz*, February 27, 2014: http://www.ibraaz.org/reviews/54. Several canvases from Mehran's series "School Girls" (2009) are illustrated in this article.
71 Shohreh Mehran, "Whatever Is Veiled Makes My Imagination Soar," November 2014: https://www.360cities.net/image/etemad-gallery-nov-2014-shohreh-mehran-whatever-is-veiled-makes-me-imagination-soar-02-tehran. A link to a downloadable catalog from the show is available on this page.

because of their shame, or in spite of it, that they are veiling themselves? Is this effacement a retreat from criminality or a continuation of it through other means?"[72]

Whether we are to understand Mehran's "criminals" as "political prisoners," strictly speaking, is unclear; but what is at stake for her subjects seems beyond dispute: the power of any government to eradicate personal identity through its penal system. Arrest and imprisonment represents a radical "disappearance" whose purpose is to cut through such superficialities as "self-presentation" and "identification" in order to attack the core of individual being, the unique interiority that is mediated, *inter alia*, by the way in which the self is projected into the world.

Artists of Mehran's generation, who undoubtedly witnessed firsthand the violence of the 1979 Revolution as well as that of the shah's dreaded (and CIA-abetted) SAVAK (the Iranian state security police), are different from the post-revolutionary generation, who are typically much more oblique or "cool" in their presentations. The works from this new generation, however, hardly signify that they have fully adopted the ideology of the revolution. Rather, they seem to take a longer view.

For example, take Gohar Dashti; in the text that accompanies the website featuring her powerful series "Stateless" (2014-2015), she places the problems confronted in this book in their widest possible perspective: "In every corner of the world, devastations of war, massacres, oppression, disease and death are the cause of widespread human disorders with no imaginable ending. When disasters force people to migration, where would they be welcomed with open arms? Hoping for a better life, they exist in a never-ending limbo, a strange place with no identity that does not belong to them. Maybe it is only at this point, when nature can be a safe haven for these refugees. Sky becomes the ceiling and mountains the walls of their new home; because Nature is the only promising place that shelters these people, an eternal and everlasting refuge."[73]

The issues we must confront are no longer state censorship of art or its digital reproduction, Iran's national dress code, the ideologies of Orientalism or western feminism, or even the search for a uniquely national identity. It is rather a struggle that takes place in "every corner of the world" (much as in the videos obsessively screened by Haji in Moshen Makhmalbaf's *The Marriage of the Blessed*) and in "limbo," a state where one's name and identity may be in flux in order to facilitate the crossing of borders or subsequent assimilation. The setting of Dashti's photos in an other-worldly desert of wind-eroded sandstone, one featuring a dead and "hog-tied" camel, suggests the specific landscape of the Middle East, but also a more universal idea of challenging

72 Mani Haghighi, Foreword to the exhibition catalog *Shohreh Mehran: Defaced*, Gallery Etemad, February 2013: http://www.galleryetemad.com/uploads/pdf/12032013/Defaced_Exibition_Catalogue.pdf. Unfortunately, we have not been able to reach the artist and thus cannot illustrate any of the works in question here.
73 Gohar Dashti, *Stateless*, 2015: http://gohardashti.com/work/stateless/#text.

Gohar Dashti, *Untitled (Stateless)*, 2014–2015. Photograph, 80 × 120 cm. Courtesy of the artist.

environments and barrenness, the hinterlands of the American southwest and U.S./Mexico border, as much as the Australian Outback or the Mongolian Desert. I have even seen landscapes like these on the California coast.

The images themselves are difficult to characterize as a group. Some indeed seem to reference plausible narratives of displacement and migration, a search for that elusive place where the refugee might "be welcomed with open arms." Others cast that search in metaphorical, even surrealistic terms; and one even presents nothing but the encircling landscape itself: an image of the desert as both exile and refuge, a trope with deep historical roots running (at least) from the writings of biblical times to the poetry of T.S. Eliot.

The image illustrated here strikes a complex, perhaps (it might even be argued) dissonant chord. Placed within the landscape we see two small figures (Dashti's figures in this series are always dwarfed by their surroundings): a standing woman veiled or shrouded in dark blue/black holding in her arms the limp body of a young man naked save for a wrapping that covers his loins and upper legs. The woman's head is canted so that she seems to stare at the face of her unresponsive burden, an explicit reference to the Pietá or the Virgin Mary holding the body of her dead son Jesus following his crucifixion (itself a subject that we have already seen referenced by Katayoun Karami in her 2009 series "Resurrected"). But the intertwining of references here is complex and pregnant with meaning.

Mary the mother of Jesus is the only woman specifically named in the Qur'an, and she is revered in Islam as a woman chosen by God as a holy vessel fit for the bearing of a prophet. Her identity would almost certainly be obvious here, although this particular incident is not itself sanctioned by the Qur'an, according to which Jesus was raised up bodily to God at the end of his earthly life (lifted up in "the little death of sleep" – in some ways like Mary herself in Catholic tradition) so that his crucifixion, and hence the mourning of Mary over His dead body, is to be understood as something that happened "only in appearance" rather than in actual fact.

Nevertheless, it seems hard to escape the conclusion that Dashti is here using this subject [heterodox as it may be within a strict Qur'anic reading] as a "type" for the idea of the mother mourning over her dead and martyred son. For our own project here, the suggestion implicit in the image is powerful and, once again, something that transcends a particular political or religious ideology: that mourning and memory (as well as art?) can provide a repository for personal identity, even an identity displaced by the ultimate defacement, the fact of death, and that this identity constructed in retrospect nevertheless recuperates something of the living presence.

This exercise in reading the way the images presented here construct "memory" as much as they do "identity" brings something else to light in the works of many younger Iranian artists. For them, the impulse to immediate revolution seems to have been displaced by a sense of history's

longue durée, a sort of cultural waiting game (as has been suggested by the writing of Shahram Khosravi) that significantly foregrounds "the one who waits," and we might add, the one who uses post-modern means toward refiguring discourse.

Actualizing public dialog to catalyze changes in culture (any culture) requires engagement on all levels: with past ideas, myths, stereotypes, current political trends, laws and bureaucracies. In this regard, Shohreh Mehran's catalog essayist, Mani Haghighi, has a jewel to pass on to any readers of this book. In an interview on the occasion that his film *Ejhdeha Vared Mishavad!* (*A Dragon Arrives!*) was screened at the Berlin Film Festival in 2016, he said in an interview,

> The problem that I've always had with all my films is that the Iranian censors, like all censors throughout history, are paranoid about stuff they don't think they understand. [...] So there have been articles already written about the film that one part represents the nation and another part represents the martyrs of the revolution, and it takes a lot of effort on my part to convince them that they're wrong. Fortunately they're reasonable enough that when I ask them to prove it – to prove to me that their interpretation is correct – when they can't do that, they seem to be a little ashamed. It's like a case of [the film] being guilty until proven innocent. It takes a lot of work, hours and hours of discussion. [...] I enjoy it in a masochistic kind of way. [...] Everybody changes their film in one way or another. Some people are pressured by their producers, other people are pressured by the audience, and some people are pressured by the censors. I have a lot of patience for the censors, I actually love doing these negotiations with them, because I change their minds, and I think there's some good in that.[74]

This act of public dialog, so necessary for political and cultural transformation, is embodied in another paradoxical image: Newsha Tavakolian's *When I Was Twenty Years Old (for Maral Afsharian)* [image not available] from a 2010 series that celebrates the accomplishments of six Iranian singers prohibited by Islamic tenets from performing in public.[75] This jewel case cover design for an imaginary CD featuring the work of Maral Afsharian (an iconic image from Tavakolian's oeuvre) shows a young woman

74 Oliver Johnston, "Mani Haghighi: An interview with the director of *Ejhdeha Vared Mishavad! (A Dragon Arrives!*)," *The Upcoming*, February 23, 2016: http://www.theupcoming.co.uk/2016/02/23/berlin-film-festival-2016-mani-haghighi-an-interview-with-the-director-of-ejhdeha-vared-mishavad-a-dragon-arrives/.
75 *She Who Tells a Story*, 68–81.

wearing bright red boxing gloves and posed in the middle of a road in front of a distant Tehran cityscape: an almost ghostly image of the arena within which this very public struggle will be waged. Hers is an image of latent female strength, "evoking ideas of youth, protest, and empowerment."[76] And, although the context is somewhat different, and the stage has become a worldwide one: Tavakolian's photo must now certainly evoke images from the 2016 Rio Olympics of Muslim women, especially of U.S. fencer Ibtihaj Muhammad as well as the Egyptian beach volleyball team in their relentlessly photographed match against bikini-clad Germany.[77]

In Tavakolian's photo, the young woman at the center of the image evokes the idea of "empowerment" in three distinct ways. First of all, she is a fighter. The boxing gloves engage the idea of struggle in a metaphorically straightforward, and ironically male-identified way (and even one that references the ancient Greeks, who after all invented boxing, although, needless to say, they did their sparring in the nude). Second, the image evokes the struggle of Maral Afsharian (the dedicatee) and, by extension and as a thread running throughout the series, all the Iranian women whose vocal talents have been circumscribed by religious and cultural prohibitions. This is a struggle to be heard, and heard in a certain way: hence the series title "Listen." Listen to the voices of all those women who would sing, and listen to this individual voice. In this case, the boxing gloves are purely symbolic, if quite cleverly chosen in a pictorial or iconographic sense.

The image might also be taken as a stand-in to refer to the empowerment of the artist in her professional role as a photographer. And it is here that the paradox lies; for while the boxing gloves provide an excellent symbolic evocation of struggle in general, in the case of Tavakolian's chosen career, they can be seen as a literal impediment. It is as if to say that "the struggle" to succeed as a photographer will be as hard as shooting a picture with your Nikon while laced up in a pair of scarlet boxing gloves.

For Tavakolian herself, who began her professional career at sixteen and by 2002 was documenting the war unfolding in Iraq, things played out differently.[78] That being so, it seems perfectly reasonable to conclude, judging from the set expression on the face of Tavakolian's model throughout the series "Listen," that, whatever the difficulty, the outcome of this particular struggle is never in doubt. And while it may be true that the calling of the

76 Ibid., 70.
77 Most western media saw the "bikini vs. burka" match as indicative of a western – Muslim "culture clash," choosing to stress the lack of Egyptian skin as a visible marker of continuing oppression in the Islamic world. Although there is no question that female Islamic athletes face serious cultural and religious challenges, few media outlets chose to focus on the obvious gains that Olympic participation represented for these women, nor to bother reporting these athlete's own reactions to the biased media coverage.
78 Since Tavakolian's time in Iraq in 2002, she has become an award-winning photographer who has covered "regional conflicts, natural disasters and made social documentary stories. Her work is published in international magazines and newspapers such as *Time Magazine, Newsweek, Stern, Le Figaro, Colors, The New York Times, Der Spiegel, Le Monde, NRC Handelsblad, The New York Times Magazine, National Geographic*, [and *The New Yorker*]." Her work photographing the 2009 elections in Iran "forced her to temporarily halt her photojournalistic work" and turn to social documentary/art. "Newsha Tavakolian Biography," *Magnum Photos*: https://www.magnumphotos.com/photographer/newsha-tavakolian/.

documentarian is grounded in the need to bear witness, he or she also presents potentially discomfiting truths. It is hard (returning one last time to Makhmalbaf's broken soldier/photographer Haji) simply to be "[an] eye," whether of a revolution or anything else.

In Tavakolian, we have an excellent example of an artist whose work is often doubly inflected: turning inward as a critique and yet also addressing an international audience – be that as an "art photographer" or as a photojournalist – where the possibilities of misinterpretation are rife. To navigate this terrain requires the ability to walk a thin line between competing cultural and global imperatives. An excellent example of what this involves has been provided by the filmmaker Mohsen Makhmalbaf, now in exile for his association with the Green Revolution of 2009. In an interview in 2015 with *The Guardian* on the occasion of the UK release of his film *The President*, Makhmalbaf was asked, "Why [do you] think pro-democracy movements have failed in Iran and other places such as Afghanistan and Latin America?" His answer, in which culture plays a surprisingly important role, turns into a wonderful two-way mirror: "Democracies are not solely based on popular revolt: we need cultural changes first. [...] We've never had a Renaissance, we never doubted our history, we never doubted our social values, and you can't build democracy without doubting first. Another important reason is the West. The West is democracy within, dictatorship outside. Look at America's role in Afghanistan – how can you learn democracy from the West?"[79] The article continues, "In the middle of this mayhem, what's the artist's role? 'An artist is not an artist without three things,' Makhmalbaf says. 'Honesty, profoundness and responsibility.'"[80]

One could argue that Makhmalbaf's "responsibility" is characteristic of all the diverse works presented in this book – a responsibility to history, to one's own culture, to a personal truth, and to confronting misperceptions and damaging but persisting myths that underscore asymmetrical power relationships. For an interesting and hopeful take on the millennial contribution to the culture and scholarship in and about Iran today, we turn to a perhaps-unlikely, but utterly appropriate source of knowledge about figuration and its role in culture: fashion.

The photographs in Hoda Katebi's 2016 *Tehran Streetstyle*[81] are often ablaze with color: scarlet, pink, blues, yellow, green, aqua. Even the blacks are rich and deep. Katebi is a Chicago-based Iranian-American fashion blogger whose site joojooazad.com[82] is an "anti-capitalist, intersectional feminist fashion blog." Katebi's perspective puts her on the cutting edge of a fashion world that, she points out, is not dominated by a few transnational

79 Saeed Kamali Dehghan, "*The President's* Mohsen Makhmalbaf: 'There's a little Shah in all of us,'" *The Guardian*, August 10, 2015: https://www.theguardian.com/film/2015/aug/10/the-presidents-mohsen-makhmalbaf-theres-a-little-shah-in-all-of-us.
80 Ibid.
81 Hoda Katebi, *Tehran Streetstyle* (Chicago: Self-published via Lulu, 2016).
82 For Katebi's blog, see http://www.joojooazad.com/. (In Farsi, "joojoo azad" = "free bird.")

Hoda Katebi, *Tehran Streetstyle*, 2016. Courtesy Hoda Katebi.

corporations dedicated above all to the exploitation of people and resources, and to the maximization of consumption-driven profit: "Iran has a growing underground 'slow fashion' movement – many independent designers working with local products and people to create a small collection that is not mass-produced."[83]

Almost by necessity, this (increasingly above-ground) underground scene exists in that space for ideological maneuvers that we have seen repeatedly as an aspect of more-or-less contemporary Iranian cultural production. Among artists whose work we have discussed and illustrated, Katebi's photographs seem closest to the contemporary gritty urban scenes painted by Daryoush Gharahzad, but equally they reflect a socio-political purpose found in the works of featured photographers and video artists.

Equally in Katebi's photographs, there are any number of fragmented bodies and turned away faces that echo issues of identity, privacy and agency that we have seen repeatedly. But there are also major differences. For example, there is a sense of vibrancy, immediacy, of being-in-the-moment that we see in Katebi's photographic work as opposed to Gharahzad's paintings, a sense that I would argue goes beyond the mediums themselves and has two distinct but related determinants: a difference in generation (Gharahzad was born in 1976, just on the cusp of the culturally and existentially "precarious" revolutionary generation, while Katebi was born in 1995, much closer to the cusp of the new millennium) as well as the fact that Katebi's photos are, for all their artfulness, intended to document and celebrate fashion in a Tehran virtually unknown in the West.

83 And, per government restrictions, not advertised as well. Katebi, *Tehran Streetstyle*, Introduction.

Katebi often writes "on the political value of fashion" from the perspective of a Muslim feminist, who is increasingly in demand as a public speaker by virtue of her strong voice and articulate opinions.[84] Her focus on fashion may well put her at odds with those feminists for whom "[a woman's] ability to resist has been reduced simply to the act of dressing like a westernized subject."[85] For Katebi, I think quite rightly, this reduction ("resistance" or "liberation" = "dressing like a westernized subject") seems to be associated with a much broader project: the project of "modernism" or "modernity," which is in fact essentially westernizing (from a slightly different ideological perspective one might even say "westoxicated") in its orientation, and hence readily amenable to Orientalizing narratives.

Iran's "slow fashion," on the other hand, escapes this bind by virtue of the kind of wide-ranging appropriations and reconfigurations that mark it as essentially post-modern in its orientation. It is definitely constitutive of a kind of Iranian identity – it is after all made by Iranians for Iranians – but it is also, as Katebi's book and writing show, indelibly personal: a non-branded, do-it-yourself expression. It must still work in the interstices of a repressive bureaucracy's national dress code, which, according to Katebi, "the majority of women [in Iran] condemn [...] as a notion that is patriarchal and un-Islamic."[86] In its necessarily "slow" unfolding, Iranian fashion may yet be the catalyst both for a "soft revolution" at home and for a correction of cultural misunderstandings abroad.

Hoda Katebi, *Tehran Streetstyle*, 2016. Courtesy Hoda Katebi.

84 For a brilliantly argued example, see her blog post on an image that has become "iconic" for many progressives in the West. "Please Keep your American Flags Off My Hijab": http://www.joojooazad.com/2017/01/keep-your-american-flags-off-my-hijab.html.
85 Katebi, 46.
86 Ibid.

Hoda Katebi, *Tehran Streetstyle*, 2016. Courtesy Hoda Katebi.

Hoda Katebi, *Tehran Streetstyle*, 2016. Courtesy Hoda Katebi.

Hoda Katebi, *Tehran Streetstyle*, 2016. Courtesy Hoda Katebi.

As a way of bringing our argument at last "full circle," we turn finally to a series of erstwhile fashion photos (which can also function as a series of Duchampian "rectified ready-mades") from Shadi Ghadirian's "West By East" of 2004 [pages 150–151]. Ghadirian presents us with a series of young women, fashionably dressed and posed as might be appropriate for use in western fashion advertisements. Following Ghadirian's own title, it seems safe to see the photos as "presumed" western artifacts, subjected, like the illustrations in Cumming's book, to the attention of an anonymous bureaucrat, ready (as always) with a rectifying marker. Still, what Ghadirian has visualized in her altered photographs is not a situation existentially or immediately threatening. Unlike Katayoun Karami's untitled self-portrait [page 91] that reads like a censored mug shot of a prisoner photographed in the nude, Ghadirian's pictures seem critical (of western fashion? of Iranian censorship? of the national dress code?) and, with perhaps a single exception, are not really hostile in their intention. How then, should we interpret them? In light of Ghadirian's other work,[87] which though insistent in its message is never overbearing in its presentation,[88] perhaps we can see them as an invitation to a dialog that the artist is having with her peers. By defacing the photographs in a way that seems almost "neutral" – even (in her wonderful half-length study) appropriated to aesthetic ends – she also sees a long future ahead, one that prefigures the fashionable transformations documented by Katebi, where young Iranians actively seek the joy in remodeling culture, an endeavor with lasting socio-political implications.

87 See the extensive gallery at the artist's website: http://shadighadirian.com/index.php?do=photography.
88 The exquisitely beautiful and ironic black-and-white series "Miss Butterfly" (2011) is especially expressive in this way.

Shadi Ghadirian, "West by East" series, 2004. Photograph, 90 × 60 cm.
Courtesy Robert Klein Gallery.

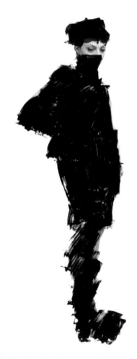

Shadi Ghadirian, "West by East" series, 2004. Photograph, 90 × 60 cm.
Courtesy Robert Klein Gallery.

Shadi Ghadirian, "West by East" series, 2004. Photograph, 90 × 60 cm.
Courtesy Robert Klein Gallery.

Shadi Ghadirian, "West by East" series, 2004. Photograph, 90 × 60 cm.
Courtesy Robert Klein Gallery.

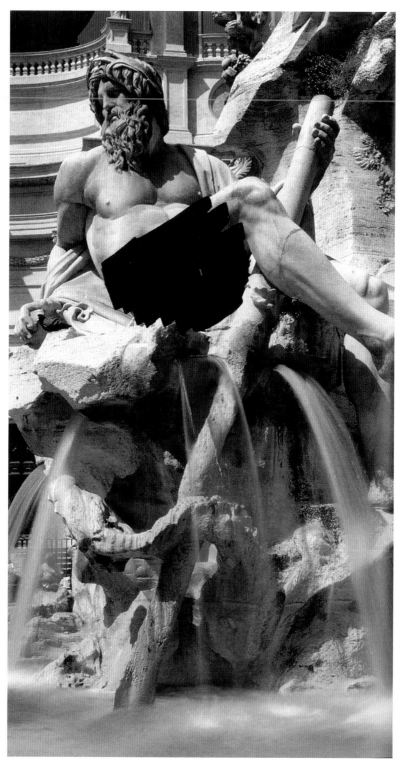

Gian Lorenzo Bernini, *Fountain of the Four Rivers*, 1651. Marble and travertine, Piazza Navona, Rome.
"The magnificence of Bernini's sculptural projects was inspired by a belief that, through art,
he was expressing the absolute authority of God and the Catholic Church."
DK Eyewitness Companion to *Art*, hand censored in Iran. Collection Kurosh ValaNejad.

Censored Books:
An Exercise in Looking

LOOKING AT CULTURE

Regardless of whether one embraces and affirms western culture, has a distanced familiarity with it, or finds oneself in an adversarial or transgressive relationship with it, canonical western artworks can be apprehended and manipulated; accepted or rejected; elaborated or contested, because one has learned about the tradition. This culture embodies meanings through sets of visual tropes and structures; for example, a classic Attic pot with naked Trojan warriors displaying a notion of heroic male nudity, or an unostentatiously naked and indubitably child-like baby Jesus indicating that for Christians, Jesus was the Word of God made flesh, and the salvation of humanity hinges on the supreme self-sacrifice of an incarnate God. But for the images to have meaning is not a matter of belief in the tenets of Christianity, or of familiarity with the details of ancient warfare. Meaning is derived from the method and context of looking at those images.

As a historian of art or (more broadly) visual culture in general, I have been trained to recognize the artificiality or conventionality of those visual tropes and structures, and of the arbitrary nature of their connection to particular cultural meanings; and part of my job is to "de-naturalize" or "de-familiarize" them so that they can be examined critically, and their place(s) within larger and more complex cultural wholes excavated and elucidated. Yet, as long as the object of my attention lies within the western cultural tradition, I am potentially blinded by my own knowledge of the version of western culture that I have inherited. Indeed, this is almost necessarily so, since a more-or-less immediate immersion in my own culture (where I exist like a fish swimming in the sea) is essential to my ability to generate specific meaning within my own life.

This is one of the reasons why I consider an object like the hand-censored Eyewitness Companion to *Art* to be so important, and why it has produced for me such a riveting experience. Leaving aside the entire argument developed in the critical and historical essays produced here, what the censored book provides me is a radically de-familiarizing look at my own visual culture. It is

Hell *Dieric Bouts, 1450, 115 x 69.5 cm (45¼ x 27⅜ in),
oil on wood, Lille: Musée des Beaux-Arts.* This work
was mistakenly believed to be part of a documented
but destroyed triptych by Bouts of the Last Judgement.
The panel is one of a pair displayed in the Musée des
Beaux-Arts; the other depicts Paradise.

DK Eyewitness Companion to *Art*, hand censored in Iran. Collection Kurosh ValaNejad.

an object that has issued forth from an almost impossible and unlikely collaboration: between the author of a western art-historical survey and an Iranian censor who judges that author's work by entirely different standards. The censor's mark-up disregards questions of intended cultural meaning and relies instead on a set of internalized cultural referents that are "other" to the author's. (Isn't this multi-valent interpretation, perhaps, where the richness in all cultures occurs?) The book provides me, and for that matter, any viewer familiar with western art, with an inexhaustible series of opportunities to re-think what I am seeing. In particular, the censored images ask and reiterate a series of questions surrounding the central "fact" of the tradition they confront: that fact, of course, is the presence of the human body as a primary carrier of meaning. If you allow these images to present those questions to you as well – no matter what your inherited "visual equipment" may be – the book may bestow insights that neither the author nor the censor intended.

C . 1 5 0 0 – 1 6 0 0 147

Madonna and Child *Giulio Romano, c.1530–40, 105 x 77 cm (33⅓ x 30⅓ in), oil on wood, Florence: Galleria degli Uffizi.* The Christ child reaches for grapes – a symbolic reference to the Eucharist, the central Christian sacrament.

DK Eyewitness Companion to *Art*, hand censored in Iran. Collection Kurosh ValaNejad.

The Birth of Venus *William-Adolphe Bouguereau, 1879, 300 x 218 cm (118¼ x 85¾ in), oil on canvas, Paris: Musée d'Orsay.* Bouguereau's mythological paintings were avidly collected, and sold for huge prices.

DK Eyewitness Companion to *Art*, hand censored in Iran. Collection Kurosh ValaNejad.

Bacchus and Ariadne

Titian c.1522–23

Titian's crowning achievements are his mythological *poesie* (poems). This early work was one of a series commissioned by Alfonso d'Este, the duke of Ferrara, in northern Italy, to decorate an alabaster pleasure chamber at his country house.

Titian chooses to focus on the electrifying moment when Ariadne, daughter of King Minos of Crete, meets Bacchus, the god of wine, and they fall in love at first sight. He later married her, and she was eventually granted immortality.

There is an overriding sense of ordered chaos about the painting. Although the scene is crowded, Titian has worked out the composition with great care. Bacchus's right hand is at the centre of the painting where the diagonals intersect. The revellers are all confined to the bottom right. Bacchus and Ariadne occupy the centre and left. Bacchus's feet are still with his companions, but his head and heart have joined Ariadne.

The greatest painter of the Venetian school, Titian was based in Venice for his entire life, inspired by its magical union of light and water. He was one of the most successful painters in history, famous for his ability to inject his pictures with moments of crackling psychological energy of the kind that pervades this work. He was also the Renaissance master of colour, and this painting's rich, glowing brilliance reflects its passionate subject.

After falling in love, Bacchus took Ariadne's crown and threw it into the sky where it became the constellation Corona Borealis.

Ariadne has been abandoned by her lover Theseus, whom she helped to escape from the Minotaur's labyrinth

Bacchus's chariot was traditionally pulled by leopards, signifying his triumphant return from his conquest of India. Titian uses artistic licence by employing cheetahs for the task

TECHNIQUES

This close-up detail of Ariadne shows Titian relishing two of the special qualities of oil paint: translucent, lustrous colour, and fine, precise detail.

Titian's name appears on an urn in Latin – "TICIA F[ecit]", or "Titian made this picture". He was one of first artists to sign his work and was active in seeki to raise the social and intellectual status of painters

A maenad crashes cymbals together in a riotous procession

The longing glance that this maenad exchanges with the satyr contrasts with the intense expressions of the main characters

This drunken satyr, crowned and girdled with vine leaves, waves the leg of a calf above his head

cular
wn
with
s is
a
antique
atue of
priest
who was
ea serpents),
s unearthed in
pages 58–59).
e's rediscovery
sensation, and
sts, including
incorporated cross-
s to it in their work.

Bacchus and Ariadne

Medium oil on canvas
Dimensions 175 x 190 cm
(69 x 75 in)
Location London: National Gallery

DK Eyewitness Companion to *Art*, hand
censored in Iran. Collection Kurosh ValaNejad.

Liberty Leading the People

Eugène Delacroix 1830

Leader of the French Romantic Movement in painting, a close friend of Baudelaire and Victor Hugo, Delacroix's own life is like that of the hero of a romantic novel. With restless energy but frail health, he had many love affairs yet remained unmarrie He died alone, exhausted by his artistic labours.

This highly controversial painting commemorates the political uprising in Paris in July 1830, when Parisians took to the streets for three days in revolt against the greedy and tyrannical regime of the king, Charles X. Delacroix had high hopes for the critical reception of this work, but he was disappointed. The proletarian emphasis was considered so dangerous that the painting was removed from public view until 1855. Delacroix's use of colour here is uncharacteristically subdued but serves to heighten the brilliance of the saturated tones of the flag.

All classes of society, except the dyed-in-the-wool monarchists, supported the revolution. Delacroix conveys this by displaying a variety of hats worn by the streetfighters – top hats, berets, and cloth caps are all represented.

TECHNIQUES

Delacroix often used short, broken brushwork, anticipating artists such as Monet (see page 310). He also investigated the juxtaposition of colours to increase their individual richness and vibrancy. His journals document his insights into colour theory.

Delacroix shows dying and dead men, victims of the battle, their faces and bodies picked out by the dramatic halo of light shining behind Liberty. To the right lie two soldiers; many soldiers refused to fire on their fellow citizens – some even joined the rebel ranks

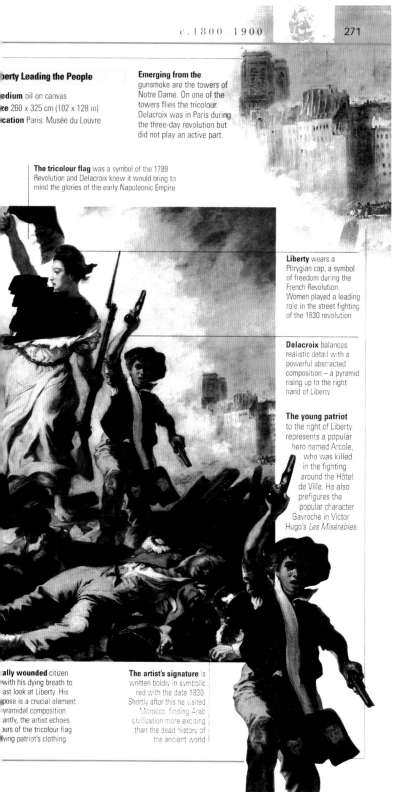

iberty Leading the People

edium oil on canvas

ze 260 x 325 cm (102 x 128 in)

cation Paris: Musée du Louvre

Emerging from the gunsmoke are the towers of Notre Dame. On one of the towers flies the tricolour. Delacroix was in Paris during the three-day revolution but did not play an active part.

The tricolour flag was a symbol of the 1789 Revolution and Delacroix knew it would bring to mind the glories of the early Napoleonic Empire

Liberty wears a Phrygian cap, a symbol of freedom during the French Revolution. Women played a leading role in the street fighting of the 1830 revolution

Delacroix balances realistic detail with a powerful abstracted composition – a pyramid rising up to the right hand of Liberty

The young patriot to the right of Liberty represents a popular hero named Arcole, who was killed in the fighting around the Hôtel de Ville. He also prefigures the popular character Gavroche in Victor Hugo's *Les Misérables*.

ally wounded citizen with his dying breath to ast look at Liberty. His pose is a crucial element yramidal composition. antly, the artist echoes urs of the tricolour flag ying patriot's clothing

The artist's signature is written boldly in symbolic red with the date 1830. Shortly after this he visited Morocco, finding Arab civilization more exciting than the dead history of the ancient world

DK Eyewitness Companion to *Art*, hand censored in Iran. Collection Kurosh ValaNejad.

Jean-Auguste-Dominique Ingres, *The Turkish Bath* (detail), 1852–59, modified in 1862.
Oil on canvas glued to wood, 108 × 110 cm. The Louvre.
DK Eyewitness Companion to *Art*, hand censored in Iran. Collection Kurosh ValaNejad.

Paul **Gauguin**

◉ 1848–1903 ⚑ FRENCH

⬚ France; Tahiti 🎨 oils; sculpture; prints
🏛 Washington DC: National Gallery of Art.
St. Petersburg: Hermitage Museum. Paris: Musée
d'Orsay ⚡ $35m in 2004, *Maternité II* (oils)

Gaugin was a successful stockbroker who,
at the age of 35, abandoned his career
and family to become an artist. Yearned
for the simple life and died, unknown,
from syphilis, in the South Seas. Had a
decisive influence on the new generation
(including Matisse and Picasso).

His best work is from his visits to Pont
Aven, in Brittany (especially in 1888)
and from Tahiti in the 1890s. Powerful
subjects expressed with a
strong sense of design:
bold, flattened, simplified
forms; intense, saturated
colours. Constant search
for a personal and spiritual
fulfilment, which remained
unsatisfied. Highly
attracted to Tahitian
feminine beauty, and
many works are as full of
sexual as well as spiritual
yearning. Also produced
interesting woodcarvings,
pottery, and sculpture.

Although an acute
observer of nature, he
believed that the source
of inspiration had to be
internal, not external (which sparked a
major quarrel with Van Gogh). Hence,
look for symbolic, not natural, colours;

Nevermore Paul Gauguin, 1897, 60.5 x 116 cm (23⅛ x
45⅝ in), oil on canvas, London: Courtauld Institute of Art.
Gauguin had a poetic ability to evoke moods that were
haunting, ambiguous, and suffused with melancholy.

complex, sometimes biblical, symbolism.
Plenty of scope for detective work on
his visual sources, among them: South
American art, Egyptian art, medieval
art, Cambodian sculpture, Japanese
prints, and Manet.

KEY WORKS *Landscape*, 1873 (Cambridge:
Fitzwilliam Museum); *The Vision After the
Sermon*, 1888 (Edinburgh: National Gallery
of Scotland); *Sunflowers*, 1901 (St. Petersburg:
Hermitage Museum); *Primitive Tales*, 1902
(Essen: Museum Folkwang); *Riders on the
Beach*, 1902 (Essen: Museum Folkwang)

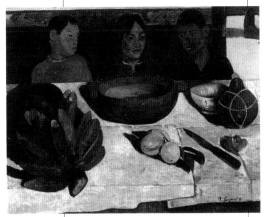

The Meal Paul Gauguin, 1891, 73 x 92 cm (28¾ x 36¼ in),
oil on canvas, Paris: Musée d'Orsay. Rich colouring and
distorted perspective combine to produce a work that is part
still life, part enigmatic portrait of three Tahitian children.

DK Eyewitness Companion to *Art*, hand censored in Iran. Collection Kurosh ValaNejad.

٣. ادموند فورتیه
زن مالینکی، آفریقای غربی
۱۹۰۶، چاپ کلوتایپ (کارت پستال)
پاریس، موزهٔ پیکاسو، آرشیو پیکاسو
۴. پابلو پیکاسو
زنی از نیمرخ
۱۹۰۶–۷، رنگ روغن روی بوم، ۵۳ × ۷۵ سانتی‌متر
کلکسیون شخصی
۵. پابلو پیکاسو
زن
۱۹۰۷، رنگ روغن روی بوم، ۹۳ × ۱۱۹ سانتی‌متر
ریحن/ بازل، مؤسسهٔ بیلر
۶. صورتک بابانگی از کنگوی فرانسه
بدون تاریخ، چوب، ارتفاع ۳۵/۵ سانتی‌متر
نیویورک، موزهٔ هنر معاصر

مونه (۱۹۲۶–۱۸۴۰)، کامی پیسارو (۱۹۰۳–۱۸۳۰)، اگوست رنوآر
(۱۹۱۹–۱۸۴۱) و پل سزان (۱۹۰۶–۱۸۳۹) بود.

در میان هنرمندان کوبیست، بیش از همه به نظریه‌های پل سزان استاد می‌شود. در مباحثات و تحلیل‌های اولیه از کوبیسم، همواره به نقش وی به عنوان پیشتاز، اشاره شده است. پیکاسو مؤکداً گفته است: «آنچه سزان با واقعیت انجام داد، بسیار پیشرفته‌تر از ماشین بخار بود.» پیکاسو اولین بار در گالری آنری ماتیس با تصاویر سزان آشنا شد؛ ماتیس نیز تابلوی آبتنی‌کنندگان (Baigneuses) سزان را در سال ۱۸۹۹ به‌دست آورده بود که حتی قبل از کوبیست‌ها خطای دید فضا را حذف کرده بود، در این تابلو منظره را همچون سطوح همواری ترسیم کرده بود که عاری از هر گونه عمق فضایی بودند. در سال ۱۹۰۴ سزان این سخنان را خطاب به شاگرد نقاشی‌اش، امیل برنار (۱۹۴۱–۱۸۶۸) گفت: «همهٔ اشکال طبیعی را می‌توان به انواع کروی، مخروطی و استوانه‌ای کاهش داد. هنرمند باید با این عناصر سادهٔ اولیه کار خود را آغاز کند، سپس قادر خواهد بود هر چیزی را که می‌خواهد با آنها بسازد. نباید طبیعت را دوباره خلق کرد، بلکه باید آن را بازنمایی کرد؛ اما با چه وسیله‌ای؟ با جایگزین‌های شکل دهندهٔ رنگی.»

در سال ۱۹۱۱، میشل پویی در مجلهٔ «لمارژ» نوشت: «کوبیسم نقطهٔ اوج ساده‌سازی است که سزان، آغاز کنندهٔ آن بود و ماتیس و دورن ادامه‌دهندهٔ آن... . گفته می‌شود که آقای پیکاسو آغاز کنندهٔ این راه بوده است، اما از آنجا که این نقاش به ندرت کارهایش را در معرض نمایش قرار می‌داد، شکوفایی کوبیسم را به طور اساسی در کارهای آقای براک می‌شد مشاهده کرد. به نظر می‌رسد کوبیسم، نظامی باشد با یک پایهٔ علمی که به هنرمند این اجازه را می‌دهد که تلاش‌هایش را بر روی یک دستگاه

محورهـای مختصات قابل اطمینان پایه‌گـذاری کند.» توصیفات پویی، سطح کوبیسم را تا حد یک روش قانون‌مدار که مورد کاربرد هنرمندان است، کاهش داد؛ نظامی که وجود یک مکتب را بدیهی فرض می‌کند و مانند آن که هرگز در گذشته وجود نداشته است. مقایسـهٔ تابلوی آبتنی‌کنندگان سزان با نقاشـی دوشیزگان آوینیون پیکاسو، چندین تشابه حیرت‌انگیز را آشکار می‌کند. از جمله اینکه در تابلوی سزان پارچه‌ای که به عنوان چادر از شـاخه‌های آویزان است، دوباره در تابلوی دوشیزگان به عنوان پس‌زمینهٔ پوشیده‌شده با پارچه ظاهر می‌شـود. ژست دو تن از آبتنی‌کنندگان را می‌توان تقریباً همانند ژست دومّین شخص ایستاده از چپ و شخص نشسته در پایین سمت راست در نقاشی دوشیزگان آوینیون پیکاسو توصیف کرد.

طرفه‌های آفریقایی – الهام از آن سوی دریاها

کوبیست‌هـا از منابـع تصویـری و رسـانه‌ای مختلفـی برای کارشان استفاده بردند. علاوه بر عکس، تمایل به هنر آفریقایی، نقش برجسته‌ای ایفا می‌کرد.

هنرمندان فوویسم نیز در سال‌های ۱۹۰۵ و ۱۹۰۶ ویژگی‌های شـاخص هنر قبیله‌ای آفریقایی را کشـف کردنـد. دو ولامینک از «کنـدوکاوی آشکار در هنر سیاه‌پوستان» سخن می‌گوید که در میان هنرمندان آوانگارد آغاز شده بود. پاریس، پایتخت قدرت استعماری فرانسـه، محل مناسبی در این زمان بود وی نیـز زمانی که در سـال ۱۹۰۵ سه مجسـمهٔ کوچک آفریقایی و یک صورتک سفید مخصوص شکار را در کافه‌ای در آرژانتویی به‌دست آورد، شخصاً در این جریان شرکت کرد. آندره دورن، که با وی دوستی داشت، بعدها این صورتک را در کارگاهش دید و به سرعت آن را خریداری کرد

۱۹۰۶ ــ سان‌فرانسیسکو با وقوع یک زمین‌لرزه تقریباً به‌کل از بین رفت

۱۹۰۶ ــ ظهور لامپ‌های رشته تنگستنی ۱۹۰۷ ــ تقدیم لایحهٔ حق رأی عمومی به مجلس اتریش

۸

Cubism, a pirated Taschen edition of western art published in Iran. Collection Kurosh ValaNejad.

۱۹. آنری لوفوکونیه
فراوانی
۱۱-۱۹۱۰، رنگ روغن روی بوم، ۱۲۳ × ۱۹۱ سانتی‌متر
لاهه، موزهٔ شهرداری لاهه

۲۰. ژان متسینگر
پرترهٔ آلبر گلز
۱۹۱۱، رنگ روغن روی بوم، ۵۴ × ۶۵ سانتی‌متر
پرَوویدانس، موزهٔ هنر،
دانشکده طراحی رودآیلند، صندوق آثار هنری
موزه و خانهٔ حراج پاریس

۲۱. فرنان لژه
زنی روی یک مبل راحتی
۱۹۱۳، رنگ روغن روی بوم، ۹۷ × ۱۳۰ سانتی‌متر
ریحن/ بازل، مؤسسهٔ بیلر

۱۹

در مُنپارناس اقامت داشت. در آنجا وی با گیوم آپولینر، روبر دلنه و بسیاری دیگر ملاقات کرد. در سال ۱۹۱۰ این افراد وی را به گالـری کان‌وایلر معرفی کردند و آنجـا بود که او با آثار براک و پیکاسو آشنا شد.

در سال‌های ۱۹۱۳ و ۱۹۱۴ آنـری لـورن (۱۹۵۴ـ۱۸۸۵)، که در سـال ۱۹۱۱ دوست نزدیک براک بود، آثار برگزیده‌ای از هنر مجسمه‌سازی را در «سالُن مستقلان» به نمایش گذاشت. توجه او در این نمایشگاه بـر پیکره‌های زنانه متمرکز بود که او انسـجام فیزیکی این پیکره‌ها را به نواحی باز می‌شکاند. ادوارد تریـر علاقهٔ هنری آنـری لـورن را اینگونه در کتاب «نظریه‌های مجسمه‌سازی» (Bildhauertheorien) توصیـف می‌کند: «در مجسمه‌سازی، حفره‌ها باید بـه اندازهٔ حجم مجسمه اهمیت داشته باشند. مجسمه‌سازی در وهلهٔ نخسـت، تخصیص دادن فضاسـت؛ فضایی که با قالب‌ها محدود شده است. بسیاری از افراد، مجسمه‌های خود را بی‌آنکه درک و احساسـی نسبت به فضا داشته باشند، می‌سازند؛ بنابراین پیکره‌هایشان هیچ ویژگی خاصـی نـدارد.» آنری لورن تـا قبل از برپایی نمایشـگاهش در «سالُن» به رتبهٔ برجسته‌ترین پیکرتراش بدیع کوبیسم نایل نشده بـود. کان‌وایلر علیرغم رابطهٔ بسیار خوبش با براک اولین بار در سال ۱۹۲۰ با این پیکرتراش آشنا شد.

خوآن گریس در همسـایگی کارگاه پابلو پیکاسـو ساکن بود. نخسـتین اثر وی به شیوه‌ای عالی نشان می‌دهد که کوبیسم در آن زمان چه تأثیر شگرفی بر هنرمندان جوان داشـته است. با خلق این اثر، انگیزه‌های جدیدی برای کوبیسم در سال‌های بعد ایجاد شـد. توانایی‌های ذهنی گریس به کوبیسم، شالودهای نظری بخشـید که تا آن زمان پی‌ریزی نشـده بود. گریس تمام

پیشرفت‌ها وموفقیت‌های کوبیسم را در نقاشی خلاصه کرد.

کوبیسـم ترکیبی

تقریبـاً بعد از سال ۱۹۱۲ اسلوب‌های هنری کوبیسـت‌ها بسیار تغییر کرد. تصاویر دوباره واضح‌تر شـدند. در دورهٔ معروف به «کوبیسـم ترکیبی» که دوره‌ای از سال ۱۹۱۲ تا ۱۹۱۴ بود، هنرمندانی همچون ژرژ براک، پابلو پیکاسو، خوآن گریس و فرنان لژه کار خود را با عناصر تصویری انتزاعی آغاز و این تصاویر را با نقش‌مایه‌های جدید ترکیب کردند. اسلوب «کاغذچسباندن» ابداع شده بود که می‌توان آن را پایه‌ای برای تمام اسـلوب‌های بعدی «تکه‌چسبانی» تا حاضر آماده‌شده در نظر گرفت.

اولیـن «کاغذچسبانده» بـا تابلوی *ظرف میـوه و لیوان* (Compotier et verre) ژرژ بـراک خلق شـد. این اثر را براک، طی اقامت تابسـتانی‌اش در سورگ در جنوب فرانسه اوایل ماه سپتامبر سال ۱۹۱۲ خلق کرد. براک بعدها بیان کرد که خیلی اتفاقی هنگام قـدم‌زدن در خیابان آوینیون، یک رول کاغذ را با تقلید از طرح چـوب بلـوط (faux bois) در ویترین یک مغازهٔ کاغذدیواری فروشی کشف کرده بود.

زمسـتان گذشـته، ژرژ بـراک روی طرحی بـا بافت چوبی کار کـرد و همچنیـن نـام باخ، آهنگساز بـزرگ را با حروف استنسـیل روی تابلویـش با عنوان «بزرگداشت ی. س. باخ» (Hommage à J.S. Bach) حـک کـرد. براک به عنوان یک نقـاش صحنه آموزش دیده بود، در هر دو شـیوه تبحر داشت؛ الگوبرداری از مواد و کاربرد حروف‌نگاری استنسـیل. وی گفت کـه مواد موجود در ویترین مغازه، به او الهام کردند که چگونه آنهـا را در کارهای هنری‌اش به‌کار بگیرد. براک، قبل از این که

۱۹۱۲ ـ شروع اولین جنگ بالکان ۱۹۱۲ ـ وودرو ویلسون رئیس جمهور جدید ایالات متحده شد

۱۹۱۲ ـ آخرین امپراتور چین، پو-یی از تاج و تخت کناره‌گیری کرد

۱۸

Cubism, a pirated Taschen edition of western art published in Iran. Collection Kurosh ValaNejad.

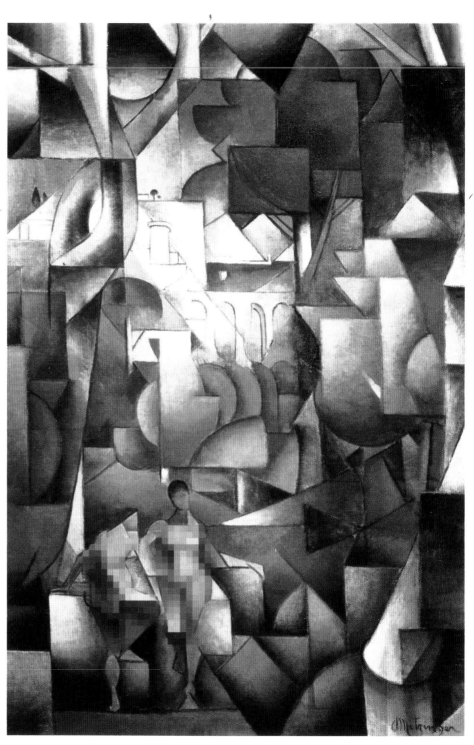

49

ژان متسینگر

۱۹۱۲

آبتنی کنندگان

رنگ روغن روی بوم، ۱۰۶ × ۱۴۸ سانتی‌متر

فیلادلفیا، موزهٔ هنر فیلادلفیا، کلکسیون لویی و والتر آرنزبرگ

آلبر گلـز و ژان متسـینگر در سـال ۱۹۱۲ در کتاب «دربارهٔ کوبیسم» نوشـتند: «فهمیدن سـزان، پیش‌بینی کوبیسم اسـت. حتـی اکنـون، مـا می‌توانیم بر ایـن نکته تأکید کنیـم که بین کوبیسم و روش‌های پیشین نقاشی تفاوت فقط در میزان شدت آن اسـت و این کـه ـــ بـرای اطمینان یافتـن از این موضوع ـــ فقـط باید رونـد تفسیر این واقعیت را بررسـی کنیم که به واقعیت سـطحی در آثار کوربه آغاز می‌شـود و با کنار زدن بدیهیات، به یـک واقعیـت عمیق‌تر در آثار سـزان می‌رسد.»

متسـینگر بعدهـا ایـن اظهارات را در متـن «تولد کوبیسـم» (La naissance du cubisme) تعدیـل کـرد: «بنابرایـن، بـرای مثـال، در حالی که من و گلز کتاب *دربارهٔ کوبیسـم* را می‌نوشـتیم، تسـلیم نظر عموم شـدیم و سـزان را در آغاز این روش نقاشـی قرار دادیم.»

متسـینگر پردهٔ *آبتنی‌کنندگان* را در سـال ۱۹۱۲ نقاشـی کرد. در ایـن سـال، ۳۱ هنرمنـد بـه یکدیگـر ملحق شـدند تا یـک گروه نمایشـگاهی کوبیسـتی بـه نام «تقسـیم طلایـی» تشـکیل دهند که بر مبنای نظریه‌های تناسـب «نسـبت طلایی» باشـد. این گروه شـامل افرادی از جمله، روبر دولا فرزنی، آلبر گلز، خوآن گریس، اُگوسـت اربَن، فرنان لژه، آندره لوت، ژان متسـینگر و ژاک ویون بـود. پابلو پیکاسـو، ژرژ بـراک و روبر دلنه در این جنبش شـرکت نکردنـد. گلز در سـال ۱۹۲۸ بـه یاد می‌آورد: «در زمسـتان سـال ۱۹۱۲ نیز نمایشـگاه «تقسـیم طلایـی» در پاریس برپا شـد؛ مهم‌ترین واقعـهٔ خصوصی آن زمان، کـه بهترین نیروهای آن نسـل که همگی موافق آمدن زیر پرچم کوبیسم بودند را با هم متحد کرد.»

نقاشـی متسـینگر حاکی از مشـغلهٔ ذهنی زیاد این هنرمند بـه گونه‌های متفـاوت *آبتنی‌کنندگان* پل سـزان و همچنین به ترسـیم‌های کوبیسـتی برهنه‌های پابلو پیکاسـو و بالاتر از همه به تصویر *دوشـیزگان آوینیون* بود. به هر حال، این آبتنی‌کنندگان کـه تصویر، نامش را از آنها گرفته اسـت، تنها بخش کوچکی از

این تصویر عمودی‌شـکل را اشـغال کرده‌انـد. دو زن برهنه در جلـوی یـک منظره، نزدیک لبـهٔ پایینی تصویر، قابل تشـخیص هسـتند. در یک سوم بالایی تصویر، یک پل راه‌آهن، این فضای طبیعی را می‌شـکافد. در پشـت آن تعدادی تکه‌های سـاختمانی ادامه یافته‌انـد که اشـکال بیرونی‌شـان به ترتیب افقی‌هایی می‌شـوند و روی آنها تک‌درختهایی قرار می‌گیرد.

متسـینگر با *آبتنی‌کنندگان*، درون‌مایه‌ای از تاریخ هنر برگرفت کـه بـه کمک آن بتوانـد امکانات طراحی جدید را امتحان کند. او طبق شـگردهای سـبک‌شـناختی کوبیسـم تحلیلی، احجام بسـتهٔ بدن‌هـا، درخت‌هـا و معماری را خرد کرده اسـت. گنجاندن پل قطـار بـه یک تکه مشـابه در تصویر *شـکارچی* آنری لوفوکونیه برمی‌گـردد کـه مدتی قبل، خلق شـده بود. در مقایسـه با هدف لوفوکونیـه، ممکن اسـت متسـینگر از تکه‌های معمـاری که، موازنه‌ای را با زنان آبتنی کننده ایجاد می‌کند نیز اسـتفاده کرده باشـد تا تنـوع پیشـرفت‌های ماشـینی و اجتماعی را در تصویرش اشاره کند.

پل سزان، پنج آبتنی‌کننده، ۱۸۹۲ـ۱۸۹۴

۶۸

Cubism, a pirated Taschen edition of western art published in Iran. Collection Kurosh ValaNejad.

167

[Persian text columns]

Dadaism, a pirated Taschen edition of western art published in Iran. Collection Kurosh ValaNejad.

[Persian text columns]

Cubism, a pirated Taschen edition of western art published in Iran. Collection Kurosh ValaNejad.

۱۴۵

Dadaism, a pirated Taschen edition of western art published in Iran. Collection Kurosh ValaNejad.

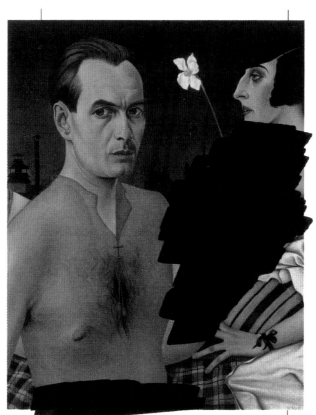

Self-Portrait with Model *Christian Schad, 1927,
76 x 62 cm (30 x 24¼ in), oil on canvas, London Tate
Collection. Neue Sachlichkeit* ("New Objectivity")
describes a tendency for German art, after 1925, to turn
away from Expressionism. Schad abandoned painting in

DK Eyewitness Companion to *Art*, hand censored in Iran. Collection Kurosh ValaNejad.

43

PERFORMANCE ART

Nude Installation *Spencer Tunick, 2003
Grand Central Terminus, New York.* The artist
directs his 450 models, who then arranged
themselves into sculptural poses and
formations. Nudity is a common feature of
provocative performance art and happenings.

DK Eyewitness Companion to *Art*, hand censored in Iran.
Collection Kurosh ValaNejad.

C . 1 9 0 0 – 7 0

437

Bellini *Robert Rauschenberg, 1986, 143.5 x 88.9 cm
(56½ x 35 in), intaglio printed in colour on woven
paper, Detroit Institute of Arts.* A late work by
Rauschenberg, which combines high and low art imagery.

DK Eyewitness Companion to *Art*, hand censored
in Iran. Collection Kurosh ValaNejad.

AFTERWORD
Pamela Joseph

In early 2012 my good friend Kurosh ValaNejad loaned me several art books, published in Iran, in which all nudity had been either blacked out or pixelated. A friend gave these books to him, and he passed them on to me because he thought they related to my work. I knew that I had a powerful statement about history and censorship in my possession, but at first I wasn't sure how to handle the issues involved.

There is never one incident that makes an artwork, but usually a confluence of events. I often sense the glimmerings of a new series when I am having a break from my work – one that is usually forced upon me. I then have the time to reflect, read and write, and to see the relationship of my work to the world around me.

When I started working on the "CENSORED" paintings in early 2012, I had just finished a series that I had been working on for four years, the "Postcard Paintings," in which I had vandalized the works of famous artists by repainting them while inserting body parts from Mexican porn comics. I used works by Rousseau, Manet, Picasso, Matisse, Hokusai and others, and I especially enjoyed working with the art historical reference material that one finds in every museum gift shop: the ubiquitous art postcards. Such cards are not just art images; they are objects unto themselves that sit at the intersection of visual culture and commerce. Yet they are democratic, affordable, highly accessible and collectible, and provide for infinite recombination or repurposing. They also suppose an "other," the one who receives the card, and thus, built into these images are two distinct points of view and perspectives.

My work in general deals with socio-political issues and makes a feminist critique. The images I used as source material from the Iranian censored art books coincided with my documentary practice of appropriation. For me, the whole conceit came together through notions of the absurd, which I have frequently called upon over the past decades in my two- and three-dimensional

artwork. I found such humor in the attempt to obliterate the naked body, and it was also obscure to me why anyone would pixelate Duchamp's *Fountain* or black over a bit of ankle.

In taking on the challenge of presenting these images in their complexity as "found objects," I was convinced that I had to reproduce each one perfectly in order for the series to work. The paintings needed to be as close to the originals as possible so as not to distract from the main point of the effort, which was a kind of reportage about this form of censorship. As an artist I approach my daily practice with dedication and serious attention although I try not to lose the fun or playfulness in the process. Yet I had to be technically adept; and even more so, I had to have a spiritual and moral commitment when I replicated these works. As I communed with each artist, there naturally occurred a spiritual connection along with what I felt to be a heavy responsibility. To create art is the ultimate act of faith for me, and I felt an overwhelming obligation to this series. In the "Postcard Paintings," I had tried to channel the artists as I worked to feel an affinity for them, and then add the sexuality where it seemed most appropriate. I didn't imagine how painful it would be when it came time for me to be the censor of works of art. My "Postcard Painting" series had been a playful attempt to invade art history, but this was purposeful desecration.

The first painting I made was the *Censored Ingres, The Valpinçon Bather*. It was actually traumatic for me when it came time to obliterate with harsh black lines the body I had just perfected. I had worked intently on getting the feeling of that beautiful form. I had felt intense love and sensitivity in its creation, as I imagined how Ingres must have viewed his own rendering when he created the original work. I made a couple of studies just to practice the blacking out. To me, it was physically repulsive, and I felt nauseous. Robert Brinker, my partner, gave me moral support as I finally defaced the Ingres.

My father had always wanted me to be a doctor, but the idea of performing surgery on someone was as inconceivable for me as the idea that I would ever deface a famous work of art. After the Ingres, I approached each painting with a grim determination, but that slowly changed as I realized how symbolic these gestures, which I had first perceived as negation, were. It was especially meaningful for me as an artist. So when I began, I was very faithful to the censored work in the books. And some surprised me as I made them. Metzinger's *Tea Time*, for example, was so delicately censored, I had an appreciation for the laborious job it involved in Iran. The spoon in the painting was left untouched, and I felt obligated to report this gesture just as it had appeared in the Iranian publication.

I continued to depict censored works as they were in the books, such as the Hockney, the Picassos and Duchamp's *Fountain*. Then with Matisse's *Large Reclining Nude*, I began to take a bit of liberty such as not making the black lines as dense, so you could see the curve of the breast just a bit

through the paint. At times, I became emboldened as the anti-censor, wanting to fight back against these violations of history and beauty, which sometimes involved religious icons I was familiar with through my Catholic upbringing. One Iranian censor using a black marker had been especially harsh with the blacked out areas in Schad's *Self-Portrait* so I decided to pixelate the forms instead as I had seen done by the Iranian publishers of the Dada and Cubism pirated books. But for the Schad, I made some of the squares transparent so that the nipples could be seen. It was then that I realized the erotic potential of the works. I began creating my own censored paintings as in works by Cézanne, Guido Reni, and Goya. The Seurat was especially dramatic for me – juxtaposing the pixelated squares with his signature dots, and not having the obliterated area extend to her pubic area.

But when it came to Manet's *Olympia* I let an inner anger gain full force, and I eviscerated her body with harsh straight lines, even over her face. My feelings toward the censors began building as I worked on the series. As I took more liberties with the process, my own subverted feelings emerged. I was furious at the idea that these beautiful works of art were being hidden from the eyes of students, scholars and artists, and that I was now making myself complicit as the censor. I took my anger out on the poor model in the Manet, but she is still able to look out at the censor, and she shows that she still survives.

I worked on the series for three years, continuing to explore the censorship of women's bodily images also found in Saudi Arabian imported products, advertisements, and of Pussy Riot's images censored in Russia. The conceit came full circle in 2015 when Fox 5 New York News blurred out offending nudity in Picasso's *Women of Algiers* (Version O) after the painting was sold at Christie's and shown on TV. I made a couple of studies and a final version of the entire painting. It was a perfect way to end this series, acknowledging that here in the United States we are faced with the absurdity of censorship.

Thinking about this series in retrospect I realize I was attracted to the project because it relates to my experiences as a woman growing up during the women's rights movement in America. I was raised in a strong matriarchal environment where my mother and grandmother told me that I could do anything a man could do but only better. On the other hand, my father was a conservative medical doctor with right-leaning tendencies who said a woman didn't need to be smart as long as she was pretty. That attitude, combined with my Catholic upbringing and its narrow views of women's independence, made me rebel against patriarchy of any kind.

I attended an all-girls high school that fostered very independent ideals and was militant about how women could excel in this world. As I matured in my life and in my work, I realized the many inequalities in the world. I am a contemporary of the first-wave feminists like Gloria Steinem, and I was friendly with Letty Cottin Pogrebin, one of the cofounders of *Ms.* magazine,

but I did not identify with the movement at that time. I felt it was lacking in the full support of all women including minorities and gays. My heroines were activists like Mary Wollstonecraft or bell hooks. Some of the select women at the forefront were also dismissive of women and artists who employed or depicted the naked body with sexual connotations. There wasn't a feeling of trust among women, all of whom I could see would benefit from a more general campaign for equality. I have always believed that it is a woman's right to do what she wants with her own body and not be dictated to by men or society.

I try to show the power of women in my work and the perils that society subjects them to. Viewing the "CENSORED" series through the eyes of the male artists who created the original works, it was challenging to my psyche and process, and that is primarily why I had to break out and begin my own censoring of the works. I had to paint the images from my own perspective as a woman. I have always used appropriations of images and ideas freely, combining them to create interconnecting tensions that make the works evolve new narratives. The "CENSORED" series fulfilled all these criteria for me, but ultimately I was unable to inhabit that external gaze of the censor because the culture and traditions were foreign to me.

Yet, these are issues that affect Muslim women, so I want to pay attention to them. When I look now at two censored Cézannes, I see echoes of the burkini-ban scandals on French beaches. I love those little paintings; there is something very tender about them. I did make their leotards a little more transparent than the censor! But I believe that it is a woman's right to do with her body as she wants, and the point of not wanting to be more naked is just as valid.

Pamela Joseph, *Censored Five Bathers by Cézanne*, 2013. Oil on linen, 20 × 29 in.
Courtesy of the artist.

Pamela Joseph, *Censored Bathers in Front of a Tent by Cézanne*, 2013. Oil on linen, 20 × 26.5 in.
Courtesy of the artist.

ACKNOWLEDGMENTS

For the possibility of working on this fascinating project, I am first of all deeply indebted to the artist Pamela Joseph and to Carrie Paterson, my editor and publisher at DoppelHouse Press. I also owe a tremendous "thank you" to editor Christopher Michno for his tireless efforts and for acting as a liaison with all of the artists in Part Two; to Kurosh ValaNejad for loaning his books and for his boundless enthusiasm and knowledge; and to Donald Cosentino for a very timely "pick-me-up." Thanks also to Erin Levy at Taschen Los Angeles and to Francis M. Naumann in New York. I am also indebted to friends and colleagues too numerous to mention (and especially to Mickey Morgan and John Leopold) for putting up with my endless chatter, and to all of my students at every level for keeping me engaged in the work and alive to its possibilities. Finally, my appreciation, my admiration, and my respect go out to all the artists whose work has engaged my attention here: without your efforts and your courage, there would be nothing to write about. This book is dedicated to Marcia Morrissey, who has shared it all.